PARIS
PICTURED

Julian Stallabrass

Royal Academy of Arts

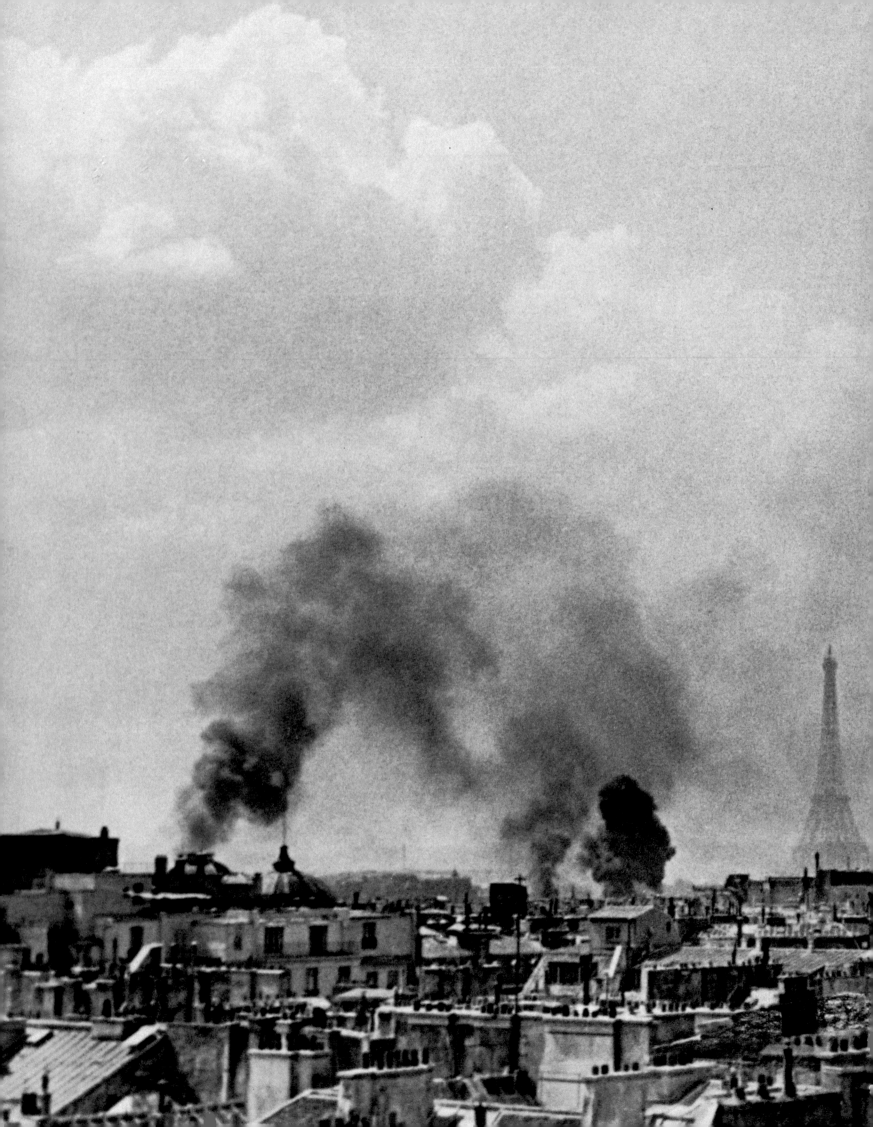

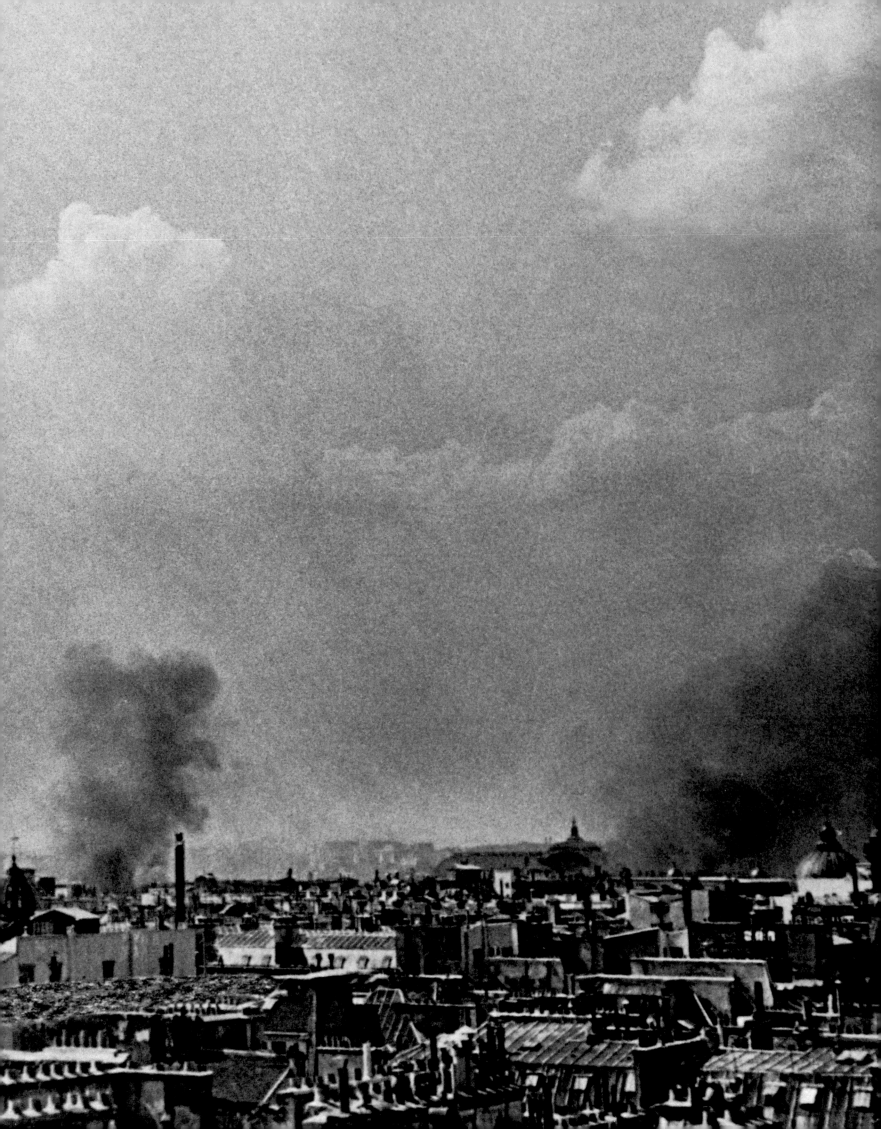

Paris Pictured:
Street Photography 1900–1968

It is a strange activity, going out into the streets of a city with a camera to snatch from the air portions of its light. What is it that photographers are looking for in their long wanderings, and what are they trying to say in their attempts to pull cogent patterns from configurations of people and things? Why do they so often turn their lenses to the same subjects – in the streets of Paris, to children, the homeless, lovers, wanderers like themselves, and to popular fairs, bars, bridges and quays, water, windows, shadows and reflections?

Paris, that great but compact cosmopolitan and imperial city, has a strong claim to be considered the cradle of street photography. The city helped form this genre of photography and, equally, photography contributed to the formation of the city, as Parisians saw first their buildings and then themselves reflected in the many photographic portraits constructed in magazines and books.

How street photography is understood depends not only on one's view of photography but on one's view of the city. Paris between 1900 and 1968 underwent many changes, of course, but also striking shifts of speed in the rate of change. There were long periods of stagnation and others of precipitate development. The far-reaching transformations wrought on the city from the mid-1900s onwards, as extreme in their way as anything that Haussmann realised in the previous century, elicited very different accounts of the urban environment and its inhabitants.

Roland Barthes, justly renowned for his writings on photography, also wrote, towards the end of our period, an essay on reading the city as a text:[1] 'The city is a discourse, and this discourse is actually a language: the city speaks to its inhabitants, we speak to our city, the city where we are, simply by inhabiting it, by traversing it, by looking at it.'[2] This system of signs, like all such systems, is built from contrasts, including those between the suburbs and the centre, and between readers of the city and their 'others', for Barthes claims that people always scour the city to find what they are not. If the city is a text, then those who move around it are readers, 'sampling fragments of the utterance in order to actualise them in secret'. Like the reader of Raymond Queneau's *Cent mille milliards de poèmes*, in which each line is borne on its own strip of paper and so may stand in any poem in the book, every reader of the city creates from the same elements a different verse.[3]

While some characteristics of photography (particularly, when left to itself, its indiscriminate recording of detail) work against its being seen as a system of signs, others aid this interpretation. Photography reduces and flattens the world, freezing movement sharply or registering it as a static blur; in most of the street photographs from this period it eliminates colour; above all, it is a recording only of light, so that shadows may take on the solidity of paving stones, or rather all solidity and evanescence is reduced to a single plane. On this view, to photograph the city is to bring together a set of discrete signs – in a typical picture by André Kertész, for instance, a quay, some *clochards*, trees and a stroller – that serve to condense a subjective view of the city, nevertheless recognisable because assembled from familiar elements, which is then purveyed to a public [pl. 22].

The characteristics of the medium that tend to make its elements appear to be signs reduce the contrast between conventional signs (all the writing in a city, including street names and commercial signs) and their surroundings. Certainly while walking, people read the street but the advert or notice may appear as an interruption in the auditory and

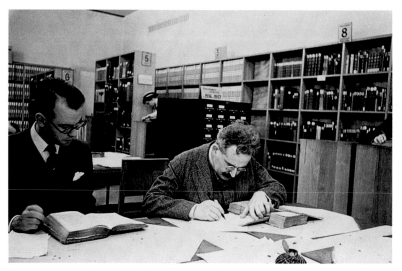

Fig. 1 **Gisèle Freund** Walter Benjamin at the Bibliothèque Nationale, Paris II arrond., 1937

Frontispiece
Henri Cartier-Bresson
Liberation of Paris: grand view, smoke-covered rooftops of Paris during the Battle of Paris, c. 23 August 1944

visual fabric of their perceptions, demanding a sudden, often involuntary switch of attention from metaphorical to actual reading. In some photography, signs sink comfortably into their casings. Yet throughout the photography of this period, particularly in the pre-war decades, there is a frequent focus upon the contrast between the inhabitants or the physical space of the city, and the increasingly intrusive apparatus of commerce that transforms them both. In Kertész, the compactness and quietness of people are contrasted with expansive, overbearing adverts [pl. 43]; in Anneliese Kretschmer, the texture of a party wall revealed by demolition, carrying the traces of people's lives, is contrasted with the palimpsest that is the result of the war of fly-posters below [pl. 41]; in photographs of Paris taken during the anxious years before the Second World War or during the Occupation, signs intrude upon the city in new ways, rousing fears or commanding attention [pl. 52]. Even so, in thinking about photography of Paris, and especially about the consistency of its concerns – that photographers of different backgrounds, times and ideologies cluster around the same subjects – the idea that the city is a system of pre-existing signs, variously shuffled by photographers into their own unique but familiar hands, is a powerful one.

Reading the city like a text certainly predates street photography made for reproduction in magazines and books, and is almost coincident with the medium's birth. If Paris is the city where street photography most speedily formed into a consistent practice, this is surely because it was also the centre of that comparable activity, flânerie. Walter Benjamin, in his renowned, uncompleted Arcades Project, researched in the Bibliothèque Nationale, assembled insightful shards of texts about both photography and the flâneur in nineteenth-century Paris [fig.1]. The bourgeois viewer, almost invariably a man, strolls the city at the pace of (or even with!) a tortoise, opening himself to the reverie brought about by its combination of sensations.[4] While the pursuit itself was an ambulatory idleness (Benjamin even saw it as a demonstration against the division of labour), it had a product, issuing into journalism.[5] For the flâneur, it is not the great monuments of the city that are stimulating but the average run of the place in all its detail, transformed in the mind so that it is treated variously and simultaneously as a natural landscape or a living room.

If the city is a wilderness, then the stroller becomes a colonial hunter of the exotic, and the lower inhabitants of the place its natives. If the city is a living room, those who have to treat it as such, those who work there and above all those who live there, become the subject of special attention: 'What do we know of street corners, kerbstones, the architecture of the pavement – we who have never felt heat, filth and the edges of stones beneath our naked soles, and have never scrutinised the uneven placement of the paving stones with an eye towards bedding down on them?'[6] This was evidently an attraction felt with equal force by photographers who throughout the twentieth century regularly turned their lenses on street dwellers.

Street photography of a kind related to flânerie came into being long after Baudelaire's flâneurs and their Paris had passed away. In such photography people as well as buildings had to be fixed, the inhabitants of the city being caught unawares; photography itself had to become tied to journalism, and this could only happen when it became cheap enough to reproduce in newspapers and magazines. Before the former, figures are absent altogether, or blurred, or leadenly fixed, or seen from a discreet distance (movement is harder to fix the nearer it is to the lens); before the latter, photographers such as Leon Robert Demachy and Constant Puyo worked less for the press than the gallery, producing finely worked, unique prints with subtleties of surface that still resist adequate reproduction [pl.4]. Both flânerie and street photography were directed towards journalism, both bound subjective observation and objective material in packages that contained uncertain portions of information and entertainment. Both also fixed upon the quotidian, but of a particular kind: the everyday life of those at the margins of society; objects slightly out of date. Benjamin argues that it is only when modernity has announced its presence – and he writes specifically of the transparent buildings of Erich Mendelsohn and Le Corbusier – that the flâneur can look fondly on what has only just become old.[7]

In flânerie, 'far-off times and places interpenetrate the landscape and the present moment'.[8] So the flâneur may be (like many Parisian photographers of the 1920s and 1930s) an exile mapping deep memories of other places onto new surroundings, or perhaps merely someone who has spent their childhood in the city, and for whom it is as alien and familiar as the traces of their early life. The interpenetration of different times is regularly captured by photography, while the interpenetration of different places can be constructed using photomontage.

Photographs act as palimpsests of the present and many pasts: Walker Evans, looking at Eugène Atget's work, felt that he was seeing not some 'quaint evocation of the past' but 'an open window looking straight down a stack of decades'.[9] In photography different time-frames are frozen and made spatial. This condensation of time in flânerie and photography is a central concern of Benjamin, but it comes to the fore through a close reading (and indeed translation) of Proust's Remembrance of Things Past. The spaces that people make may likewise be seen as the inscription of time in the world, and the city therefore contains particularly dense configurations of interpenetrating time-frames.[10] In Henri Cartier-Bresson's picture of a rundown area of Montmartre in the 1950s, there is the fast movement of the children's games and the laundry on the line, the slower passage of the sun and shadows over a day, and the even slower time of the growth of the tangle of trees and scrub, of makeshift buildings and their decay [pl. 67].

What is found in great measure in Cartier-Bresson's work, though it is also an aspiration of most street photographers of this period, is the coincidence of narrative subject and formal coherence. There is a simultaneous expansion and diminution in these images. The condensation of different timescales and of subject and form can be grasped clearly because of photography's reductions: of colour to black and white, of the three dimensions of the world to the two dimensions of the print. These effects are reinforced in a photography that has strong formal concerns, leading the viewer to pay attention to the two-dimensional patterning of shades of grey. Because time is made spatial, temporal subject matter and static form come together. As Cartier-Bresson describes it in his book, The Decisive Moment: 'We work in unison with movement as though it were a presentiment of the way life itself unfolds, but inside movement there is one moment at which the elements in motion are in balance.'[11] The ambition, then, is that narrative coherence forges formal coherence. Just what significance can attach to this combination is one of the central questions of street photography. A clue is given by Cartier-Bresson's use of the word 'presentiment', for it

suggests that close attention paid to the time-frames that make up the present may give a glimpse of the future.

It is not just time but space itself that can become condensed and layered. Benjamin wandered into the place du Maroc in the working-class area of Belleville on a Sunday afternoon, finding 'not only a Moroccan desert but also, and at the same time, a monument of colonial imperialism: topographic vision was entwined with allegorical meaning in this square, yet not for an instant did it lose its place in the heart of Belleville'.[12] What matters here, says Benjamin, is not the association but the interpenetration of images. This is literally what François Kollar provides with his photomontage centred on the Arc de Triomphe, which replaces the boulevards that radiate from the monument with fragmentary scenes of the Empire [fig. 2]. In Benjamin's wanderings through Paris, as with those of the Surrealists, what emerges are not merely subjective impressions and the overlaying of the present with many pasts, but the activation of a political consciousness that sees within the current form of the streets temporal and spatial spectres of a revolutionary history and a bloody colonial present.[13]

The temporal frame of photography has often inclined towards melancholia, and in photography of Paris towards elegy. The radical surgery of the city under Haussmann, clearing densely packed ancient neighbourhoods to create apartment buildings fit for the bourgeoisie and wide boulevards suitable for modern traffic and rifle volleys, produced, as a reaction, concern for what had survived. As Haussmann's programme of demolition and construction took place, Charles Marville photographed the process, establishing a tradition of photographic recording of the urban condemned [fig. 3]. Eugène Atget, who in his extensive documentation of Paris never photographed the grand projects of the nineteenth century (not even the Arc de Triomphe or the Eiffel Tower), was the twentieth-century photographer of this sense of elegy. He took pictures of quiet, undistinguished streets, the façades of shops and bars, courtyards and details of old buildings, selling the prints to artists and historians.[14] He also photographed the extensive shanty dwellings of the 'Zone', the area beyond Paris's fortifications in which building was officially forbidden [pl. 9].

Yet these pictures, which appear so poignant, were not originally as they seem to us now. The Surrealists, among others, admired Atget's work for its banality, and because the eccentric photographer could be thought of as an unconscious artist. The novelist and journalist Pierre Mac Orlan, one of the most important French writers on photography in the inter-war years, claimed that, while Atget, as much an artisan as an artist, was in full technical control of his medium, he loved his subjects with the same tenderness as did the Douanier Rousseau.[15] Critics, with an eye on Surrealism, saw in Atget's work the same naivety, detailed realism and sinister mood that they admired in popular mystery movies such as the Fantômas series.[16] The nostalgia of Atget's work, as inflected in writing at the time of his 'discovery' as an artist in the late 1920s, was a peculiar one, fixed on the near past, on the despised trash of a decade or so ago, not yet rehabilitated. (The Surrealists shared that enthusiasm, with Louis Aragon, for example, finding poetic material in vanishing arcades [fig. 4] and in the tawdry artificial waterfalls and grottoes of the Parc des Buttes Chaumont.)[17] Again, as Benjamin reminds us, the *flâneur* is attracted to the newly old. The effect was all the stranger because, despite Atget's ageing photographic equipment, his pictures

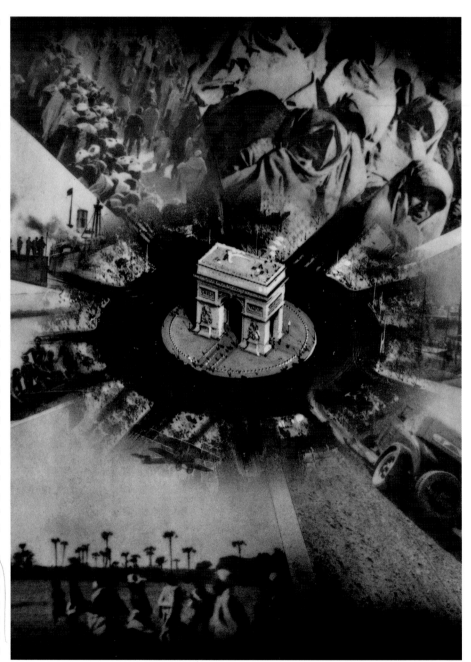

Fig. 2 **François Kollar** Photomontage: Arc de Triomphe, Paris XVII arrond.

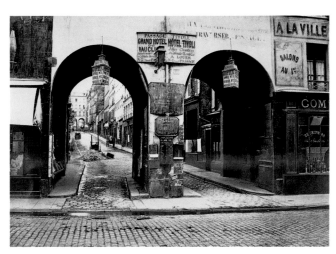

Fig. 3 **Charles Marville** The Passage Tivoli, Paris, 1865

Fig. 4 **Seeberger Brothers** The Passage Jouffroy, Paris IX arrond., 1926

seemed extraordinarily modern: 'Black and white, colours of night and principles of the photographic image illuminate it with a fire as inhuman as it is intelligent,' wrote Mac Orlan, 'A photographic knowledge of the world is cruel'.[18] The merciless clarity of Atget's approach collided with his subject matter, or did so at least for contemporary viewers, who were used to prettier pictorial effects. Benjamin, as is well known, described Atget's pictures as lacking in aura – and he thought this was remarkable because they depicted a city soaked in romanticism.[19] Such a judgement may seem incredible today, but was perhaps not so at the time, when so much of what Atget recorded in his deadpan manner still stood before the Parisian wanderer.

The strange success of Atget, lauded as an artist in the years immediately following his death in 1927, set in train the continuing elegy of Parisian photography, which regularly comments on what is passing away. As we shall see, there is a paradox to this concern.

In the late 1920s photography began to be discussed in the same terms, and by the same figures, as 'fine art' – a break in the long prejudice against the mechanical art. That Atget's work came to be considered art was indicative of this development. Photographers had long sought to vanquish fine art's disdain for their craft by making their pictures look more like paintings. Such attempts, practical and theoretical, had, as Benjamin notes, no success, for they were attempting 'nothing less than to legitimise the photographer before the very tribunal he was in the process of overturning'.[20] As photography in Germany and France came to take on a role in magazine illustration and was simultaneously influenced by avant-garde painting, photographers concentrated upon what they took to be the qualities inherent to their medium: sharp focus, full tonal range and a relatively unmanipulated recording of the subject. Photographs began to be shown in large exhibitions, receiving considerable press attention, at least for being symptomatic of modern times.

The emerging character of street photography was formed by linked technical factors. Most important was the falling cost of photographic reproduction in half-tone in magazines and newspapers, so that a market for news images, fashion and publicity photographs, and pictures of quotidian life emerged. Most of the photographers included here engaged in a mix of such work, and many pictures that later became known as exemplars of an individual photographer's *oeuvre* were taken on assignment.

Responding to the economics of photographic reproduction, a new form of illustrated magazine emerged, dependent upon building up meaning primarily through images rather than text. From the late 1920s, these magazines gained mass readerships. Lucien Vogel at *Vu* was among the first to realise the importance of reportage for this new type of publishing, commissioning work from Germaine Krull, André Kertész and Éli Lotar from 1928, and many others in later years. Vogel encouraged daring formal innovations on the part of his photographers and matched them with striking layouts. *Vu* devoted a special issue to Paris in October 1932, featuring the work of Brassaï, Kertész, Krull and Maurice Tabard, bolstered with texts by Jean Cocteau and Mac Orlan – one of the first forays into what was to become a familiar combination of photographic and literary talent.

Films and cameras also changed. Films became faster (that is, more sensitive to light) so that photographers could shoot successfully

in murky conditions, or in bright light could capture more rapid movement or achieve greater depth of focus. Lenses, too, became faster (that is, their maximum apertures were larger), again permitting a wider range of shooting conditions and, when photographers wanted it, narrower depth of focus. Film became available on rolls so that photographers did not have to reload after each shot. Combining these advantages in a remarkably well-designed, compact package, the Leica (manufactured from 1925) was the perfect street camera of the age. It used 35-millimetre film (originally designed for cine-cameras), was pocketable, very quiet, and had excellent lenses. Yet, in judging the quality of these early street photographs, it should be appreciated how far even these Leicas were from their counterparts today. Early models had tiny separate focusing and framing windows and were slow to focus accurately. The wind-on mechanism was a knurled knob, not a lever, and was likewise slow to use, allowing photographers few second chances. Given these constraints, Cartier-Bresson's technique of first finding a background and pre-framing and focusing a shot, and then waiting as long as necessary for 'something to happen' made perfect sense.[21]

As films and cameras progressed, Paris in photographic representation changed slowly from an unpopulated collection of sturdy edifices to a scene of mobile and transient light in which people appeared closer and closer to the lens and in ever greater sharpness. A few unlikely, slow shades appear in photographs of the Exposition Universelle of 1900; in street scenes around this time most walkers blur, or record only as strange shadows, while those who loiter solidify; the boy Lartigue took photographs of ladies and incidents that amused him, fixed in the bright sunshine of days out in the Bois de Boulogne [pl. 14]; Atget's streets remained generally empty, unless he had some tradesperson pose before his camera, or some wavering presence is caught behind the plate glass of a bar or shop [pl. 10]. As capturing movement close by became possible, many street photographers were caught up in the novel task of producing from frozen combinations of people's movements a suggestion of meaning.

In the late 1920s and early 1930s, a substantial number of photographic books about Paris were published. These included Germaine Krull's 100 x Paris (1929); André Warnaud's Visages de Paris (1930), containing more photographs by Krull; Atget, photographe de Paris (1930); Moï Ver's montages and multiple exposures of the city (1930) and Paris: 258 Photographes; Brassaï's Paris by Night (1933); Paris vu par André Kertész, with a text by Mac Orlan (1934); and Paris de jour (a companion volume to Brassaï's book with photographs by Roger Schall and an introduction by Cocteau).[22] While, as we shall see, these books adopted a variety of approaches, their basic and durable trick was to validate photography with texts by well-known literary figures: on the cover of Paris by Night the name of writer Paul Morand features far more prominently than that of the then little-known Brassaï.

Street photography of this period appears to fall into three distinct tendencies: Surrealist, Modernist and, between them, a humanist, universalising middle ground. Surrealism as a movement had a limited use for street photography, using such photographs as found objects in its journals, and later commissioning photographers to record aspects of contemporary life. Jacques-André Boiffard took photographs of Parisian streets to record the backdrops to Breton's strange wanderings and encounters in his book Nadja.[23] Éli Lotar (with André Masson) visited the

slaughterhouses of La Villette and Vaugirard in 1929 and 1930.[24] Here was slaughter on the production line, not in violent passion, but for instrumental gain, a face of violence familiar enough from the mechanised slaughter of the First World War. This aspect is expressed in the photographs Lotar took, including one of animals' hooves lined up as if on parade or in a shop display [pl. 24]. More important was a strain of photography that, while not formally associated with Surrealism, was informed by it and by Pierre Mac Orlan's writing on the 'social fantastic'– a somewhat morbid fascination with the banalities and extremities of urban life and their interconnection.[25]

Brassaï and Cartier-Bresson were connected with the Surrealists loosely and in very different ways. Brassaï's book Paris by Night brought an aspect of the city into photography for the first time, often dwelling upon the transformation wrought by street lighting on scenes that would be banal or overfamiliar by day.[26] The photographs seemed to present the viewer with an ungraspable mystery, suggested by their deep areas of black, though equally by circles of light, glimpsed through the tracery of branches or railings. Sometimes the elements came together in a more overtly bizarre combination, as in the photograph of the statue of Marshal Ney (animated, as statues often are, by the frozen medium of photography), who appears to be about to advance, sword drawn, through the fog on the illuminated sign of a hotel [pl. 39].

In later work, Brassaï continued his nocturnal pursuits, photographing brothels, including those in the district around the market of Les Halles, which catered to visiting farmers. Not far away clochards, as orderly as if they were in a dormitory, slept in the arches of the Bourse du Commerce [pl. 36] (they would often gather around the market because of the charity of the workers there). Brassaï was to become best known for photographs of various activities that shunned the light – behind the scenes at risqué shows, the hang-outs of criminal gangs, gay and lesbian venues – and of those who literally inhabited an underworld, cesspool cleaners [pl. 37].

It is clear that Brassaï's work was a form of ethnography – one that revelled in the strange rather than sought to explain it – applied to the hidden and the oppressed who lived in the capital, rather than to the colonised abroad. This alone links his project to Surrealism.[27] It is also clear that the market for Brassaï's photographs (as earlier for his writings) was among cultural tourists, those who wished to explore the exotic, erotic or dangerous elements of a city at a safe distance.[28] This is exactly what Barthes says 'readers' of the city are looking out for – whatever they themselves are not and can never be.

Just as the photographs of Ansel Adams, which celebrate the wild beauty of the US National Parks, helped to turn the parks into sites for mass tourism, so Brassaï's work, and that of writers such as Léon-Paul Fargue, who accompanied the photographer on some of his trips as well as guiding rich literary types about the low-life areas of Paris, changed the places they depicted. In his 1939 book, Le Piéton de Paris, Fargue complained that some areas of the city were losing their hard edge as they opened to tourists and businesses which exploited their picturesque character. Indeed, the rue de Lappe (where Brassaï often photographed) had become little more than a 'stage set'.[29] As they often have, artists played a role in this transformation, leading the gentrification of down-at-heel areas by their presence and popularising those areas with their depictions.

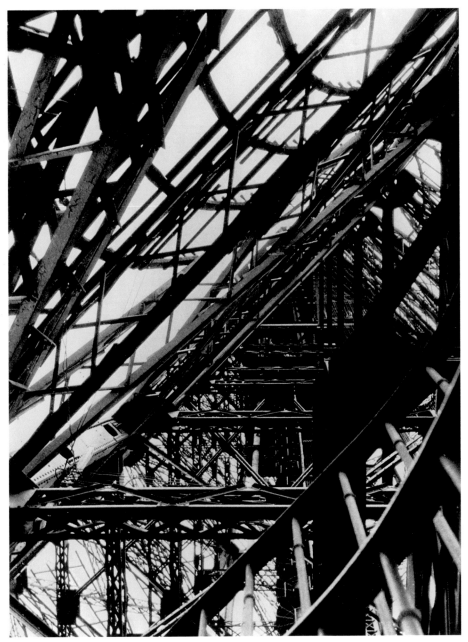

Fig. 5 **László Moholy-Nagy** Paris, 1925

Cartier-Bresson has said that Surrealism was important to his whole practice and it is not hard to see why.[30] A few of his pictures contain specific Surrealist motifs and themes (an example is the reference to what lies out of sight in the photograph of men by a railway cutting [pl. 28]), but the movement was integral to the method and subject matter of his work as a whole. Cartier-Bresson's technique was to go out into an environment over which he sought no control, to discover 'found objects' rendered in silver. These 'objects', configurations of people in a space, are recognised in the blink of an eye and reacted to at a speed that leaves no time for conscious decision. Cartier-Bresson's insistence on remaining inconspicuous so as not to disturb the subject with his presence, and on leaving the print uncropped and unmanipulated, is about maintaining the purity of the object as found.

As with many photographers of the inter-war years, Cartier-Bresson's subjects are often drawn from those excluded from bourgeois norms of behaviour by their social status or their activities: children, the indigent, sleepers, the working class, peasants.[31] Cartier-Bresson seems to have produced textbook instances of the Surrealist marvellous, snatched from the banality of the street and very often from the poor, the street's involuntary inhabitants. Yet his deeply political Surrealism goes further than this, as we shall see later, being connected to Benjamin's notion of time.

Quite different from the work of Brassaï and Cartier-Bresson was Kertész's restrained photography, which dwelt upon the quiet disposition of people in urban spaces, the poignant distance between figures, the artistry of their arrangement (partly the photographer's, partly their own), and the play of light. These pictures, especially the long shots, with their unusual viewpoints, slight flattening of space, and layering of variegated planes, have a relation to Cubism.

More generally, Kertész's work seemed to have an affinity with the middle ground of French art of the 1920s, which took its distance from both the excesses of avant-gardism and the ossification of academia. This tendency, *Art Vivant*, which was highly successful both critically and commercially, was less a movement than an attempt to carve out a specifically French path through a cultural world that seemed disordered and prey to irrational extremes. Its adherents, often former avant-gardists like Maurice de Vlaminck or André Derain, sought to acknowledge the claims of Modernism and classicism at once. For Jean Gallotti, writing in the journal *L'Art Vivant*, Kertész's pictures impart a sense of the hour, the light, and the point of view, the specificity of the circumstances of the object, but also the presence of the photographer, which is inscribed like an invisible signature.[32] In most discussion of *Art Vivant* painting, the artist is imbued in the work, so much so that subject matter becomes no more than a vehicle for subjective expression.[33] In photography this process cannot be taken so far and there is thought rather to be a merging of object and subject. Indeed, Kertész claimed to be an amateur in the sense that, since photography's beauty is dependent upon its truthfulness, professional virtuosity and trickery must be guarded against.[34]

Kertész took the middle ground in other ways. His vision of Paris was melancholic and nostalgic, remote from the dark images of Mac Orlan and the Surrealists.[35] The city is strange and full of incident but is also gently comforting. His subjects were generally ordinary people, though he also photographed flea markets, circuses, fairs and street

performers [pl. 46] (and was far from alone in this); his world was neither the haute bourgeois milieu of Lartigue nor the *demi-monde* of Brassaï.[36] In this, he prefigured much of the photography that followed, with the crucial difference that Kertész was an exile from Hungary (having fled the dictatorship of Admiral Horthy) who never perfected his French and thus viewed his subjects and his environment as an outsider.

In marked contrast, a few technophile Modernist photographers worked on producing visions of the contemporary age from the city, at first sight an unpromising project. Germaine Krull, following the lead of Modernist painters such as Delaunay, took the Eiffel Tower as one of the subjects for her album, *Métal*, which celebrated modern constructions.[37] In this book and for *Vu* she made close-up photographs of the structure and lift mechanisms, along with views with plunging perspectives. László Moholy-Nagy made similar pictures of the tower [fig. 5]. Krull also devoted a book to Paris, *100 x Paris*, in part stressing its Modernist aspects with, for instance, pictures taken from cars – she was one of the few photographers to take the side of the driver against that of the pedestrian [pl. 21].[38] As an aside, Krull's way of making photographs tells us something about why there were only a small number of women street photographers; male photographers would often wander alone but Krull generally worked with an assistant – for a time Éli Lotar. Shooting from a car was another way of assuring her safety and freedom from harassment.

It would be too simple to see Krull's work as a pure product of technophile Modernism. Her vision was tempered by a commitment to honest reportage, for she too saw photography as a meeting point between the outside world and the subjectivity of the photographer.[39] Furthermore, Krull's work was important enough to become a battle-ground for competing critical readings, which variously stressed its Modernist abstraction, lyricism and truth to life.[40] *100 x Paris* was prefaced with a highly romantic text by art critic Florent Fels, which dwelt not on the march of modernity but, in a manner typical of *flânerie*, on the saturation of streets and buildings with historical and literary associations. Krull's work, with its Bauhaus-inspired formal techniques, rather then stands at the technophile end of the blurry spectrum of French street photography at this time.

In these various images of Paris there stand great contrasts: in the photographs of those associated with the Surrealists (Brassaï, above all, but also Man Ray, Boiffard, Cartier-Bresson and Lotar), in the technophile work of Krull, dwelling on metal and speed, and in the modest, restrained work of Kertész, the most popular of them all. Their work overlaps: Krull's *clochards* are not so different from Kertész's; there are pictures by Brassaï, especially his night photographs, that could be mistaken for ones by Kertész, and Kertész's own *Meudon* (1928) [pl. 42] shows a configuration of little events worthy of the Surrealist marvellous or the social fantastic. This common ground is unsurprising, since all these photographers worked for the same magazines, developing their practices with a mix of commissioned and personal work. Even so, there is a broader cultural and political explanation for this configuration (also apparent in fine art and literature) of technocracy and irrationalism flanking a gentle, compromising modern art. Following the First World War, many were frightened by modernity and its cultural expressions, and with just cause. In a celebrated album of photography published by *Arts et Métiers Graphiques* in 1930, the conservative critic Waldemar

George commented on its contents: 'Architecture, machines, panoramas. Plunging views, extreme perspectives. A new world or a world turned upside down?'[41] State policy towards economic development was congruent with the middle-ground culture of *Art Vivant*. The hope was that France would avoid the grim fates of those countries enslaved to heavy industry (Britain and the US were models here, but above all inhuman Germany), not by retiring into the past but by leavening its modernity with high culture and good taste, impressing not by the quantity of its manufactures but by their artistry.[42] It is just this middle position that Kertész holds – a classically inflected art of the everyday, combined with hints of Modernism in the framing and angles.

The Depression, slow to hit France but long-lasting when it did, transformed French politics and culture, along with the photographic scene. Politics, spurred by the economic crisis and developments in Italy, Germany and later Spain, became increasingly polarised. Magazines, including *Vu*, adopted a more explicitly political stance. In a symptomatic move, Kertész emigrated to the US in 1936, no longer finding such a ready market in France for his mild, poetic work. Enthusiasm for the machine and the products of modern life faded, both in France and in the US, where images of natural wonders and folk culture became more commonplace than those of factories and mass-produced consumer goods.

In 1936 a broad wave of strikes and factory occupations heralded the accession of the Popular Front government. After such a long period of working-class oppression and denigration, the Popular Front, an alliance of socialists, radicals and communists thrown together in part by the threat of Fascism, seemed to offer prospects for fundamental improvements to workers' lives. The factory occupations put the government in a strong position to negotiate with employers not only substantial pay rises but also paid holidays and a forty-hour week. Naturally, such developments were greeted with joy by the workers. Strikes and demonstrations were often the scenes of carnivalesque partying [pl. 48]. Photographers on commission from leftist papers, notably Chim (David Seymour), Robert Capa, Robert Doisneau and François Kollar, went to the factories to document working conditions, union activity and the new waves of dissent. Others photographed striking shopworkers relaxing in the streets [pl. 50], or people enjoying their first paid holidays.

The optimism of 1936 was short-lived, however, as the Popular Front soon floundered, brought into crisis by its failure to deliver further reform, its refusal to act against the Fascist forces in Spain, and by the draining of investment funds from France as the markets reacted against the very existence of a leftist government. *Regards* (a communist weekly magazine) asked Willy Ronis to photograph a strike at the Citröen works in the rue de Javel in 1938, as employers attempted to claw back rights recently conceded [fig. 6].[43] *Vu* was forced out of business as advertisers recoiled from its partisan political line.

While political commitment among photographers had been rare, the mid- and late 1930s presented such clear political choices that many intellectuals and artists moved to the Left (and a few to the Right). Cartier-Bresson, Chim, Capa and Ronis were members of the Association des Ecrivains et Artistes Révolutionnaires, an organisation affiliated to the French Communist Party.[44] Cartier-Bresson worked with Capa on Aragon's communist newspaper, *Ce Soir*. Chim, Capa and

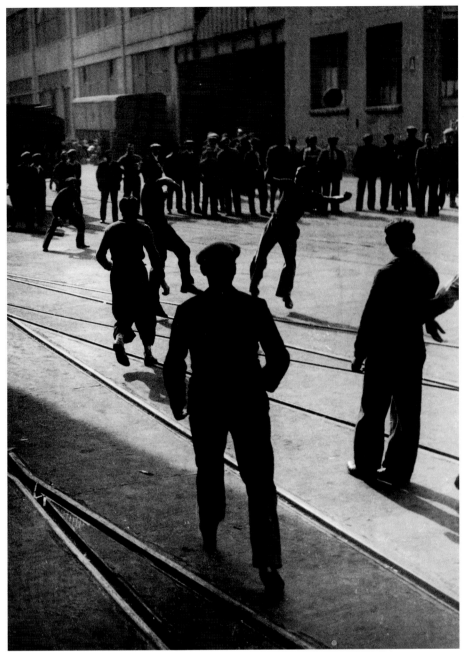

Fig. 6 **Willy Ronis** Citröen workers strike, Paris, March 1938

Cartier-Bresson even had discussions in the 1930s about setting up a group of 'revolutionary-minded photographers'.[45] For photographers with such views, work was available on a number of leftist journals and magazines, including *Ce Soir*, *Regards* and *La Vie Ouvrière*, the magazine of the Confédération Générale du Travail (CGT) union, allied to the Communist Party.

For Barthes, it will be remembered, people went to the city in search of their 'other'. In street photography of the late 1920s and early 1930s, this often seemed to be the impetus. Kertész, it is true, often photographed anonymous figures who could stand in for any person, but many photographers concentrated on the indigent, wandering street performers, or on surreal juxtapositions, and in Brassaï's case on an underworld of prostitution, cross-dressing and crime. In the new political situation, however, popular magazines and newspapers, some of them communist, delivered to their readers images of themselves. Such work would be revived, with less explicit political force, in the post-war years, during which the photographers themselves claimed that they, too, were no different from their subjects (if not their viewers).

Many prominent street photographers of this period were communists, and would remain so after the war. Yet they were communists of a particular kind, formed in the period of the Popular Front, in a broad left alliance that stood successfully against the development of French Fascism (which remained until the Occupation a divided force), and that fought not for immediate revolution but rather the amelioration of workers' lives. Their communism was not sectarian or doctrinaire but was allied to a simple humanism. It was plainly expressed in photographs that showed workers – their activities, politics and organisations – sympathetically. It was apparent too in the many pictures taken in working-class areas of Paris that, without the taint of ethnography, attempted to make sense of, or at least suggest a sense to, the lives of the inhabitants. It was there also in something less obvious – in the photographers' representation of time in their work. To get a grasp of this, we should return to the question of time in the work of Cartier-Bresson.

In an essay introducing Cartier-Bresson's book, *D'une Chine à l'autre*, Jean-Paul Sartre showed how the photographer's depiction of apparently mundane and simple activities could also act as political statements. Viewed as exotic 'others' by colonisers, the Chinese were oppressed, but Cartier-Bresson shows them simply as people. His Chinese subjects awaiting the arrival of the Revolutionary Army in Shanghai are doing what they have always done: labouring – especially carrying burdens – scavenging, gleaning. In this, said Sartre, Cartier-Bresson's pictures show his subjects as materialists, that is, first and foremost as people with bodily needs who must work. The Chinese are subject to economic forces just like everyone else, and their hunger is no different to that of Europeans (Sartre was writing at a time when the memory of widespread hunger in Europe was not at all distant). 'Cartier-Bresson's snapshots trap man at top speed without giving him time to be superficial,' he wrote, 'At one-hundredth of a second, we are all *the same*, all of us at the heart of our human condition'.[46] This is communist humanism, and in this sense, claimed Sartre, Cartier-Bresson had photographed eternity. Yet, in a sudden twist, Sartre said that this very eternity is fragile, for history is now at the gates of the city: 'These timeless snapshots are precisely dated: they fix forever the last instants of the Eternal.'[47]

This whole line of criticism was far more plausible then than now, being dependent upon a belief in historical progress. It points to both the qualified universalism of Cartier-Bresson's work, its engagement with political critique, and the way in which it contains a number of different time-frames at once. For Walter Benjamin, it was by looking backwards that you could glimpse the future, particularly in those layered moments of *flânerie* that condense different spatial or temporal frames. Perhaps in specific circumstances photography's version of that condensation can offer up some revolutionary potential. In looking back to states of existence that are not dependent upon the division of labour and industrial production, whether it is looking back to childhood or to those who cannot or chose not to work or to the peasantry, an image of a world governed not solely by the imperatives of commerce is evoked. With it, hopefully, there also comes a glimpse of a Utopian future.[48]

Revolution, of course, was not fomented in France; rather, as the Second World War broke out, the Allied forces collapsed under attack, not least because there were many among the French bourgeoisie who were far from convinced that Fascism rather than communism was the real enemy. The Germans entered a city from which millions had fled. Under the Armistice, France was split between one zone – which included Paris – occupied by the German Army and another in which the French zealously administered their own variety of Fascism, hoping to lay to rest forever the spectre of the Popular Front. As the war turned against Germany, all of France became subject to the demands of the Axis forces, its resources drained, its men sent to labour abroad. So the French discovered what it was like to be colonised.

The Occupation was not conducive to street photography. Photographers were likely to be viewed with suspicion, and had to seek permits to make their work. Ronis, a Jew, thought it prudent not to put himself in the hands of the police, who issued permits, and eventually fled to the south.[49] Robert Doisneau, Roger Parry and Roger Schall, among others, managed to make a few striking images of occupied Paris, of German soldiers in the streets [pl. 53], of posted edicts, and road signs in Gothic script [pl. 54] – minor signs of an oppression that could not be straightforwardly depicted.

The liberation of Paris [fig. 8] brought an influx of photographers, some (like Capa) riding with the French vanguard. They took pictures of the communist-led uprising against the Occupation, of the scenes of celebration when Allied troops arrived, of people taking shelter from snipers left to harry the Allies and their supporters [pl. 56], of captured enemies and the humiliation of collaborators. Doisneau made an extraordinary picture of a group of resistors who stripped off the surface of a road, rolling it up to make a barricade [pl. 57]. Cartier-Bresson, still hinting at the horror, photographed a room that the Gestapo had used for interrogation, hastily abandoned [fig. 7]. He also photographed the smoke from fires burning in the city (Hitler had given orders that areas of the city be razed as the Germans retreated; if his orders had not been disobeyed Paris would have shared the fate of Warsaw) [Frontispiece].

Material conditions in France immediately following the war were harder even than during the Occupation, food and fuel being in short supply at least for those unable to afford to buy on the black market supplied by US armed forces' stores. For a time, such privation lent the French population the illusion of a certain equality in adversity, and this

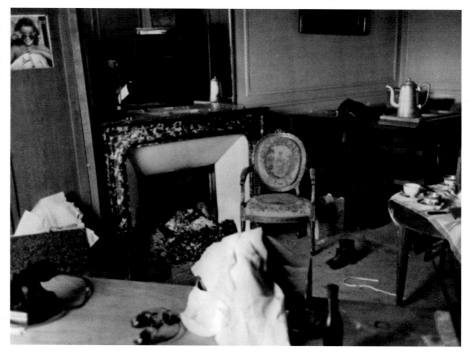

Fig. 7 Henri Cartier-Bresson Abandoned Gestapo interrogration room, Paris, 1944

Fig. 8 **Roger Touchard** Liberation of Paris, XIV arrond., 1944

solidarity was fostered by positive images of everyday life.[50] In this situation, it was the gentle, humanistic work of Doisneau, Ronis and Izis that came to prominence, much featured in magazines at home and abroad and collected into books that gave a poetic and romantic view of Paris. These photographers presented a vision of social cohesion that encompassed much of the population. Its class character is suggested by Louis Chevalier, writing of the mixing of many types of people at Strasbourg-St. Denis: all of Paris was present, he claims, 'except the high society, of course, who were not missed'.[51]

Ronis and Doisneau began to make pictures of mundane life at the edges of Paris. Ronis made a study of Belleville-Ménilmontant. Situated near the Zone, this area was, until the nineteenth century, two separate villages and, although it had become working class with a reputation for rebelliousness, it retained a somewhat rustic air. Small factories and workshops were common, and many artisans lived there. It was ethnically diverse, with Armenians, Greeks and Polish Jews settling after the First World War, and Tunisians, Moroccans and Algerians after the Second.[52] Similarly, collaborating with Blaise Cendrars, Doisneau worked on a project about the Parisian *banlieue*.[53] The core of Doisneau's work depicts urban light, air and space, and people's responses to them and each other, subtly composed within the quiet, square format and low viewpoint of the Rolleiflex, a camera that could be used at waist level. His pictures for *La Banlieue de Paris* exude the stillness of the fringes of the city at this time, often shot in a granular, misty light that partially dissolves the distant figures [pl. 64].

Such photographers were dependent upon the still thriving illustrated magazines. The US market was important but France had its own domestic productions, *Regards* and *Paris Match*, modelled upon *Life*. In addition, many photographic books about Paris continued to be published. Izis's wistful and romantic book *Paris des Rêves* appeared in 1950, with a preface by Cocteau and texts by many well-known authors accompanying the plates.[54] Doisneau and Cendrars followed *La Banlieue de Paris* (1949) with *Instantanés de Paris* (1955). Ronis found it hard to find a publisher for *Belleville-Ménilmontant* but it did appear in 1954 and was a critical if not a commercial success.[55]

There are strong similarities in the work of Doisneau and Ronis. Both were wonderful photographers of children, and could imbue rundown urban environments with an almost magical significance by allowing the viewer to empathise with a child's point of view [pls. 66, 69]. The birth rate – long a source of concern in France, threatened by its more populous neighbour – had jumped upwards following the war, a sign, it was hoped by some, of a new national confidence, and so pictures of children carried more than their usual poignancy. Both photographers could spin out of what were apparently the flimsiest of elements, suggestions of great meaning. In contrast to Surrealism, the ordinary is valued in their work as ordinary, no longer being a vehicle in which to escape into the marvellous. Both took little distance from their subjects. In *La Banlieue de Paris*, Cendrars refers to Doisneau as an artisan, and the photographer himself continually stressed his closeness to the working people he depicted.[56] Ronis, in a text he wrote for an exhibition at the Museum of Modern Art in New York in 1951, stressed that his work presupposed 'a sincere love and respect for mankind'.[57]

A continuing engagement with left-wing politics motivated both photographers. They were members of the Communist Party, and

worked for the communist and socialist press. While it was important to Doisneau and Ronis to depict the working class positively, especially given the continuing isolation of its representatives from mainstream politics as the Cold War developed, this interest remained broadly humanist. Both were also members of Rapho, founded in 1945 – an agency that served clients in the communist and Catholic press with a brand of humanism that was congenial to both. Peter Hamilton, who has written about both photographers, notes that Doisneau's celebratory picture of a line of people dancing before a new housing block was used with differing interpretations by communist and Catholic publications [pl. 63].[58]

There is a strongly elegiac air to many of the pictures of the sub-urbs, and to the very purpose of taking them: Ronis said that Paris was changing very fast between 1947 and 1950 and he wanted to record it before the changes took hold.[59] The economy of France grew at a remarkable rate in the late 1940s and throughout the 1950s, though the gains were unevenly distributed. As it did, the basis of solidarity on which left-wing humanist photography had rested was eroded, and the urban environment this photography depicted altered radically. Ronis was to witness the transformation of much of Belleville-Ménilmontant when new housing was built and new immigrants from North Africa moved into the area.[60] Doisneau, though he had often claimed to be photographing ordinary people like himself, said something quite different when interviewed in 1979: 'My little universe, photographed by scarcely anyone, has taken on an aspect so exotic as to have become the reserve of an amazing fauna. But I don't laugh at these images at all…even though, personally, the desire to amuse myself was great; indeed, throughout my life I have amused myself, I've constructed my own theatre.'[61] As with Atget's banal Paris, when the world depicted passed away, the photographs taken there became exotic. Ethnography caught up with them.

The material conditions for the creation of such images were unusual in a major capital city. Real estate in Paris had been barely profitable for forty years before the First World War. In 1914, rents were frozen and remained so until 1948. After 1919, the French bourgeoisie did not find investment in property at home attractive (speculative funds went instead to Central Europe or the colonies). The Depression, natur-ally, led to a fall-off in all investment. Remarkably, then, from 1914 until the end of the Second World War, most bourgeois proprietors who owned property in central Paris derived no benefit from their real estate. In wealthy areas, rents barely covered maintenance costs. In poor areas, buildings were simply not maintained, so that parts of the Marais, for example, came to look like an urban ruin.[62] Furthermore, France's late, long and bloody relinquishing of its colonies meant that the government turned tardily towards reconstruction at home. So the height of street photography in Paris, in the years between the wars and up to the mid-1950s took place in a city that was in stasis or slow decline. The elegiac character of the photography was paradoxical because it was recording something that hardly changed, though it always seemed under threat. Such photography was like a breath held, awaiting the great uneven wave of consumerism that was to break upon the nation.

The humanism of Doisneau, Ronis, Izis and others found expres-sion in the US, where Edward Steichen showed their work at the Museum of Modern Art, and in the large, very popular touring exhibition,

The Family of Man, which was shown in Paris.[63] The ambition of that show, skewered by Barthes in a little essay in *Mythologies*, was to demonstrate that 'Man' was essentilly and eternally the same every-where in birth, death, labour and laughter, although all now lived under the shadow of the Bomb.[64] While the humanism of the French photo-graphers was founded on political solidarity and national identity, its appearance in Steichen's show, divorced from its context in magazines and books, tended to render it vacuous.

In the US at this time a photography emerged that rejected human-ism – certainly that of Steichen, which was charged with sentimentality – but also more specific and political practices. It became apparent in the work of Robert Frank and William Klein, and later Gary Winogrand and Diane Arbus. The effect of this cold, sometimes aggressive photo-graphy when it was turned upon Paris can be seen in pictures by Frank taken in the early 1950s [pls. 87, 88]. Yet it was in the US, in grimy indus-trial towns, in vast formless spaces, in a society already thoroughly dominated by the automobile and in which the windscreen often served as an additional pane of glass between the photographer and the world, that Frank's vision was to reach its bleak conclusion.[65]

From the late 1950s onwards, street photography came under increasing pressure from various directions. The same technologies of reproduction and transmission of still images that had enabled the rise of the genre, when applied to moving images, contributed to its decline. Television competed with the illustrated magazines and slowly drove them out of business, or led them to switch to niche markets. The left-ist humanism that had for so long sustained this photography came under consistent attack, first plainly due to the Cold War and the reve-lation of the hideous acts of Stalin's regime, later from post-structuralist thinkers in France, and more fundamentally through the rise of con-sumerism, which made it less plausible to think of the fundamental needs of some singular and universal 'Man' that never changed. Cartier-Bresson was acutely aware of this last point: 'We have to acknowledge', he wrote in 1968, 'the existence of a chasm between the economic needs of our consumer society and the requirements of those who bear wit-ness to this epoch'.[66]

Beyond these broad transformations, evident throughout the West, Paris itself was changing fast. A major factor that made street photo-graphy increasingly difficult was the rise of mass private transportation. Complaints were heard even at the beginning of the twentieth century that motor traffic had ruined the tranquillity of Parisian streets. This was no doubt true of the major thoroughfares, though mass transit using horses was also noisy, smelly and dangerous. Yet it was the sheer vol-ume of traffic that was to drive photographers and their subjects from the streets – a destruction of community space on a massive scale which took place with a thoroughness and ruthlessness that made it seem planned. Cars in the Paris region more than tripled in number between 1925 and 1939 to 500,000, but had not at that point begun to affect the entire environment of the city. During the war, the number of cars in use greatly declined due to fuel shortages, and most Parisians travelled on foot or by bicycle. The revival of mass motorised transport following the war was slow. Yet between 1960 and 1965 there was a doubling of cars in Paris to 2 million [pl. 98].[67] From the mid-1950s onwards, traffic lanes were added at the expense of pavements, greatly reducing the number

of trees in the city (some boulevards used to have double rows of trees). Pavement 'clutter' – that is, bazaar, café and circus activities – was crowded out by road-widening and parking over the kerb.[68] Beyond this general bullying of people out of the street, there were high-profile decisions to favour traffic flow over social spaces. The banks of the Seine, particularly the Right Bank, were given over to motorways, destroying the tranquil spaces that had been left to walkers, anglers, lovers – and photographers [pl. 80]. Izis continued to photograph on those quays that were left as if nothing had happened but the character of his pictures changed nonetheless, for it was mostly young tourists and *clochards* who now assembled there before his lens.

Property values in Paris, as we have seen, remained static for many years. Such a situation could not last for long in the strong post-war economy, and between 1948 and 1954 rents increased sixfold, doubling the cost of living, and producing intense speculation in housing.[69] While Paris continued to be protected from development by a conservation-minded city government and the decentralising policy of the central government, the result was not the desired dispersal of the population but makeshift settlements appearing even in the centre of the city, and many homeless people living on the streets who would often freeze to death, as many did in the winters of 1954–55 and 1955–56 when slabs of ice floated on the Seine.[70] The long years of stagnation in the property market had left numerous areas in which the existing housing was ill-maintained and antiquated. In the mid-1950s nearly a quarter of Parisian housing lacked running water, and over fourth-fifths had no bath or shower.[71] Atget, as we have seen, photographed the plaster and tar-paper shanties of the Zone beyond the fortifications of Paris. In various guises, in speculative building in the suburbs, and later in housing for post-war immigrants, shanties were a persistent feature of the Paris landscape into the 1970s. A Cartier-Bresson of 1968 shows a shanty town in the foreground, while behind it rise the towers of new housing developments [pl. 96].

New housing, public and private, was built on a vast scale from the mid-1950s, while power was transferred from local to state planning bodies that had fewer conservationist scruples.[72] By 1974 one in five dwellings in Paris was less than twenty years old, and nearly a quarter of Paris's buildable surface had been redeveloped.[73] Most of the building in the centre of the city was relatively expensive, so working-class people were pushed out to the suburbs.[74] This slowly brought about a change in the character of central Paris, as it became a scrubbed-up business and heritage ghetto, to which (as Henri Lefebvre points out) those deported to the suburbs return as dispossessed tourists.[75] This was a joint state- and market-led development, well underway when Lefebvre wrote his important book *Right to the City* in 1967, which, along with various Situationist texts, had considerable influence over the participants in the revolt of 1968.[76] Modernisation programmes also destroyed some formerly cherished areas of the city. A significant battle over the identity of Paris centred around Les Halles and its nineteenth-century pavilions built by Victor Baltard. Despite concerted protest, the market was closed in 1969 and demolished two years later, making way for an underground interchange between the Metro and the RER and a large subterranean shopping centre. Photographers from Atget onwards had made work there, and photographers recorded its destruction.

Some photographers followed their subjects to the outer suburbs, now notorious for their depredation, gang warfare and racial tension, and as the subjects of brutal policing. Cartier-Bresson, Ronis and Doisneau attempted to record the life of the new estates. Strikingly, while their earlier street scenes of the city had been full of interaction, in these new photographs single figures are often dwarfed by large blocks of houses or expanses of wasteland [pl. 97].

The quality of housing undoubtedly improved, and (as in Britain) those moved to the new estates were initially enthusiastic about their homes with their modern facilities. Yet the price was a decline in working-class sociability in public spaces. Norma Evenson claims that this was just what the planners intended:

> The café had been viewed as a centre of sedition, and the street as a theatre of immorality. The motivation of housing reform had been the image of mother, father and children, snug behind closed doors, keeping themselves to themselves, thank you, and supporting a social order dedicated to the perpetuation of families securely and comfortably walled in.[77]

In his book, *Society of the Spectacle*, taken up by the activists of 1968, Guy Debord, in a series of sometimes dense, sometimes witty, sometimes borrowed observations, analysed what he saw as the occupation of social life by consumerism. There is a section on the organisation of space, which he argues becomes increasingly homogeneous under the impact of consumerism, and he describes the tyranny of the car, the rise of the shopping mall, the authoritarian estates containing atomised individuals locked away with their receiving sets. If cities are the locus of history, concentrations of social power and collective memory, then this attack on their very nature is no less than an attempt to end history itself.[78] For Lefebvre, too, in *Right to the City*, housing, traffic and consumer goods all contribute to this erosion of the social, and tend to make of the city a uniform, isotopic space full of instructions and signals but lacking the variegation of neighbourhoods and the overlaid patterns of history.[79] There is another way of putting this, more closely related to *flânerie*. For Benjamin, the street is the home of the collective:

> The collective is an eternally unquiet, eternally agitated being that – in the space between the building fronts – experiences, learns, understands and invents as much as individuals do within the privacy of their own four walls. For this collective, glossy enamelled shop signs are a wall decoration as good as, if not better than, an oil painting in the drawing room of a bourgeois; walls with their 'Post No Bills' are its writing desk, newspaper stands its libraries, mailboxes its busts, benches its bedroom furniture, and the café terrace is the balcony from which it looks down on its household.[80]

Yet it is no longer true that Parisians merely camp in their cramped homes and expect to find diversion in the streets.

The events of 1968, in which De Gaulle's government was almost toppled by mass demonstrations of workers and students, with tanks massed on the outskirts of the city ready to intervene, stand as a symptom of many of these changes. Radicalisation of youth was brought

about by many factors, one of the most important being the genocidal war being pursued in France's old colony, Vietnam. The impoverished state of the universities (overcrowded by the generation of the post-war baby boom), the social conformity forced on the students, and the brutality of the police response to the first protests, also made a contribution. The movement began at the University of Nanterre, and Louis Chevalier believes that the progress of what he calls 'Nanterrisation', the transformation of the city into inhuman concrete and trafficked environments, was also a cause. The revolt was a refusal to live in this new urban milieu, 'this city whose boredom, hideousness, rawness, whose reinforced concrete, condemned students to a kind of captivity and summed up all they detested'.[81] As it spread, it took in more genteel areas and older universities, notably the Sorbonne [fig. 9]. Gilles Caron and others made some extraordinary photographs of the events [pls. 107, 110], but this late flourishing of street photography was enabled by temporary circumstances brought about by the protest, which had blocked the traffic and formed instant communities in opposition to the police, while causing the consumerism the demonstrators so hated to stutter throughout the city. As Angelo Quattrocchi put it, for a brief time, 'people have less and less money, and more and more friends'.[82] The actions of the protestors were a political form of street theatre that briefly revived a lost urban social life. While the revolt was put down and De Gaulle's government survived a little longer, such an intoxicating, Utopian tonic of sedition and sociability could not be so easily forgotten, and similar demonstrations and battles with police continued for years.[83]

In Barthes' essay about the city as a text, there appears a technocratic passage in which it is claimed that, by thinking of the city as an amalgam of separable signs, it can be opened up to more effective management through making comparable the data of psychology, sociology, geography and demography.[84] The role of the signified, says Barthes, when it is discovered, is only to speak of the specific state of a signifying distribution.[85] Applied to photography this would approach the thinking of Vilém Flusser, for whom photographers do no more than search for novel combinations in a pre-existing field of photographic possibilities.[86] Applied to the photography of Paris, this view would indeed have something to say of the increasingly restricted possibilities for photographers approaching a city in which so many options are closed off by well-known precedents.

Yet it is important that, for Barthes, the reading of the city is always made 'in secret'. This is a thoroughly individualistic, intellectual view, very much that of the *flâneur*, and not at all that of the participant. It cuts against the public, collective project of the communist and humanist photographers who dominated the depiction of Parisian street life. Against this conception may be pitched Lefebvre's view of the city as a collective work of its inhabitants, borne out of the struggle between the instrumental requirements of industry, 'rational' planning and those who live within it, attempting to escape the demands that are thrust upon them. 'The city is not only a language but also a practice,' he writes, in a sentence that seems to answer Barthes.[87] For Lefebvre the city is a complex spatialisation of time. Photography, as we have seen, shares this quality, and photographers have been attracted to those elements of the city that reflect that congruence either directly, in pictures, say, of other photographers, or allusively, in pictures of reflections and shadows. In the works of the street photographers, people as well as the urban architecture are frozen, a fragment of their time suggestive of its own past and present made still and spatial. They can be read as if they were architecture, as Brassaï sought to read the traces of history on the walls of slums [pl. 25]. Perhaps it is this common ground between photography and urban space that attracts photographers to cities as surely as ants to sugar, and that also finally gives their work in city streets its significance.

Yet that significance, both of the activity and the results of street photography, is historically contingent. It depends upon an urban realm that is alive and diverse, changed by its inhabitants as it changes them, and upon a market for a photography that will attempt to grasp that life. It withers in circumstances in which history in cities is confined to strictly bounded heritage districts, and where collective life is in decline.[88] Today it does indeed survive, in places less evenly subject to the operations of modernity, as in (to take just one example) the extraordinary work of Antonio Turok made in Chiapas.[89] Elsewhere, as Lefebvre puts it, 'If the spectre of communism no longer haunts Europe, the shadow of the city, the regret of what has died because it was killed, perhaps guilt, have replaced the old dread.'[90] In Paris today there are signs that people want their city back – even the Right Bank motorway is given over to pedestrians at certain hours on weekends. Yet for the moment, as in so many First World cities, the delicate interchange between urban life and its photography remains moribund or given over to the trickeries of contemporary art.

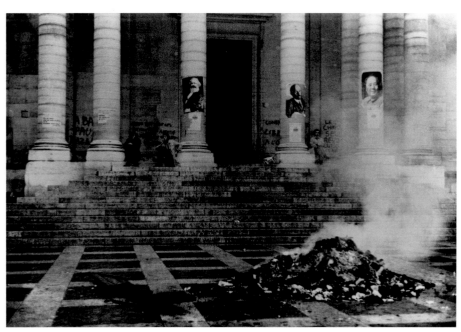

Fig. 9 **Henri Cartier-Bresson** The Sorbonne University, Paris V arrond., May 1968

1 Roland Barthes, 'Semiology and Urbanism', 1967, in *The Semiotic Challenge*, Richard Howard (trans.) , Berkeley, 1994. Barthes' later writings on photography have a different view than this post-structuralist text. See *Camera Lucida: Reflections on Photography*, Richard Howard (trans.), London, 1984.

2 Barthes, 'Semiology and Urbanism', p.195.

3 Barthes, 'Semiology and Urbanism', p.199; Raymond Queneau, *Cent mille milliards de poèmes*, Paris, 1961.

4 This passage draws upon the 'Flâneur' section of Benjamin's *The Arcades Project*, Howard Eiland and Kevin McLaughlin (trans.), Cambridge, Mass., 1999 (the text on tortoise pace is on p.422), and 'The Return of the *Flâneur*', in *Selected Writings, Volume 2, 1927–1934*, Michael W. Jennings, Howard Eiland and Gary Smith (eds.), Cambridge, Mass., 1999.

5 Benjamin, *Arcades Project*, p.427.

6 Benjamin, *Arcades Project*, p.517.

7 Benjamin, 'The Return of the *Flâneur*', p.264.

8 Benjamin, *Arcades Project*, p.419.

9 Walker Evans, 'The Reappearance of Photography', *Hound and Horn*, no.5 (October–December 1931), p.125; cited in Belinda Rathbone, *Walker Evans: A Biography*, Boston, 1995, p.69.

10 See Henri Lefebvre, Introduction to *Writings on Cities*, Eleonore Kofman and Elizabeth Lebas (eds. and trans.), Oxford, 1996, p.16.

11 Henri Cartier-Bresson, *The Decisive Moment*, New York, 1952, n.p.

12 Benjamin, *Arcades Project*, p.518.

13 For an account that links Benjamin and the Surrealists' concerns with the topography of Paris, see Margaret Cohen, *Profane Illumination: Walter Benjamin and the Paris of Surrealist Revolution*, Berkeley, 1993.

14 The key work on Atget is John Szarkowski and Maria Morris Hambourg, *The Work of Atget*, 4 vols., New York, 1981– 85.

15 Pierre Mac Orlan, *Atget, photographe de Paris*, Paris, 1930, in *Oeuvres complètes: masques sur mesure I*, Geneva, 1970, p.360.

16 Maria Morris Hambourg, 'Atget, Precursor of Modern Documentary Photography', in *Observations: Essays on Documentary Photography*, David Featherstone (ed.), Carmel, California ,1984, p.26.

17 Louis Aragon, *Paris Peasant*, 1926, Simon Watson Taylor (trans.), London, 1981.

18 Mac Orlan, *Atget, photographe de Paris*, reprinted in *Photography in the Modern Era: European Documents and Critical Writings, 1913–1940*, Christopher Phillips (ed.), New York, 1989, p.43.

19 Benjamin, 'Small History of Photography', in *Selected Writings, Volume 2, 1927–1934*, p.518.

20 Benjamin, 'Small History of Photography', p.508.

21 Cartier-Bresson, *The Decisive Moment*, n.p.

22 See Marja Warehime, *Brassaï: Images of Culture and the Surrealist Observer*, Baton Rouge, 1996, p.61.

23 André Breton, *Nadja*, 1928, Richard Howard (trans.), New York, 1960.

24 See William Rubin and Carolyn Lanchner, *André Masson*, exh. cat., Museum of Modern Art, New York, 1976, p.133.

25 Pierre Mac Orlan, 'Elements of a Social Fantastic', in *Photography in the Modern Era*, pp.31–3. The essay was first published in *Le Crapouillot* in March 1929.

26 Photographing at night was not then a simple matter. Brassaï's own account of his methods was published as 'Technique de la photographie de nuit', *Arts et Métiers Graphiques*, no.33 (15 January 1933), pp.24–7.

27 An important essay exploring the connection is James Clifford, 'On Ethnographic Surrealism', in *The Predicament of Culture: Twentieth-Century Ethnography, . Literature, and Art*, Cambridge, Mass., 1988.

28 Warehime, *Brassaï*, p.104.

29 This point is made by Warehime, *Brassaï*, pp.105–6. Léon-Paul Fargue, *Le Piéton de Paris*, Paris, 1939, pp.102–3.

30 Yves Bourde, 'Les Érotiques de Cartier-Bresson', *Photo*, no.57 (June 1972); cited in Jean-Pierre Montier, *Henri Cartier-Bresson*, London, 1996, p.84. For an account of Cartier-Bresson's links to the Surrealists, see Peter Galassi, *Henri Cartier-Bresson: The Early Work*, exh. cat., Museum of Modern Art, New York, 1987, pp.12f.

31 See Galassi, *Cartier-Bresson*, pp.35–6.

32 Jean Gallotti, 'Kertész', *L'Art Vivant*, no.101 (1 March 1929), p.211.

33 For a discussion of the ideology of *Art Vivant*, see Christopher Green, *Cubism and its Enemies: Modern Movements and Reaction in French Art, 1916–1928*, New Haven, 1987, especially ch.7.

34 Jean Vidal, interview with Kertész, *L'Instransigeant* (1 April 1930); as discussed in Pierre Borhan, 'Introduction: The Double Life', in *André Kertész: His Life and Work*, Boston, 1994, p.19.

35 See Dominique Baqué, 'Paris, Kertész: Elective Affinities', in Borhan, *André Kertész*, pp.91f.

36 See Borhan, 'Introduction: to *André Kertész*, p.15.

37 Germaine Krull, *Métal*, Paris, 1928.

38 Germaine Krull, *100 x Paris*, Berlin, 1929.

39 Germaine Krull, 'Pensées sur l'art', in Pierre Mac Orlan, *Germaine Krull*, Paris, 1931; as discussed in Kim Sichel, *Germaine Krull: Photographer of Modernity*, Cambridge, Mass., 1999, p.90.

40 Sichel, *Krull*, p.93f.

41 Waldemar George, 'Photographie: Vision du monde', *Arts et Métiers Graphiques*, no.16 (15 March 1930), p.142.

42 See Richard F. Kuisel, *Capitalism and the State in Modern France: Renovation and Economic Management in the Twentieth Century*, Cambridge, 1981.

43 Peter Hamilton, *Willy Ronis: Photographs 1926–1995*, exh. cat., Museum of Modern Art, Oxford, 1995, p.24.

44 Hamilton, *Ronis*, p.22.

45 Russell Miller, *Magnum: Fifty Years at the Front Line of History*, London, 1997, p.25, citing Inge Bondi, *Chim: The Photographs of David Seymour*, London, 1996.

46 Jean-Paul Sartre, Preface to Henri Cartier-Bresson, *D'une Chine à l'autre*, Paris, 1954, n.p. A translation can be found in Sartre, *Colonialism and Neocolonialism*, Azzedine Hadour, Steve Brewer and Terry McWilliams (trans.), London, 2001.

47 Sartre, Preface to *D'une Chine à l'autre*.

48 Galassi, *Cartier-Bresson*, p.22, cites Nicholas Nabokov on Cartier-Bresson seeing the communist movement as the future of mankind: Nabokov, *Bagázh: Memoirs of a Russian Cosmopolitan*, New York, 1975, pp.200–1.

49 Hamilton, *Ronis*, p.27.

50 Hamilton, *Ronis*, p.30.

51 Louis Chevalier, *The Assassination of Paris*, David P. Jordan (trans.), Chicago, 1994, pp.254–5.

52 Hamilton, *Ronis*, p.30.

53 Robert Doisneau, *La Banlieue de Paris*, Paris, 1949.

54 Izis, *Paris des Rêves*, Lausanne, 1950.

55 Hamilton, *Ronis*, p.52; Willy Ronis, *Belleville-Ménilmontant*, Paris, 1954.

56 See Peter Hamilton, *Robert Doisneau: A Photographer's Life*, New York, 1995, p.178.

57 MOMA archives; as discussed in Hamilton, *Ronis*, p.35.

58 Hamilton, *Doisneau*, p.138.

59 Hamilton, *Ronis*, p.30.

60 See Patrick Deedes-Vincke, *Paris: The City and its Photographs*, Boston, 1992, p.112.

61 As quoted in Hamilton, *Doisneau*, p.113.

62 This passage is dependent upon Chevalier, *The Assassination of Paris*, pp.22f.

63 *The Family of Man*, exh. cat., Museum of Modern Art, New York, 1955.

64 Roland Barthes, 'The Great Family of Man', in *Mythologies*, Annette Lavers (trans.), London, 1973.

65 Robert Frank, *Les Américains*, Paris, 1958.

66 Henri Cartier-Bresson, *The World of Henri Cartier-Bresson*, London, 1968, n.p.

67 Norma Evenson, *Paris: A Century of Change, 1878–1978*, New Haven, 1979, pp.54–5.

68 Evenson, *Paris*, pp.55–6, 58.

69 Chevalier, *The Assassination of Paris*, p.29.

70 Chevalier, *The Assassination of Paris*, p.20.

71 Evenson, *Paris*, p.232.

72 For a powerful, detailed and personal account, see Chevalier, *The Assassination of Paris*.

73 Evenson, *Paris*, p.310.

74 Evenson, *Paris*, p.236.

75 Lefebvre, Introduction to *Writings on Cities*, p.34, discussing Lefebvre's article 'Les illusions de la modernité', published in *Le Monde Diplomatique* in 1991.

76 Lefebvre, Introduction to *Writings on Cities*, p.42.

77 Evenson, *Paris*, p.264.

78 Guy Debord, *Society of the Spectacle*, 1967, New York, 1994.

79 Lefebvre, *Writings on Cities*, p.127f.

80 Benjamin, *Arcades Project*, p.423.

81 Chevalier, *The Assassination of Paris*, p.12.

82 Angelo Quattrocchi, 'What Happened', in Quattrocchi and Tom Nairn, *The Beginning of the End: France, May 1968*, London, 1998, p.55.

83 For a collection of photographs of these later demonstrations, see Michel Field, *Jours de manif: années 70*, Paris, 1996.

84 Barthes, 'Semiology and Urbanism', p.195.

85 Barthes, 'Semiology and Urbanism', p.197.

86 Vilém Flusser, *Towards a Philosophy of Photography*, London, 2000.

87 Lefebvre, *Writings on Cities*, p.143.

88 For an account that draws a contrast with Benjamin's urban remembrance, see Christine M. Boyer, *The City of Collective Memory: Its Historical Imagery and Architectural Expression*, Cambridge, Mass., 1996, pp.191–2.

89 Antonio Turok, *Chiapas: El fin del silencio*, New York, 1998.

90 Lefebvre, *Writings on Cities*, p.142.

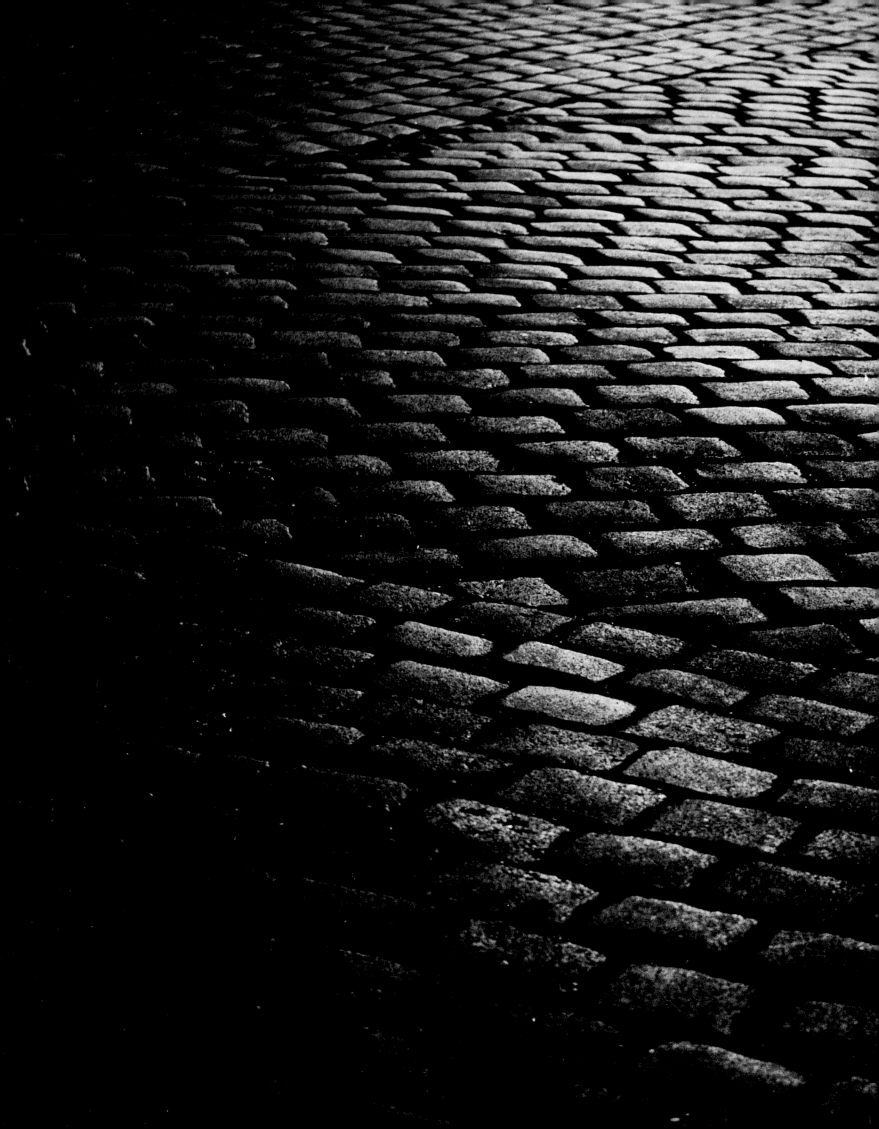

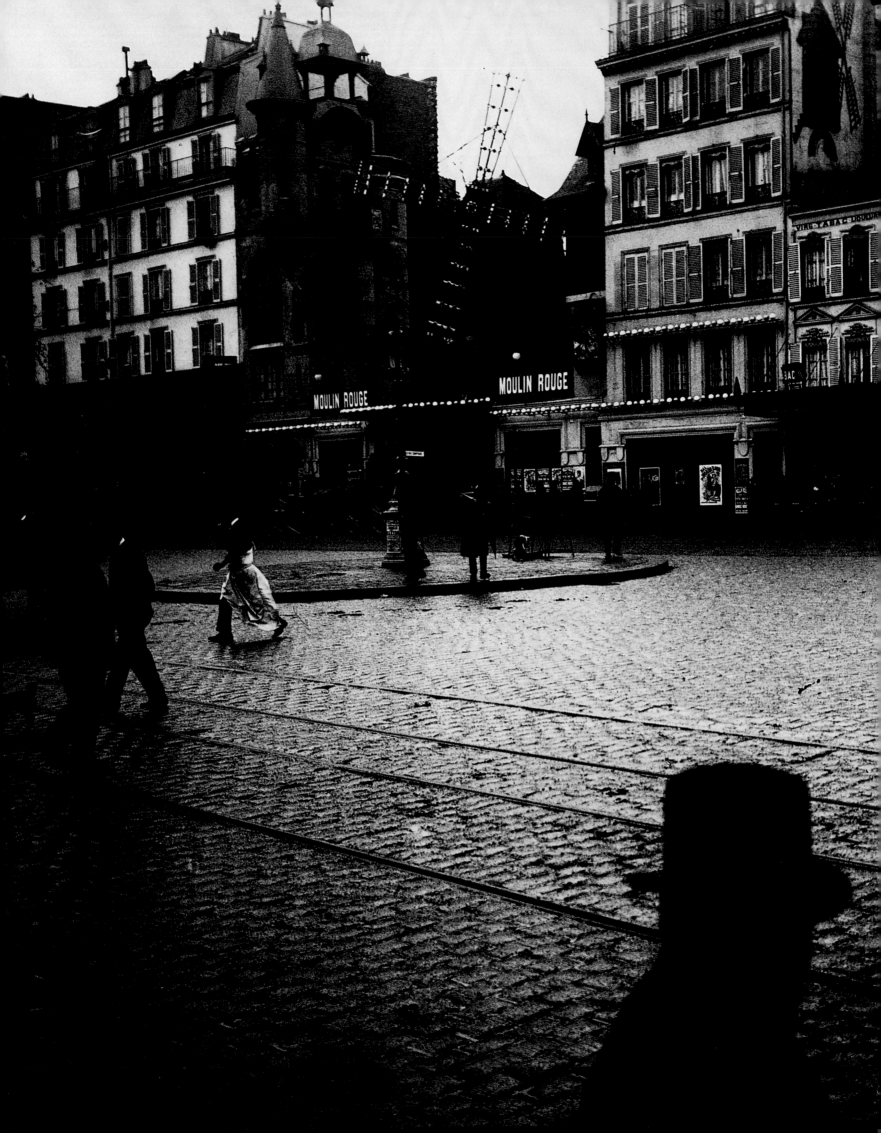

3

1 **Brassaï**
Paving stones, c. 1930–32

2 **Aurélio da Paz dos Reis**
Le Moulin Rouge, 82 boulevard
Clichy, Paris XVIII arrond., 1900

3 **Aurélio da Paz dos Reis**
Exposition Universelle, 1900

2

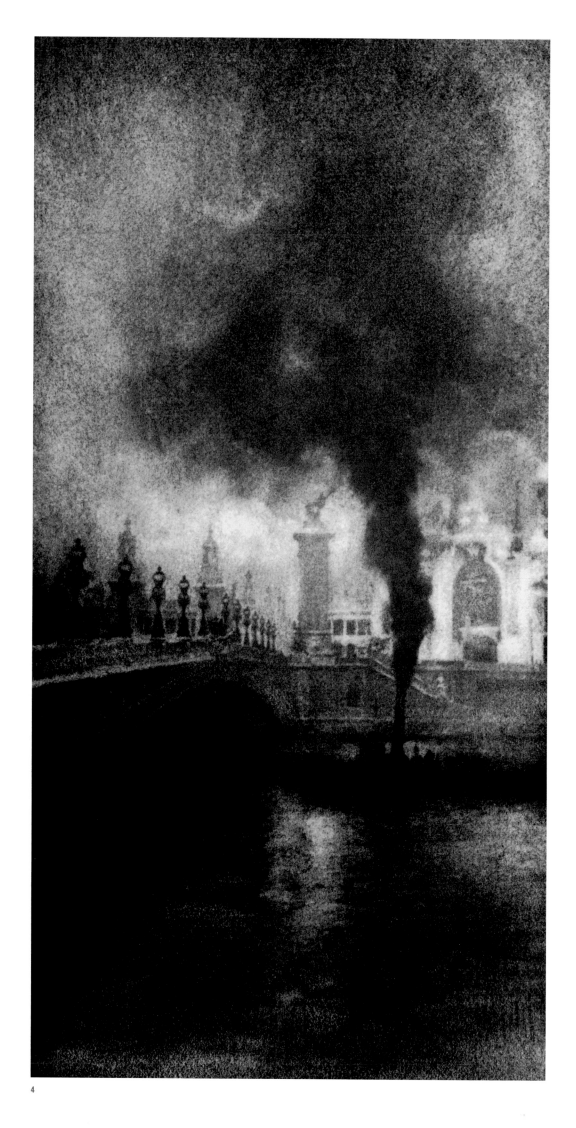

5

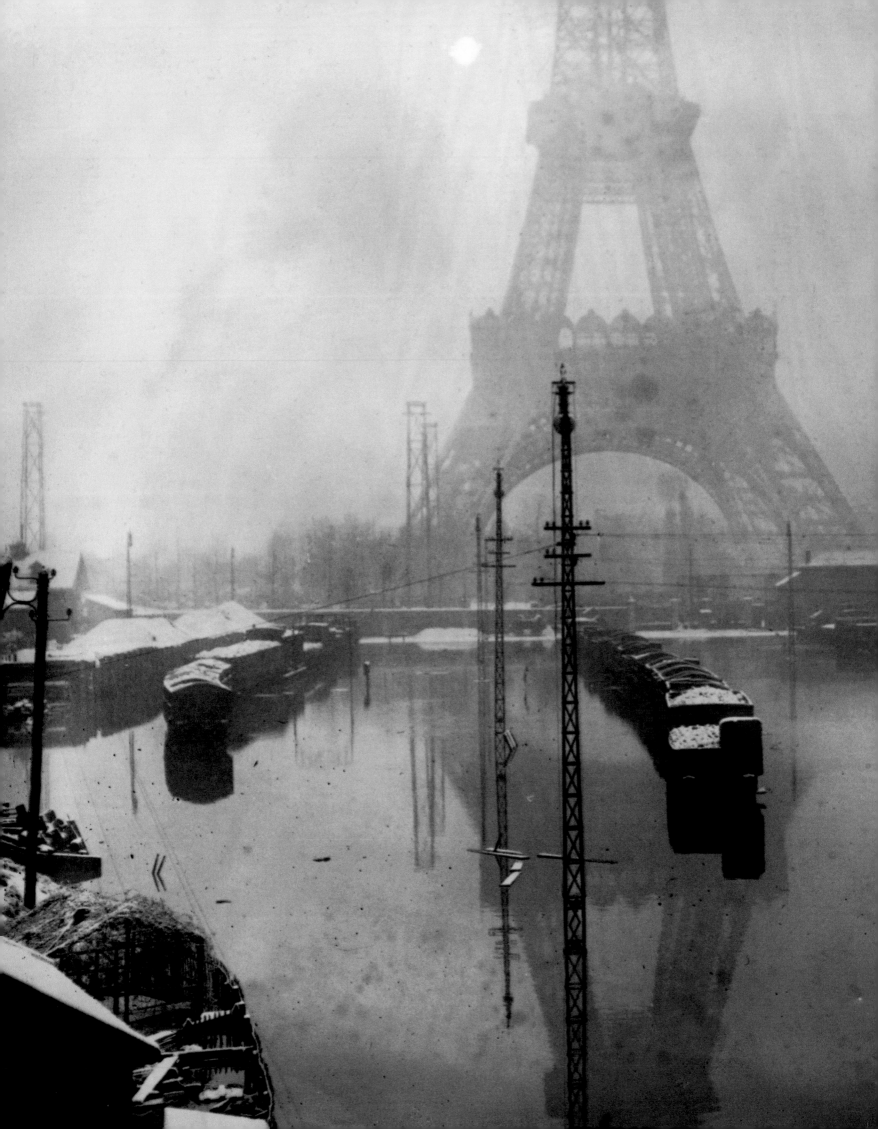

6 **Seeberger Brothers**
Flooded Paris, winter 1910

6

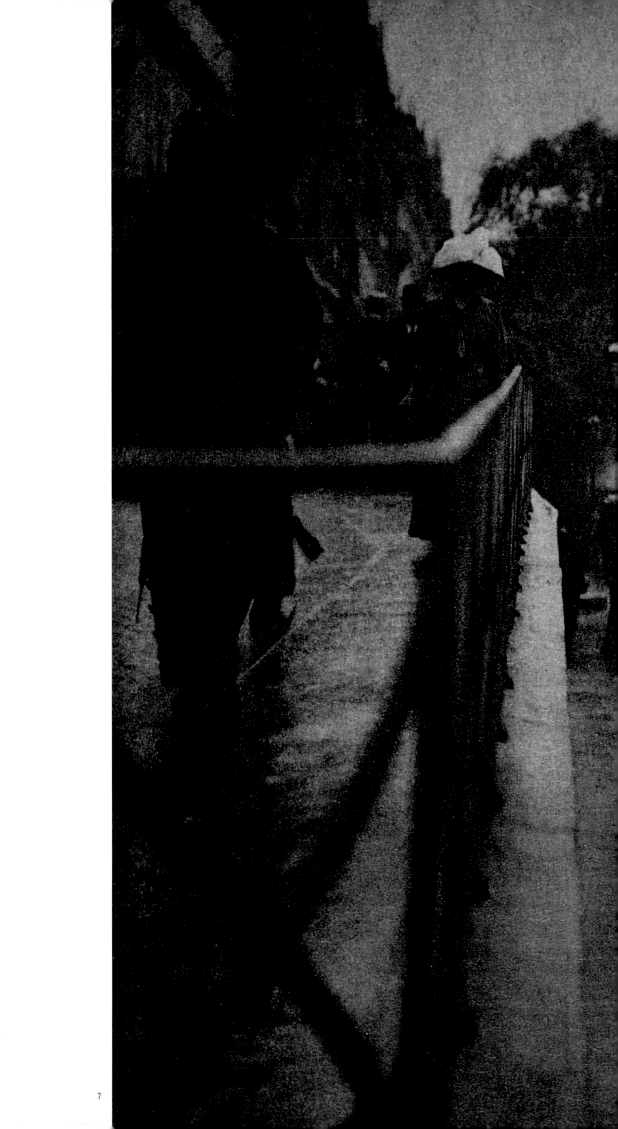

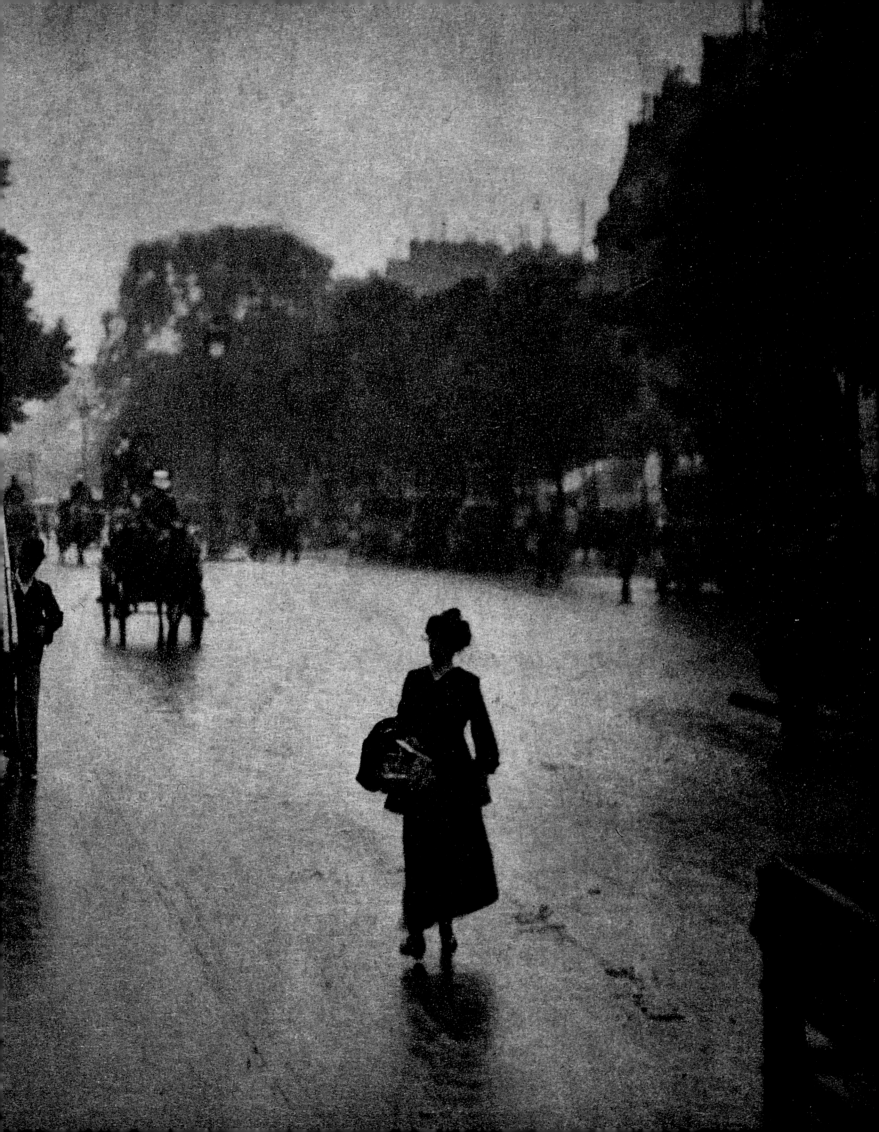

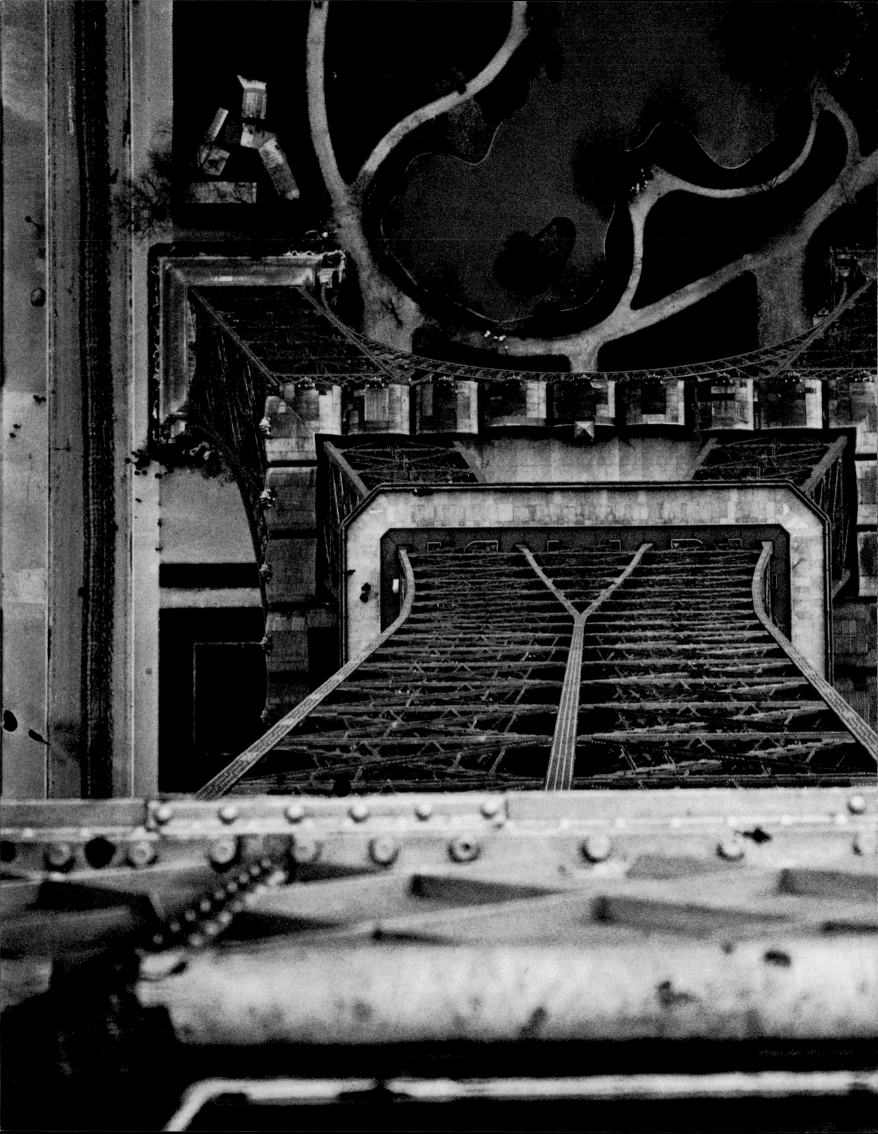

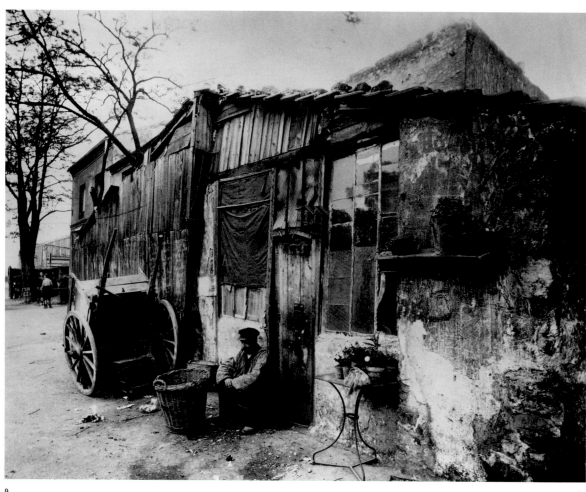

9

9 **Eugène Atget**
Chiffoniers, boulevard Masséna,
Paris XIII arrond., 1913

10 **Eugène Atget**
Au Petit Dunkerque, 3 Quai
de Conti, Paris VI arrond., 1900

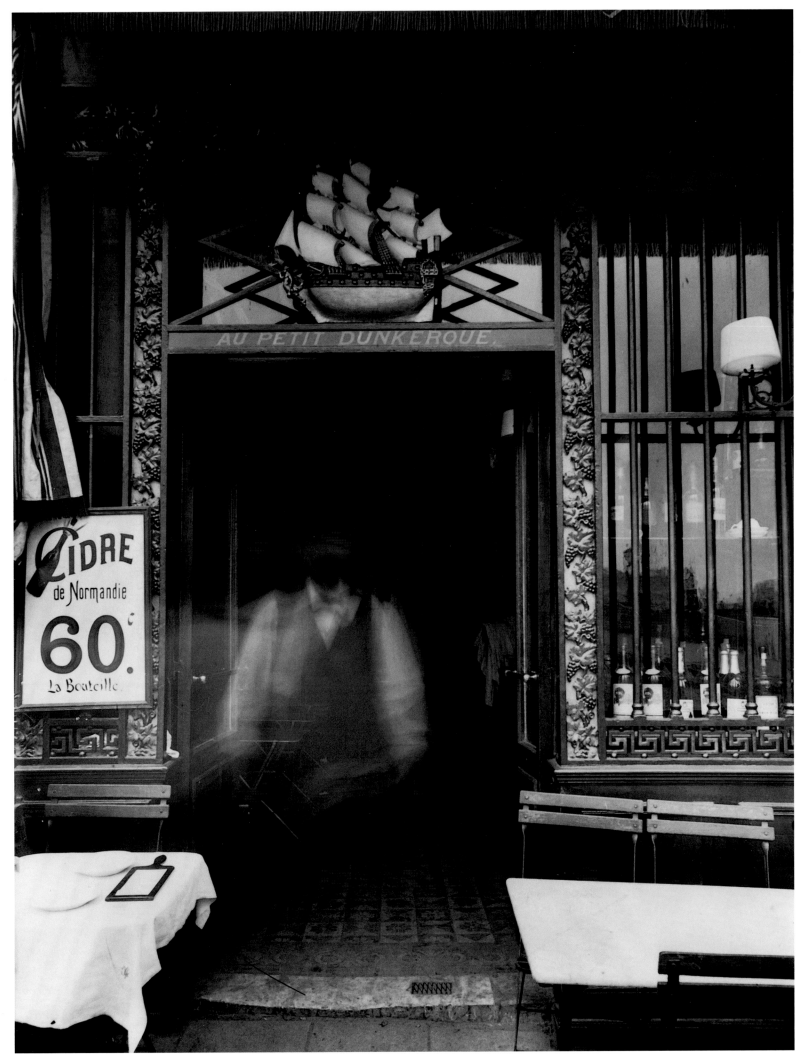

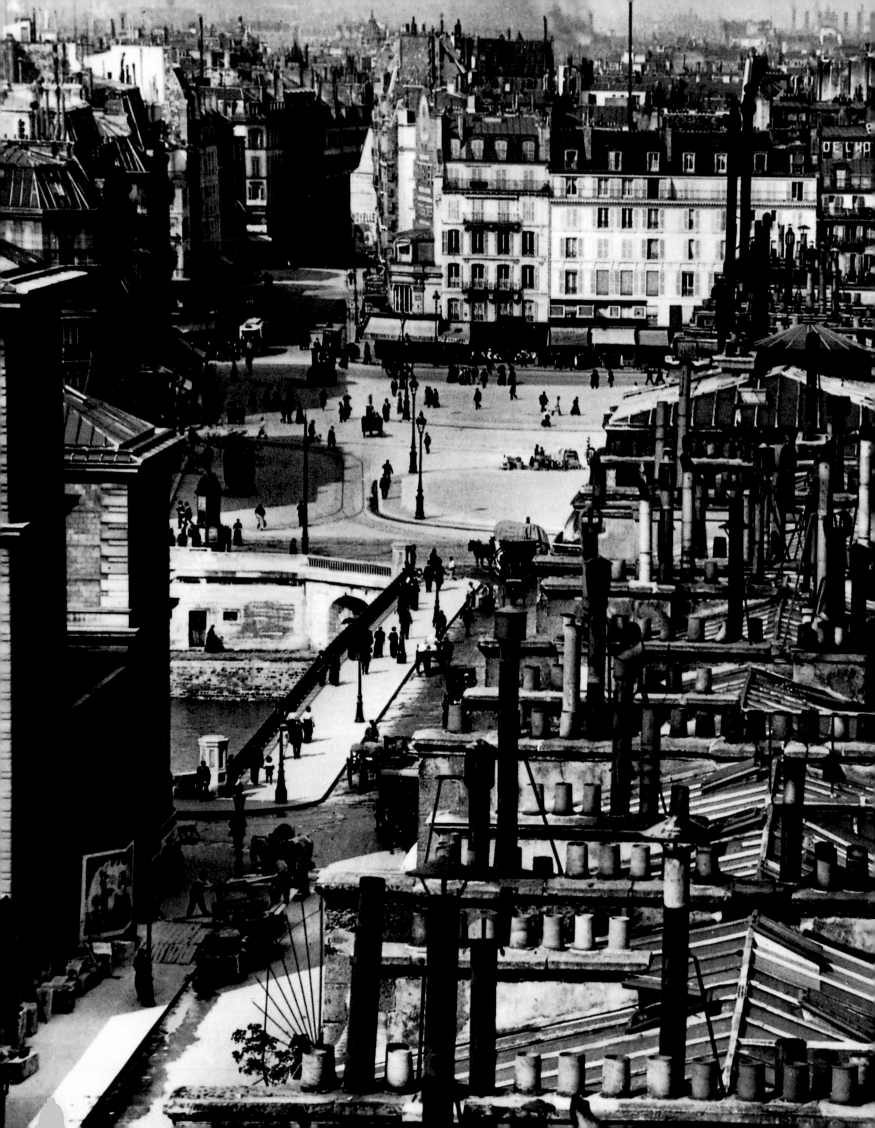

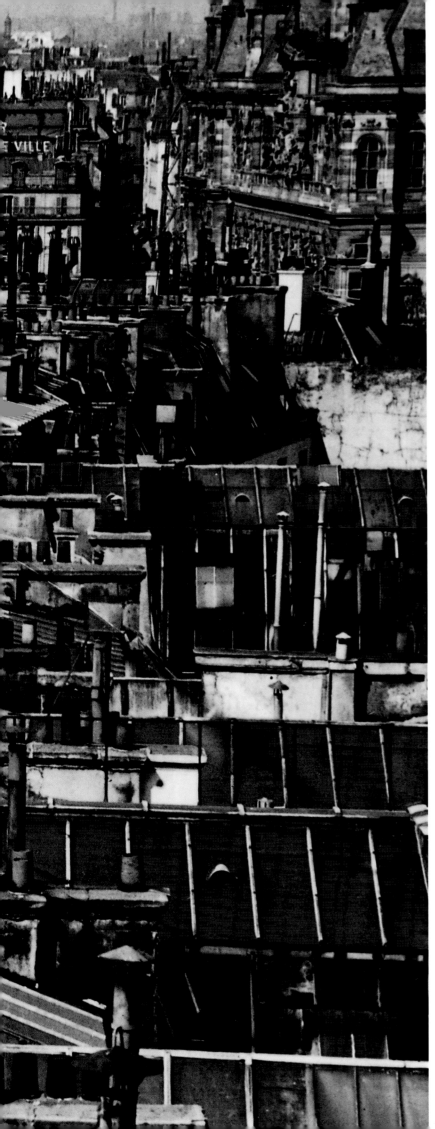

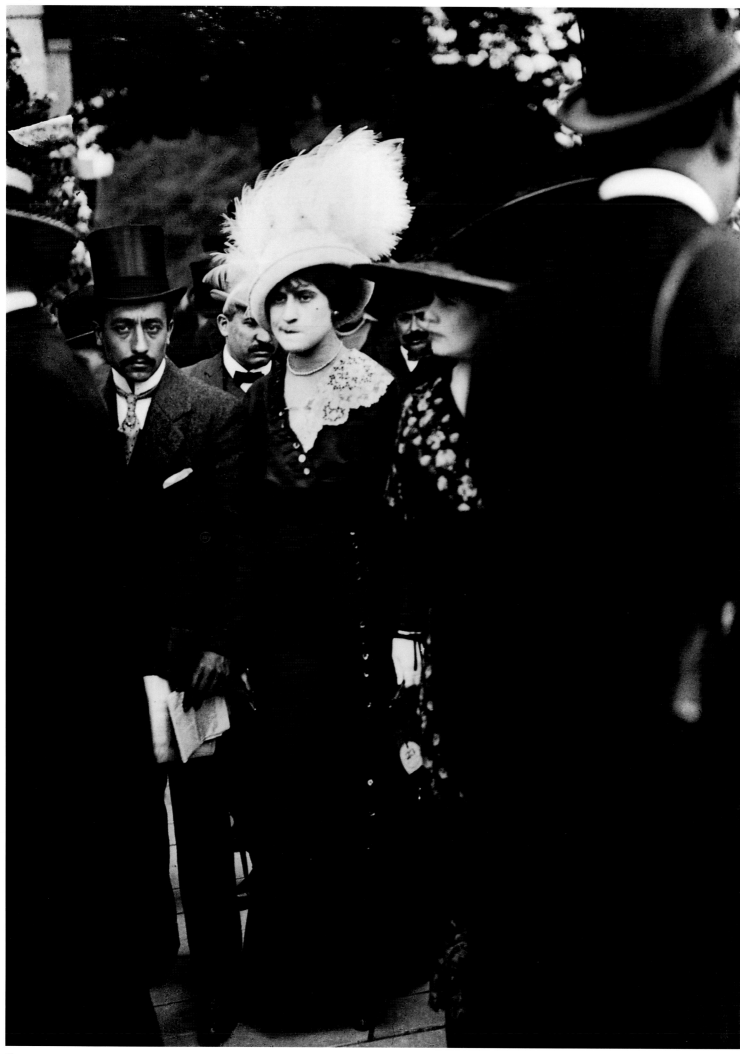

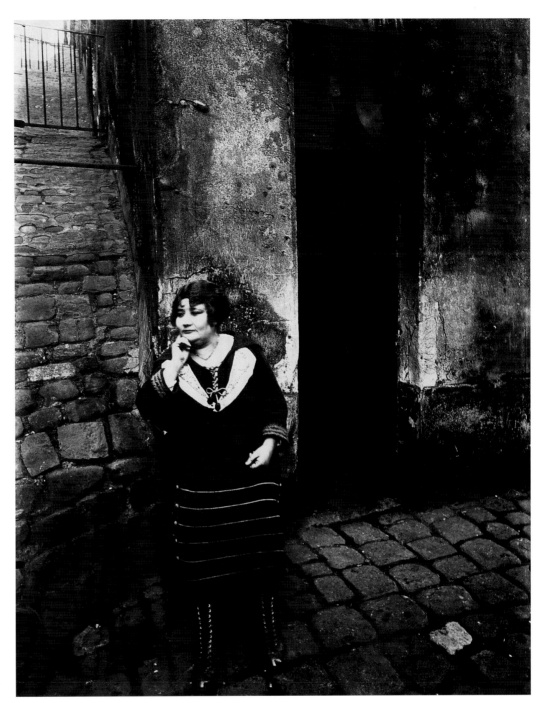

13

12 **Jacques-Henri Lartigue**
Losers at the Auteuil races,
Paris XVI arrond., 23 June 1911

13 **Eugène Atget**
Prostitute in a doorway,
7 March 1921

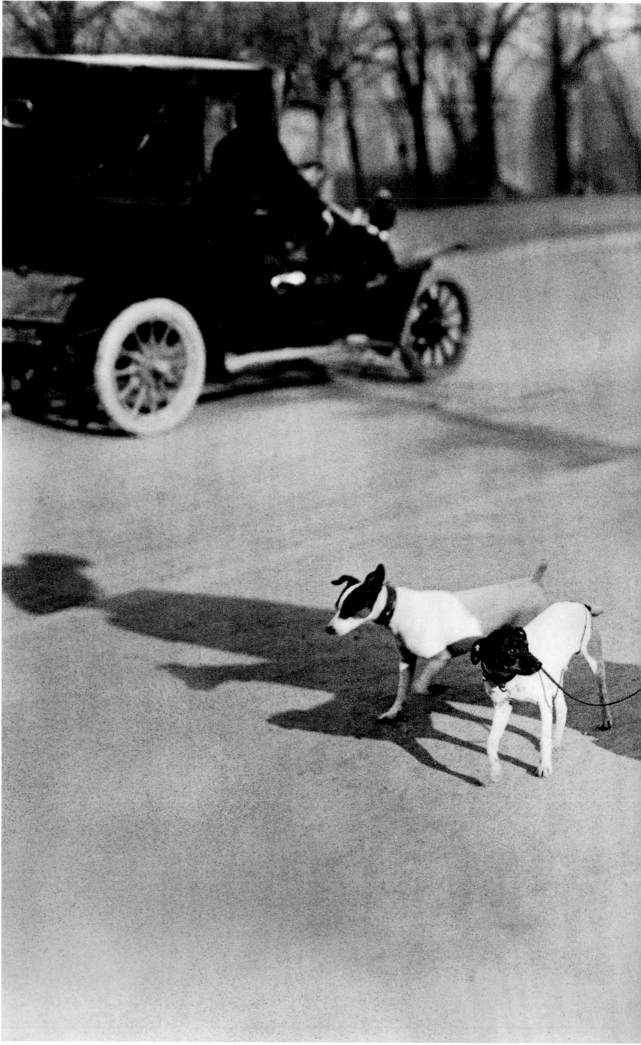

14 Jacques-Henri Lartigue
Avenue du Bois de Boulogue,
Paris XVI arrond., 15 June 1911

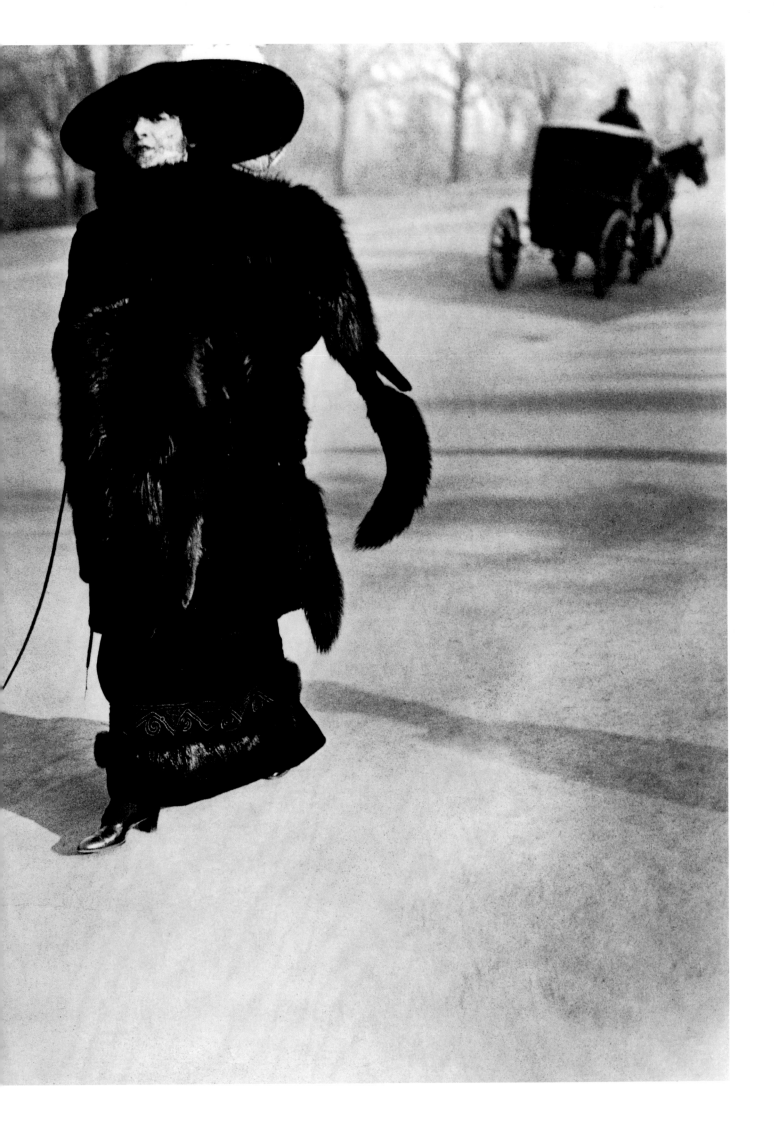

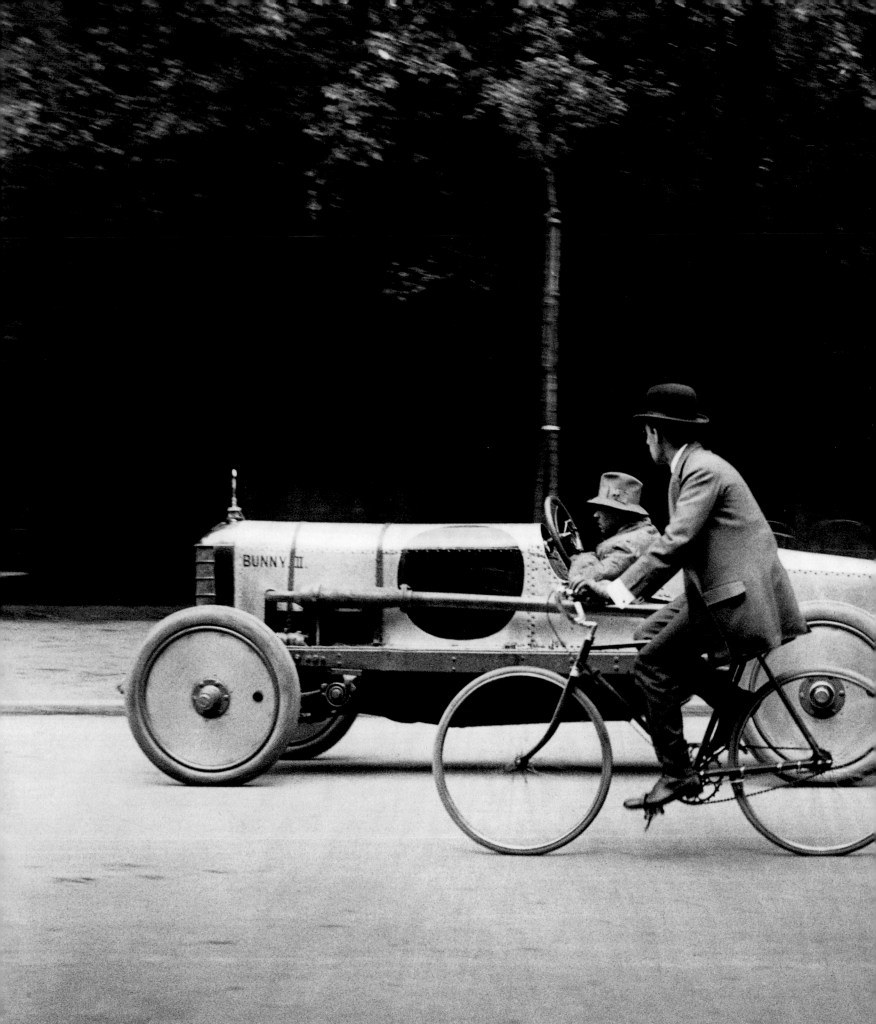

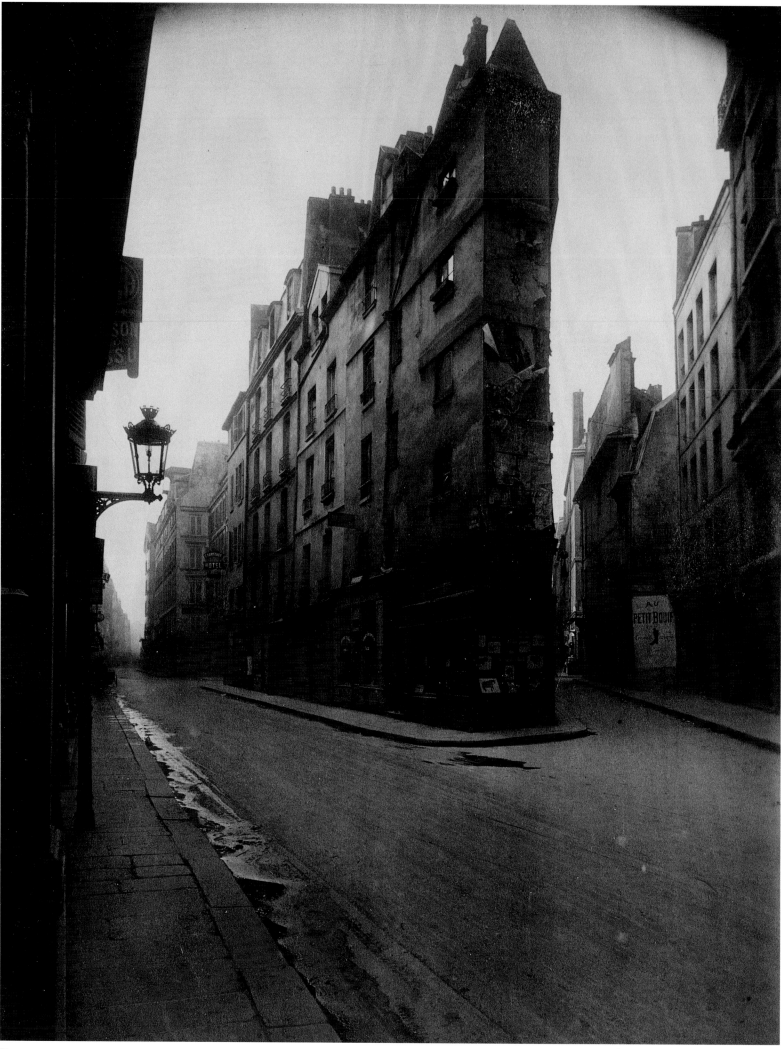

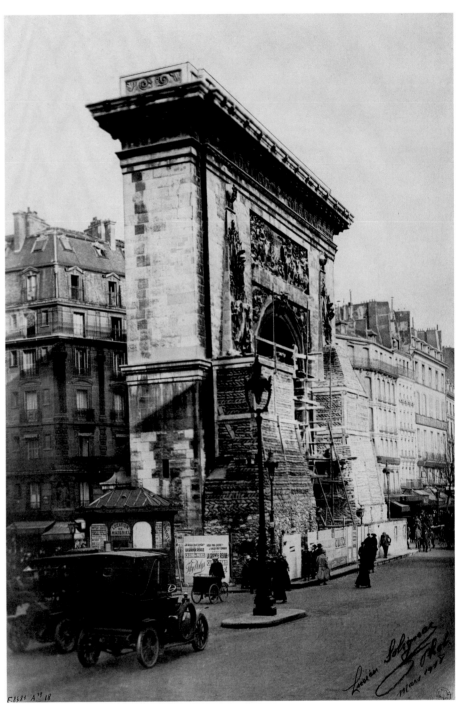

17

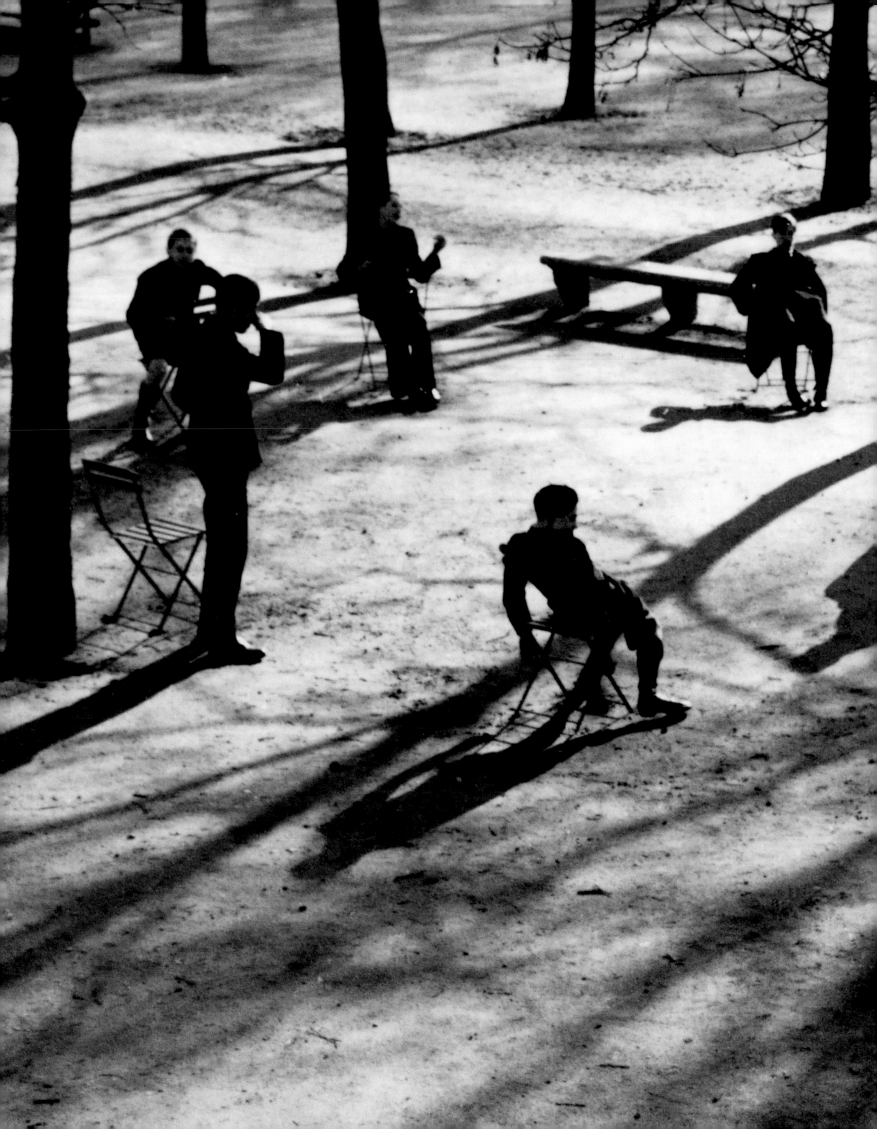

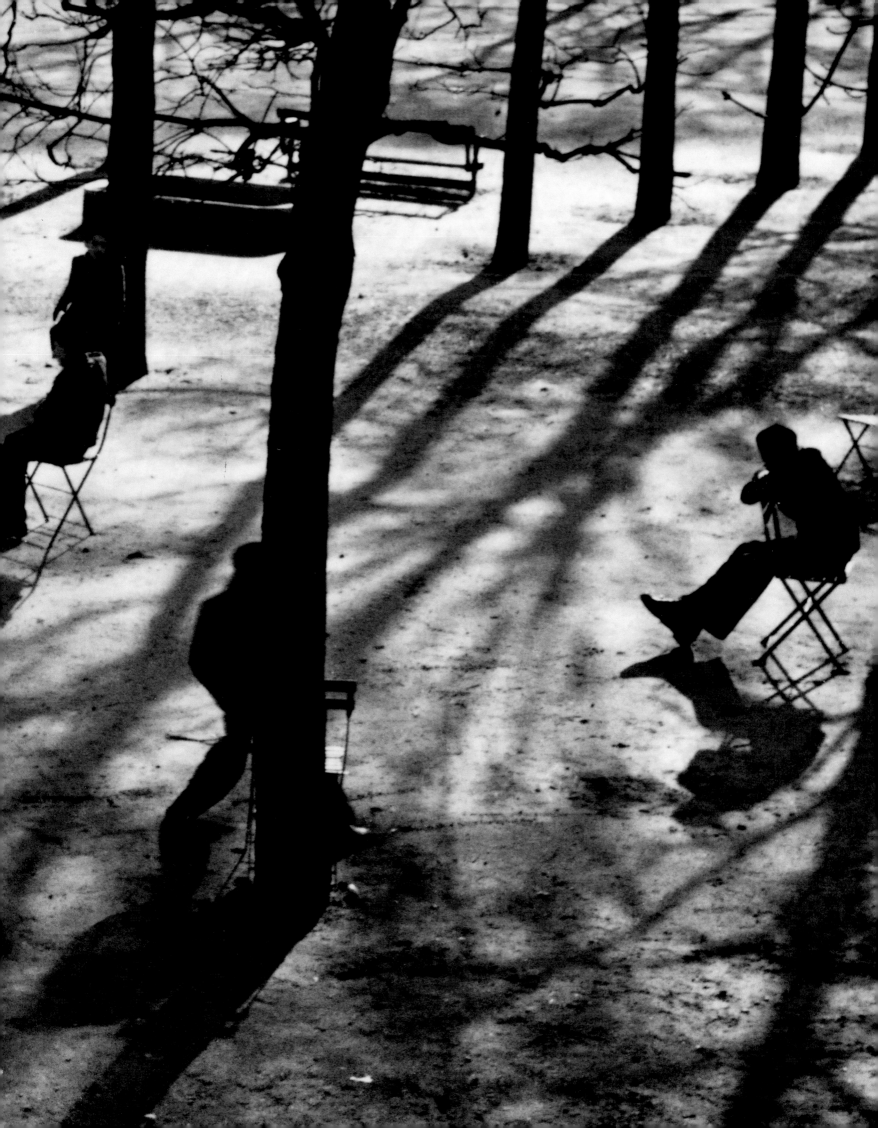

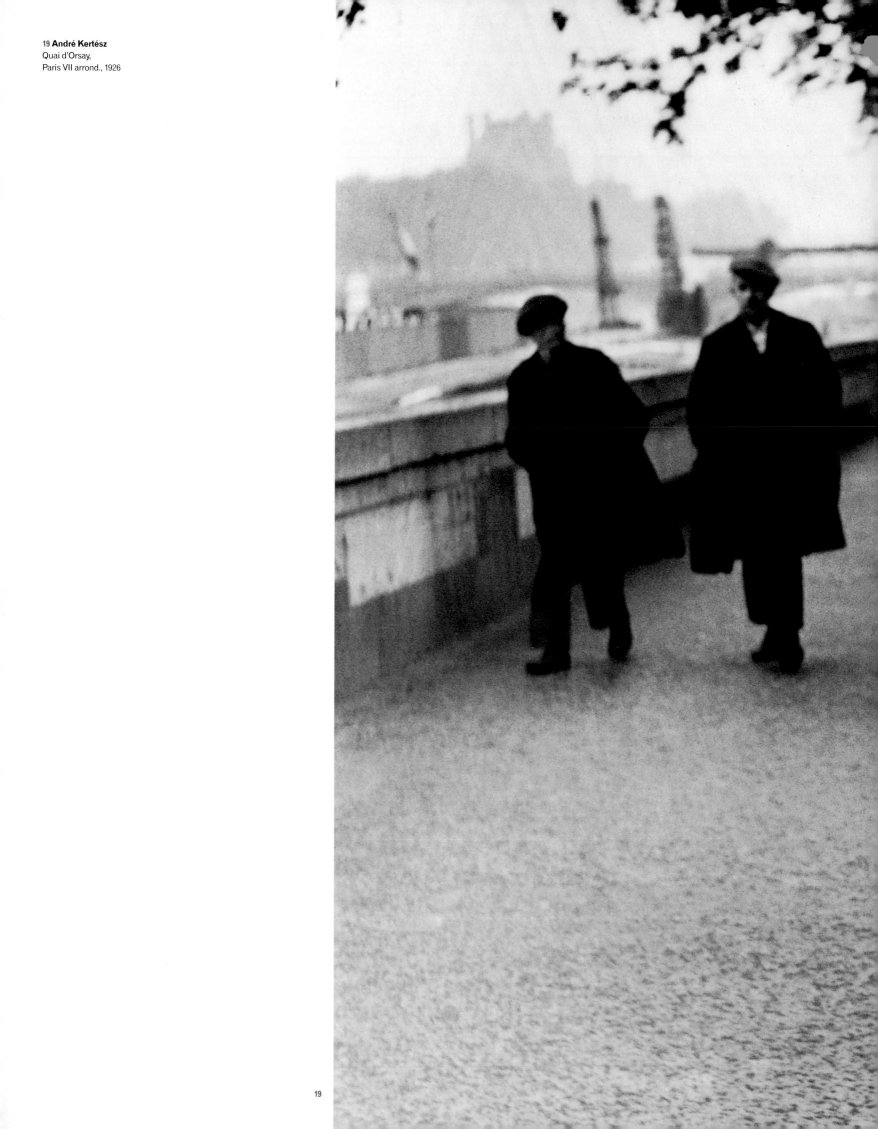

19 André Kertész
Quai d'Orsay,
Paris VII arrond., 1926

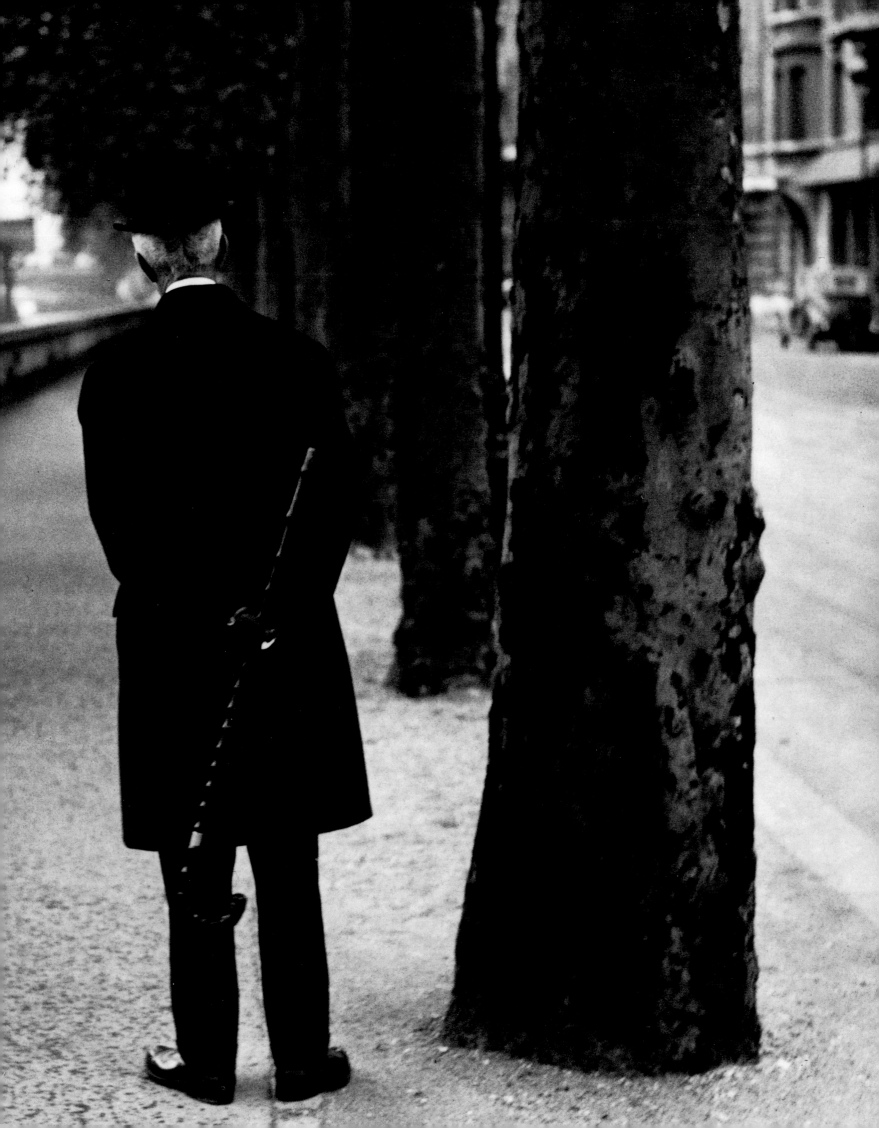

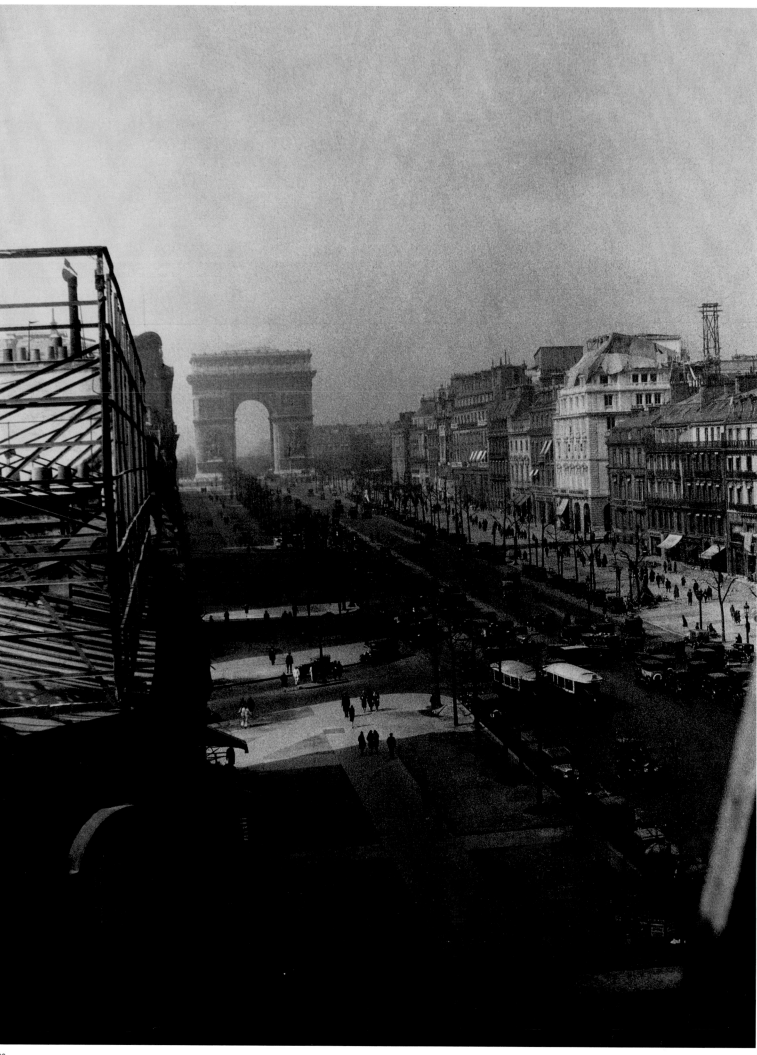

21

20 **Germaine Krull**
Champs-Elysées,
Paris VIII arrond., 1926

21 **Germaine Krull**
Boulevard des Maréchaux,
porte de Vanves level,
Paris XIV arrond., 1930

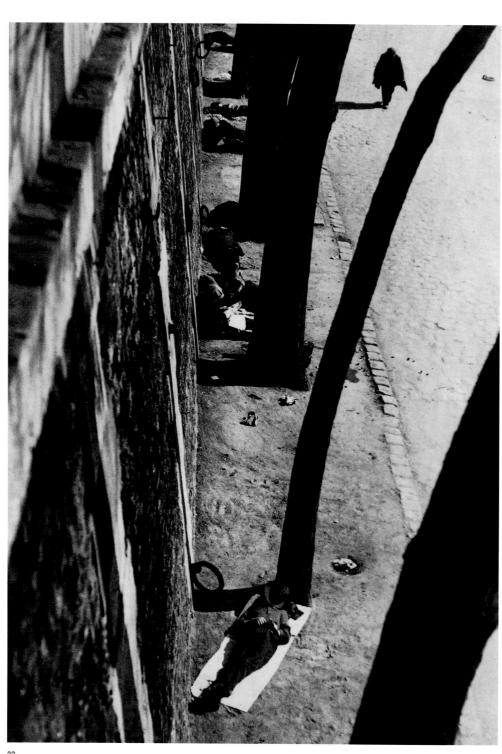

23

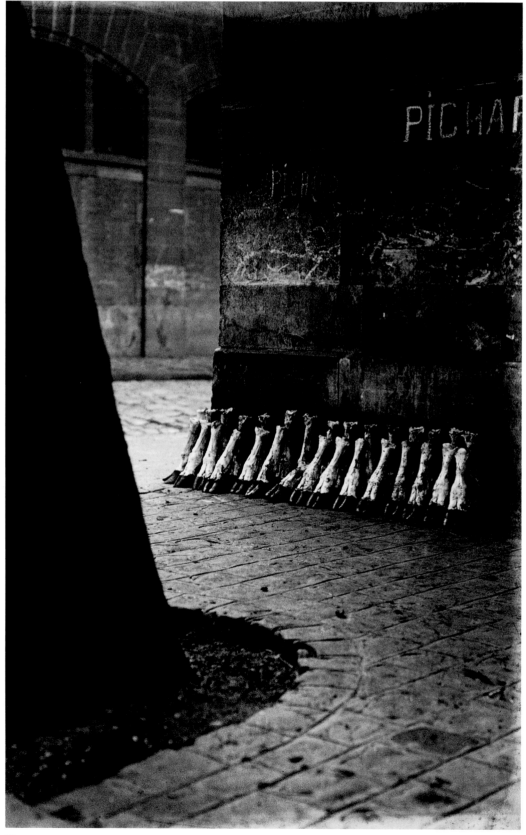

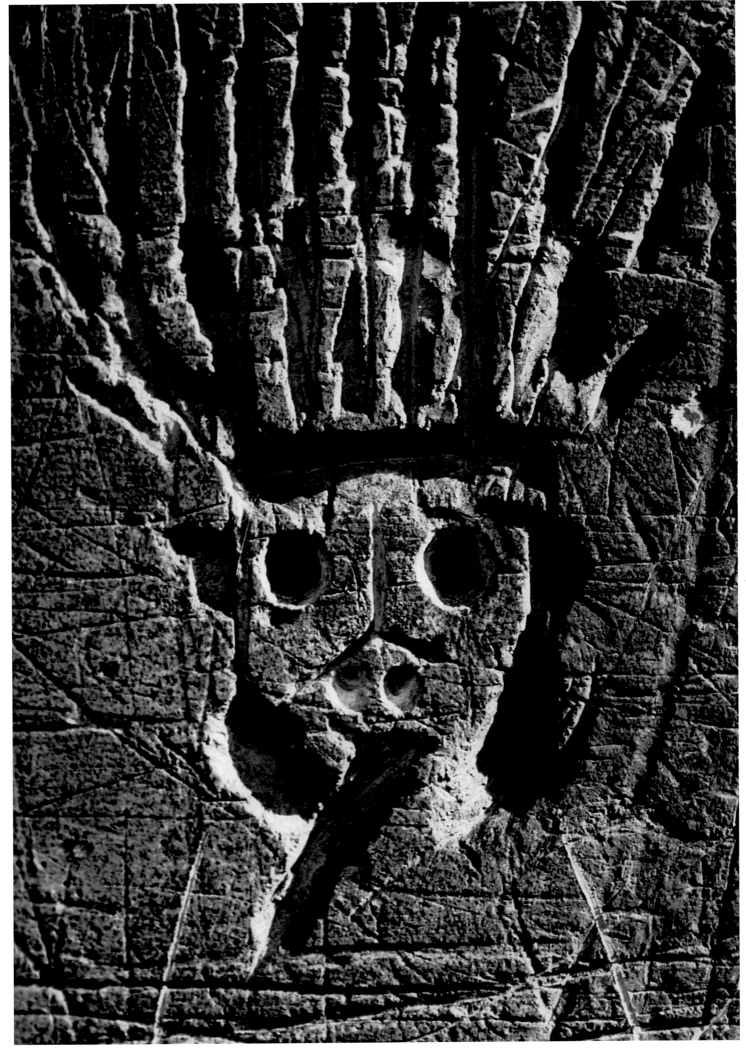

27

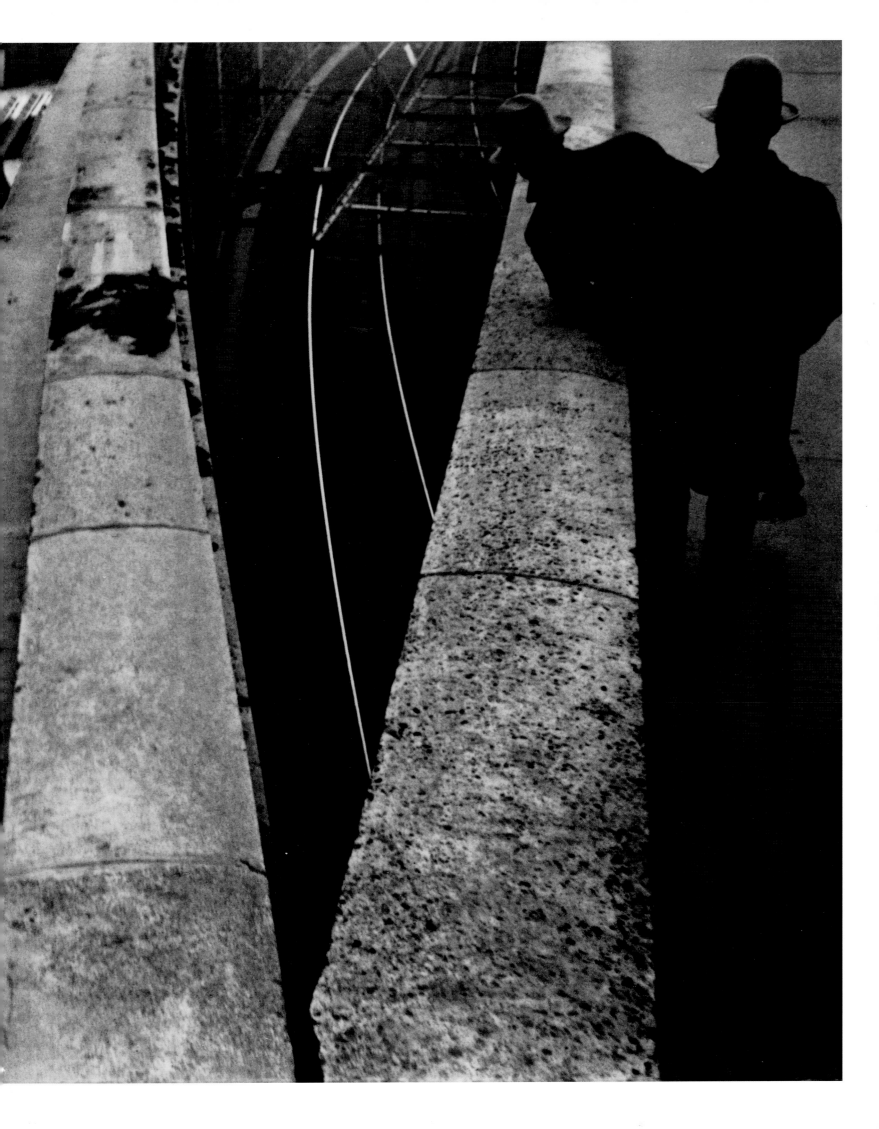

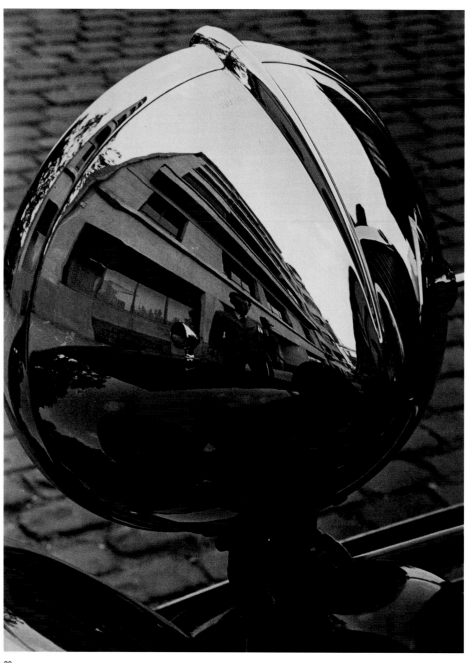

29

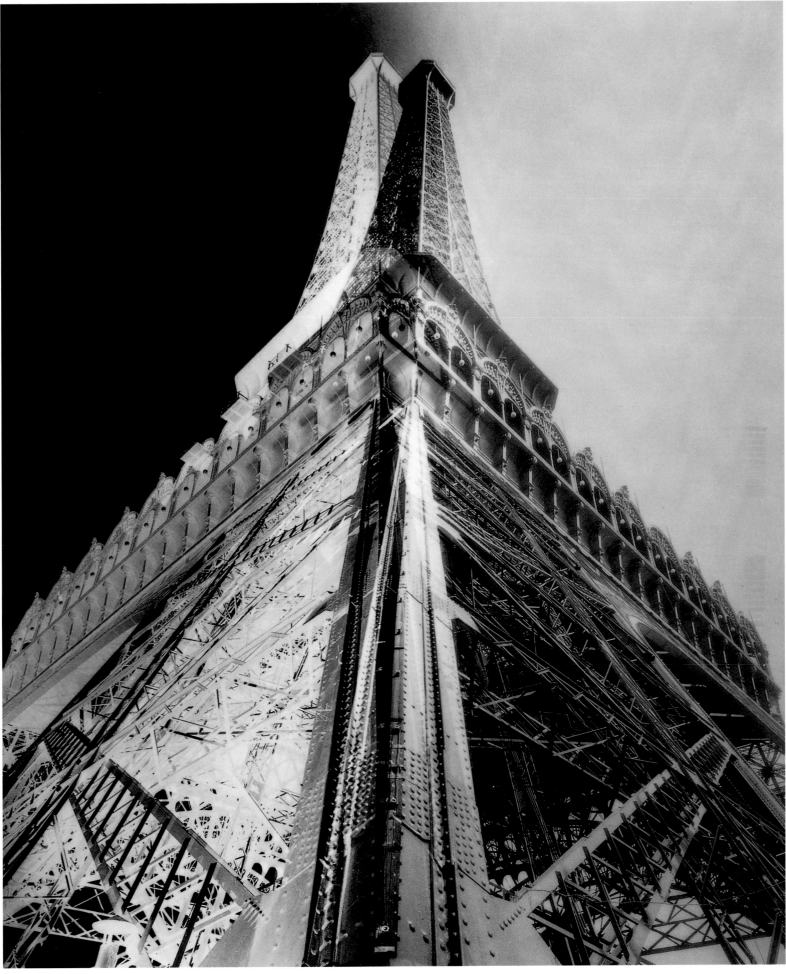

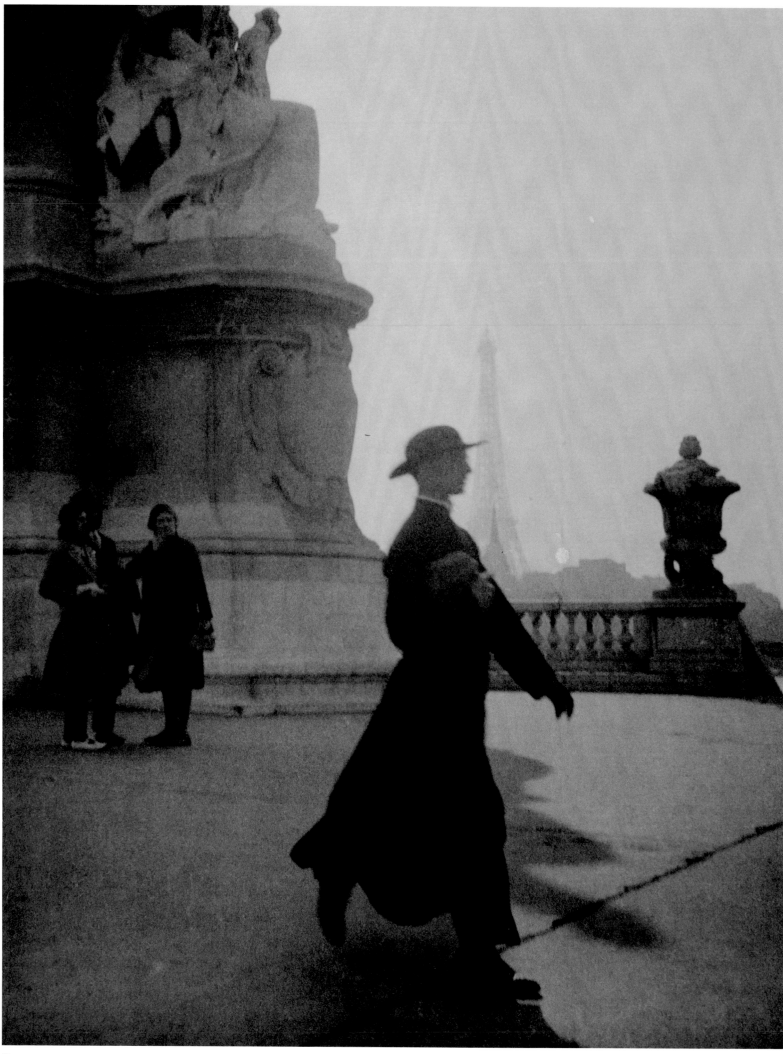

31 **Jacques-André Boiffard**
Priest crossing bridge,
Paris, 1929

32 **André Kertész**
Party at Montparnasse,
Paris XV arrond., 1929

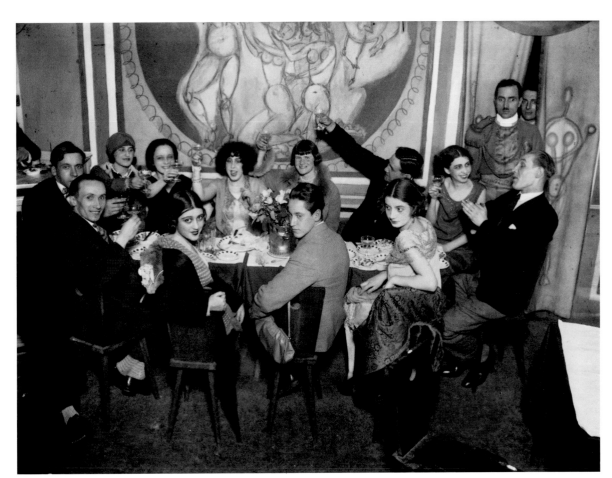

32

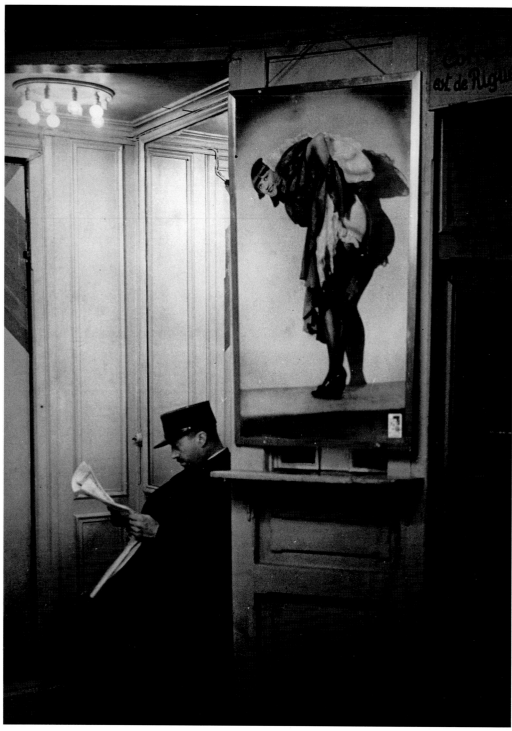

33

33 **Brassaï**
Entrance to the Bal Tabarin,
Montmartre, 1930–32

34 **Brassaï**
Behind the scenes at
the Folies-Bergère,
Paris IX arrond., c. 1932

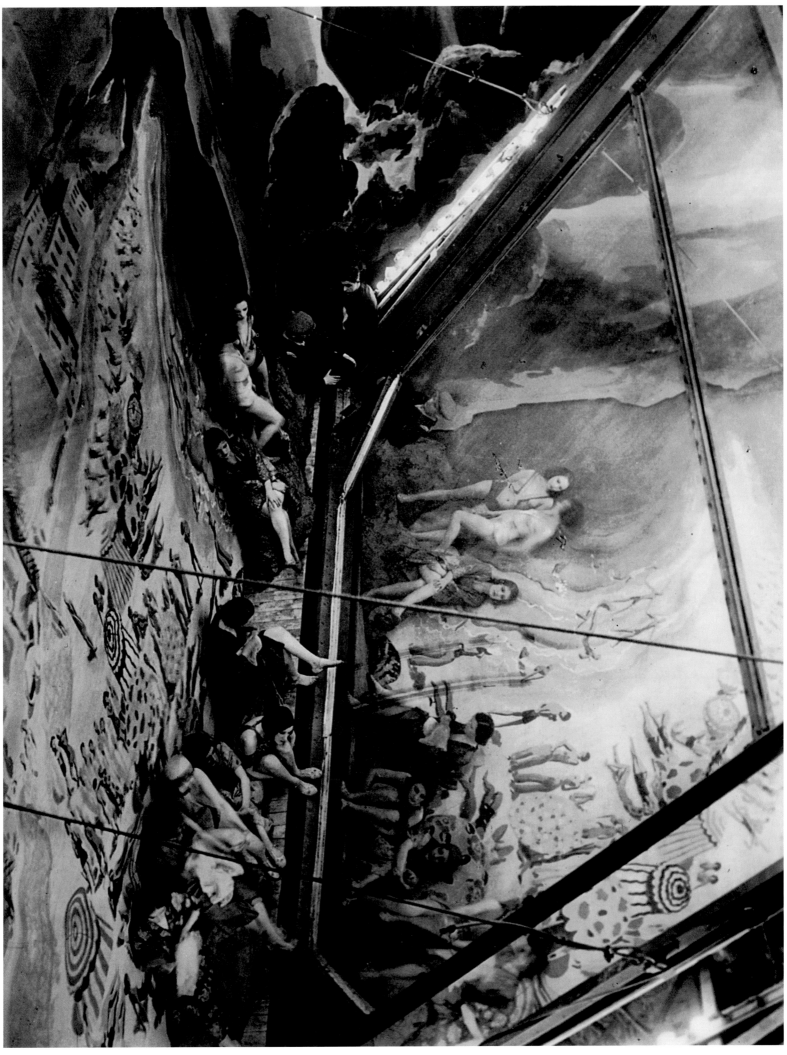

35

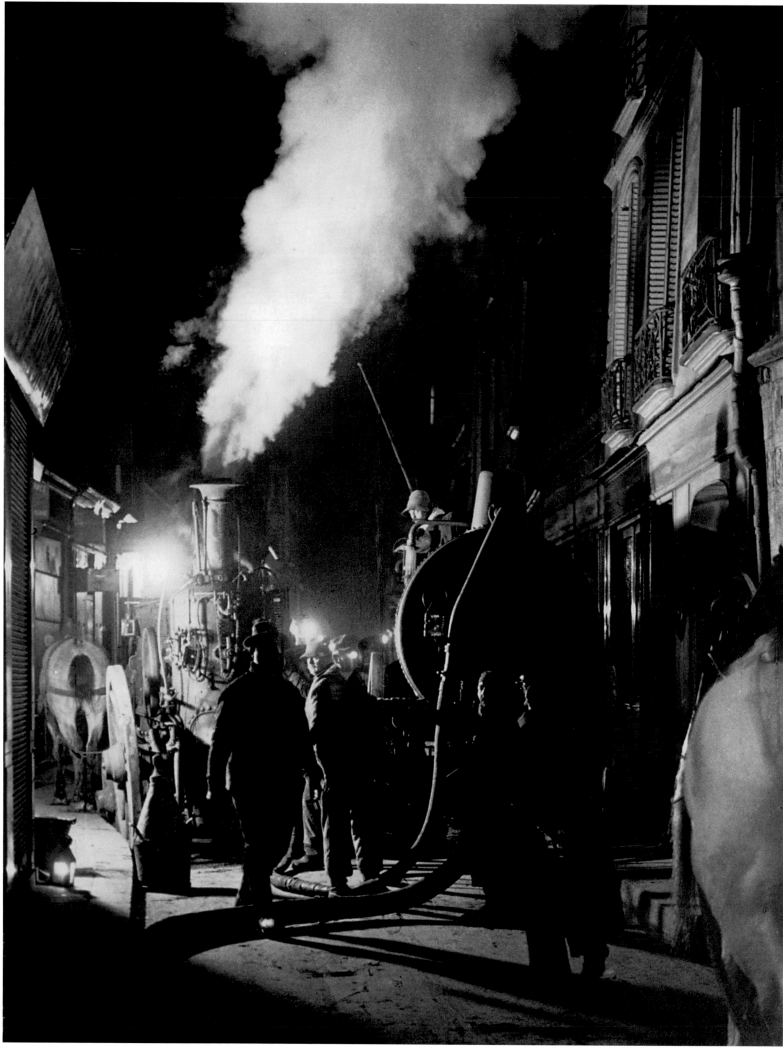

37 Brassaï
The cesspool cleaners and
their pump, rue Rambuteau,
Paris I, III, and IV arrond., c. 1931

38 François Kollar
Rain in Paris, 1930

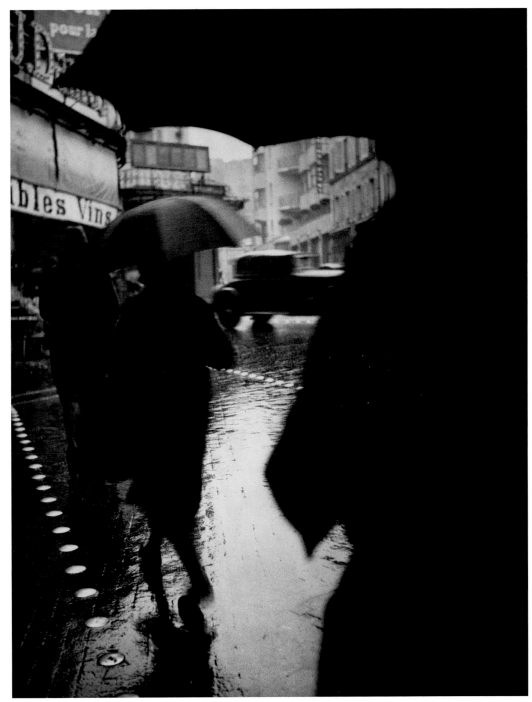

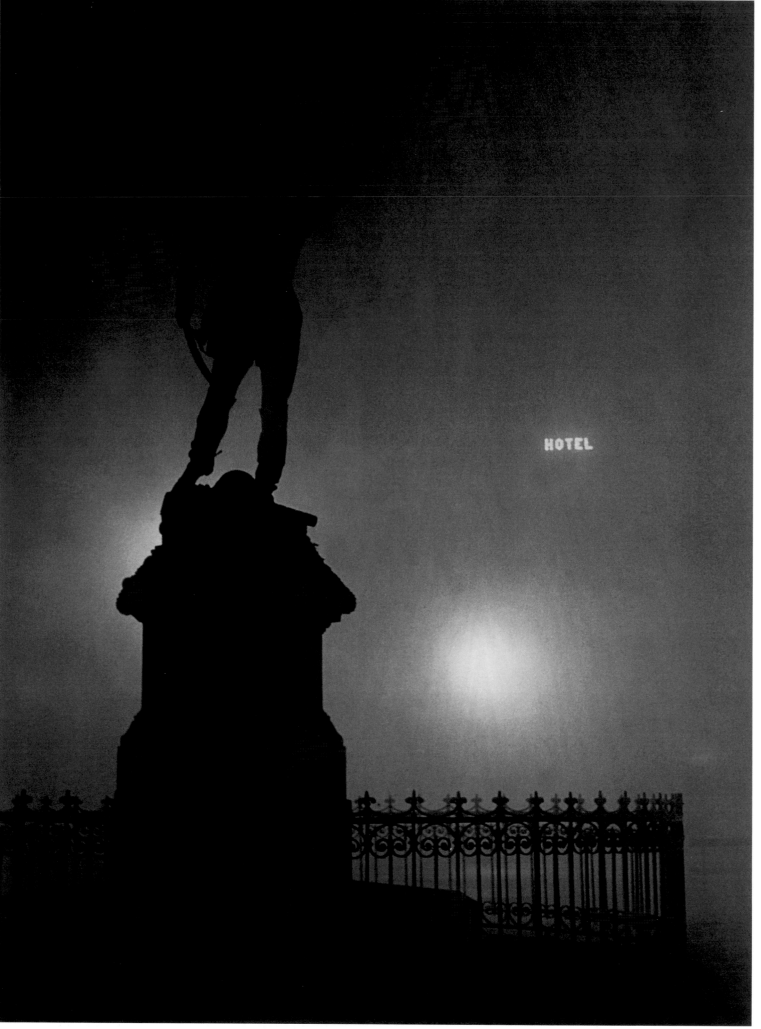

39 Brassaï
Statue of Marshal Ney in
the fog, Paris IV arrond., 1932

40 Marcel Bovis
The Eiffel Tower,
Paris VII arrond., 1912

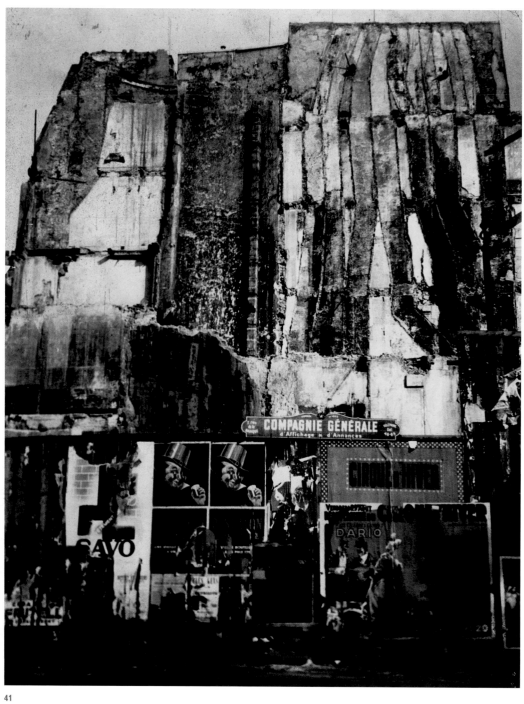

41

41 Anneliese Kretschmer
Dividing wall, Paris, 1928

42 André Kertész
Meudon, 1928

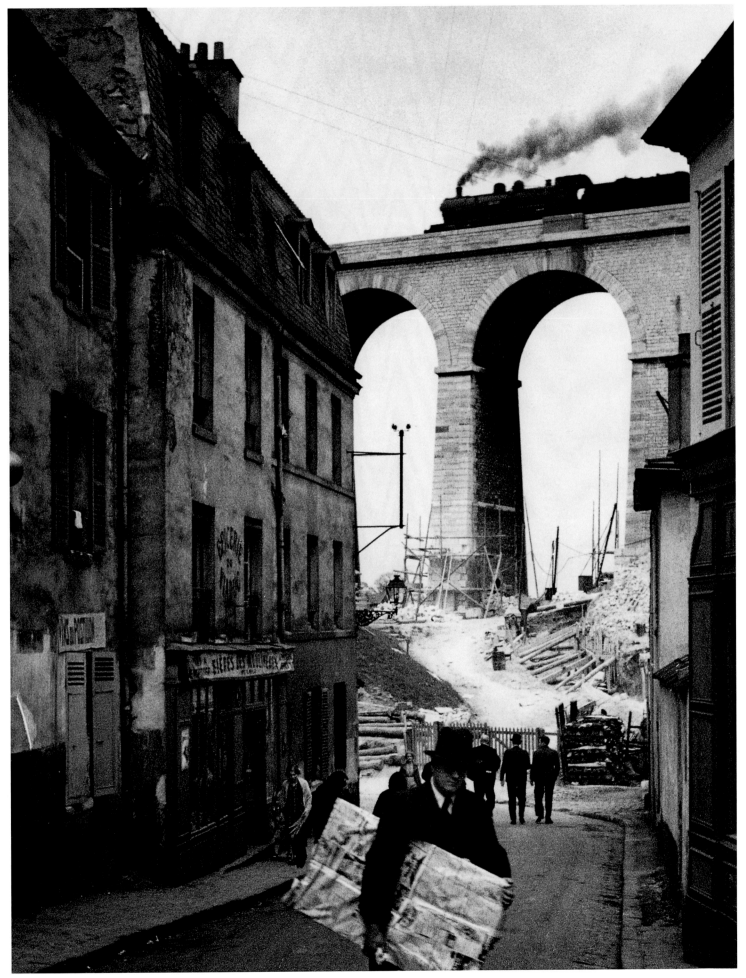

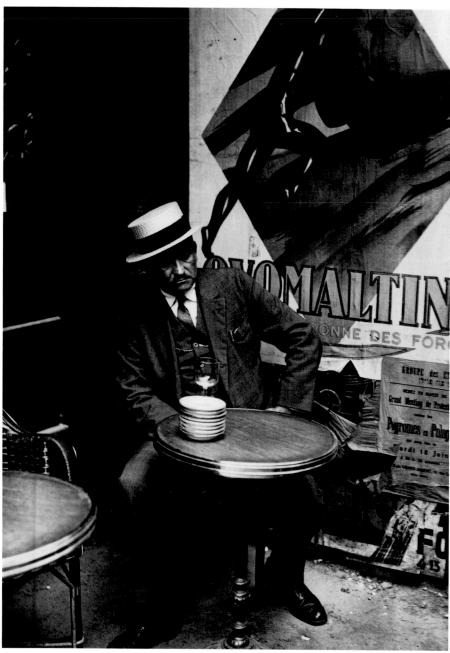

43

43 **André Kertész**
On a café terrace,
Paris, 1928

44 **François Kollar**
Les Halles,
Paris I arrond., 1930–31

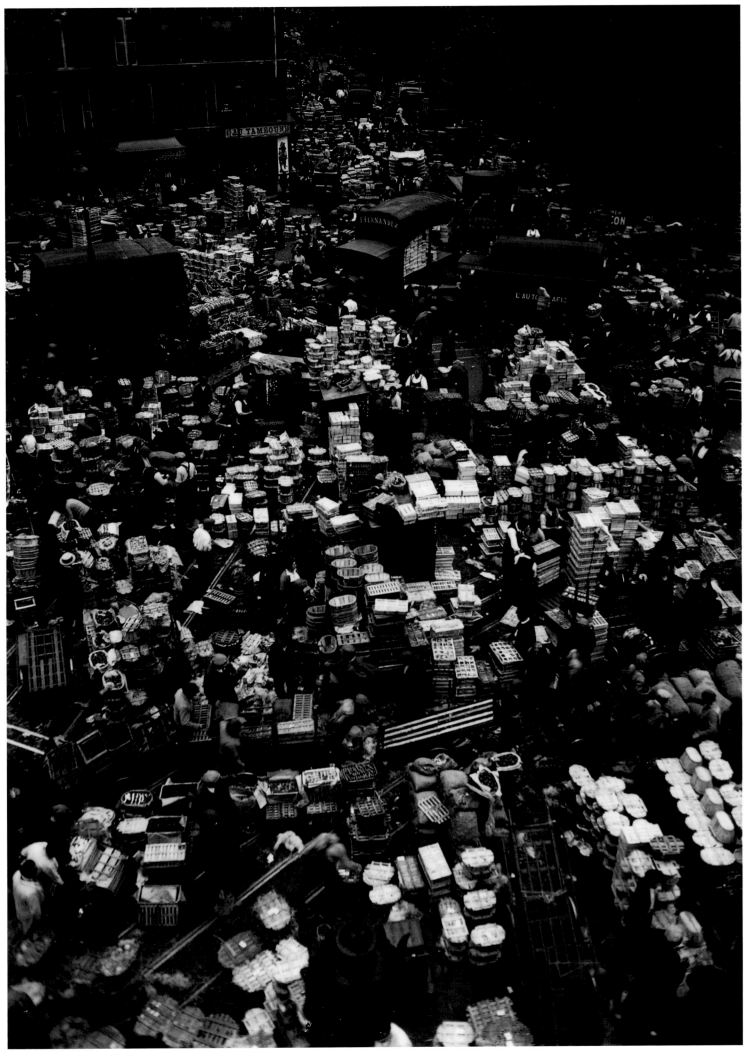

44

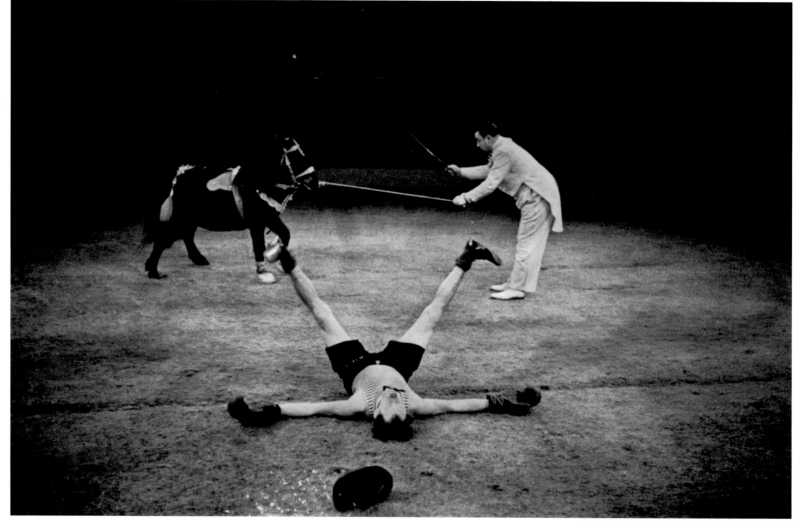

45

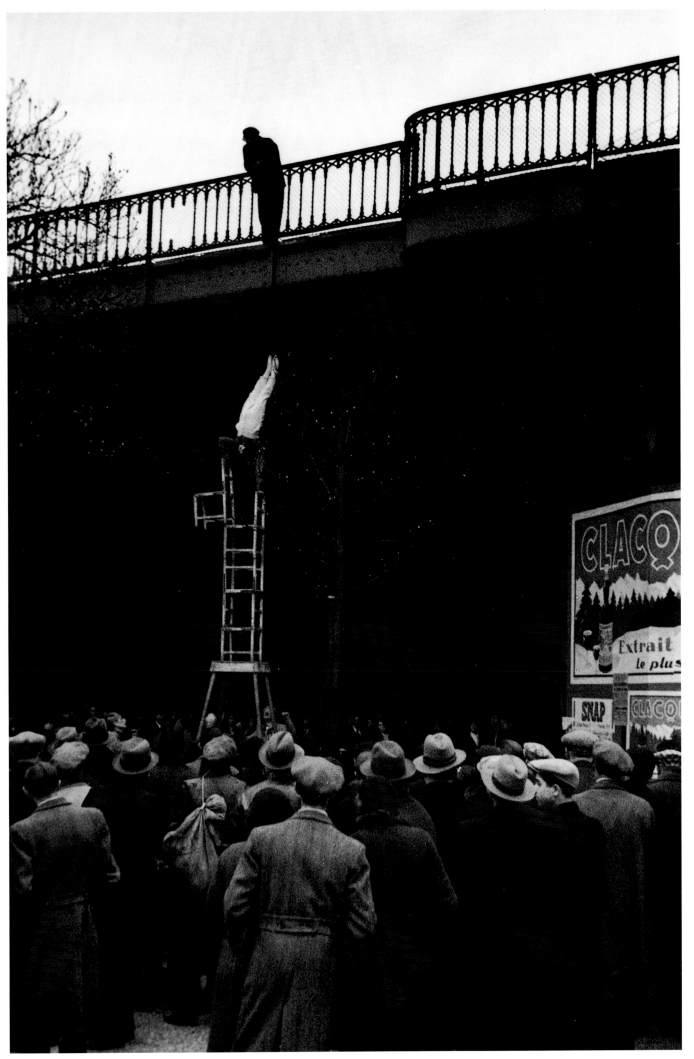

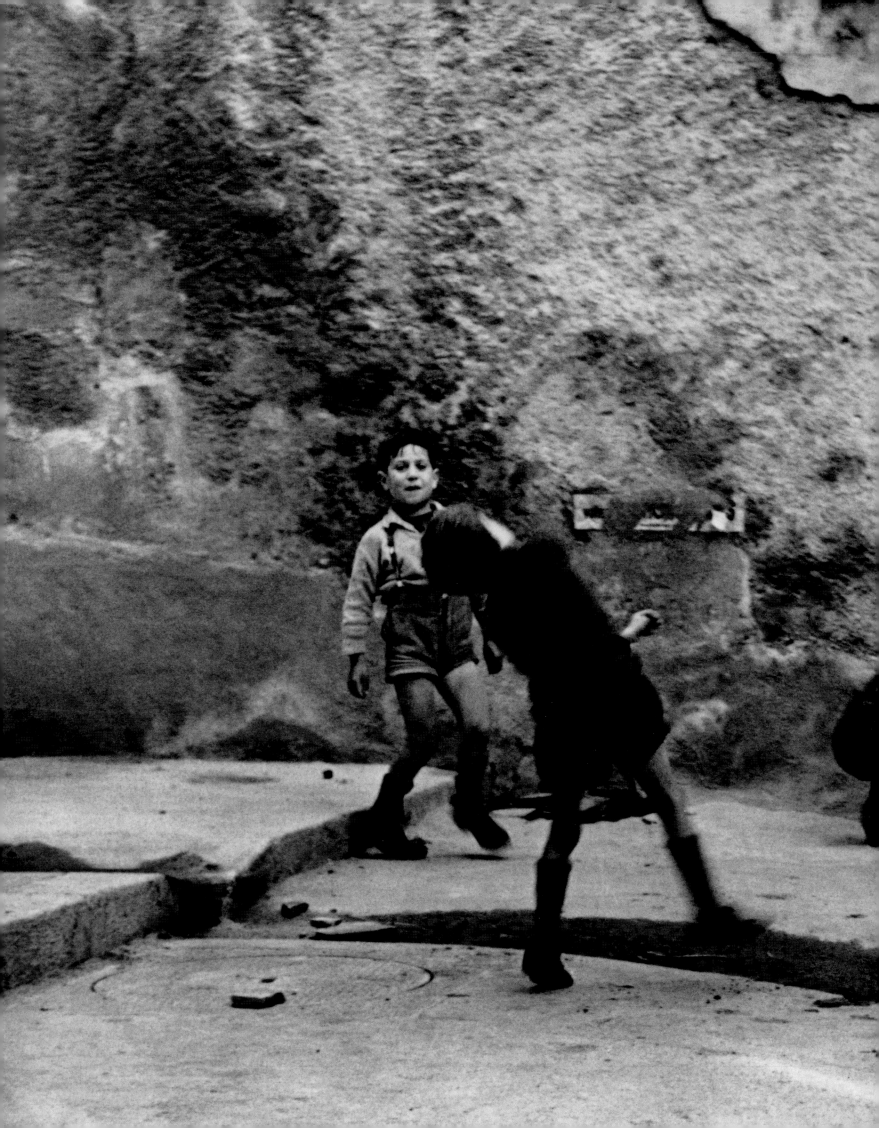

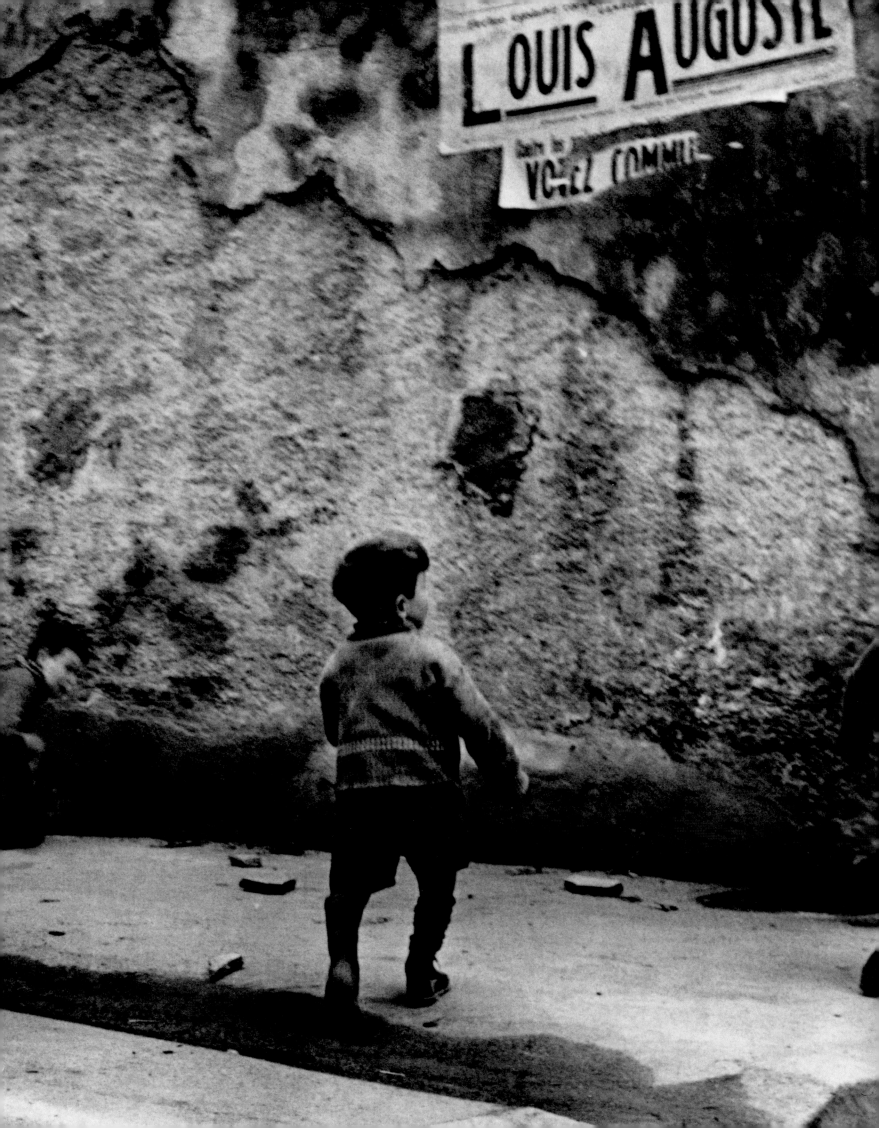

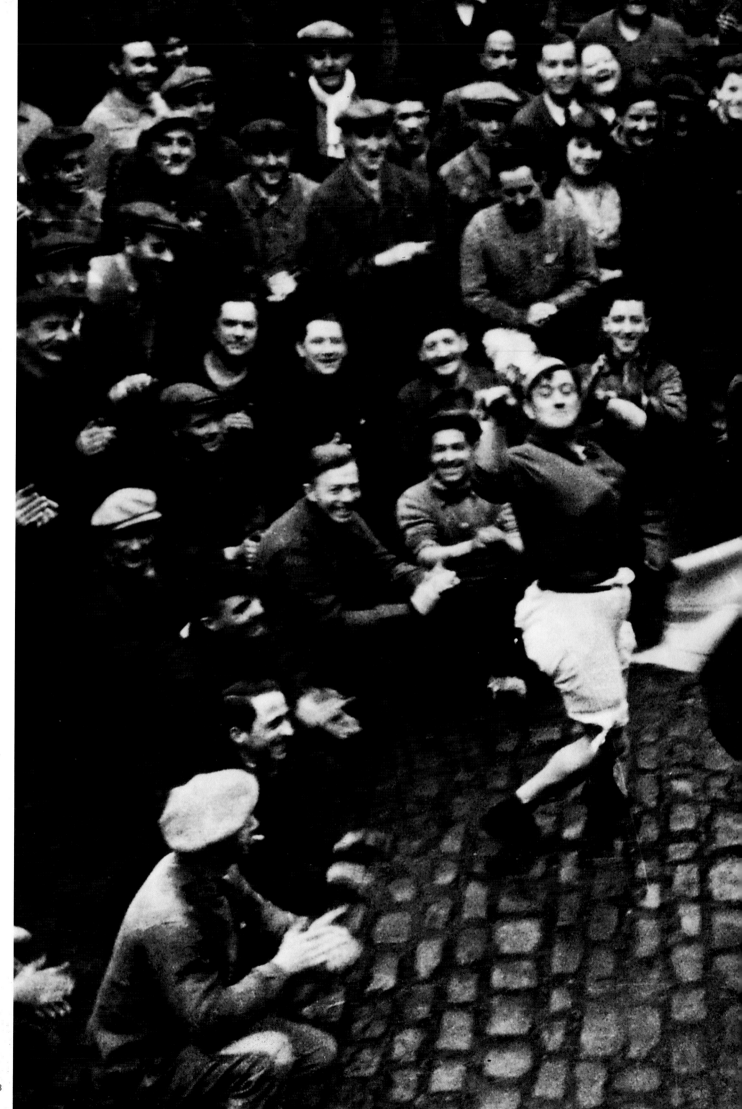

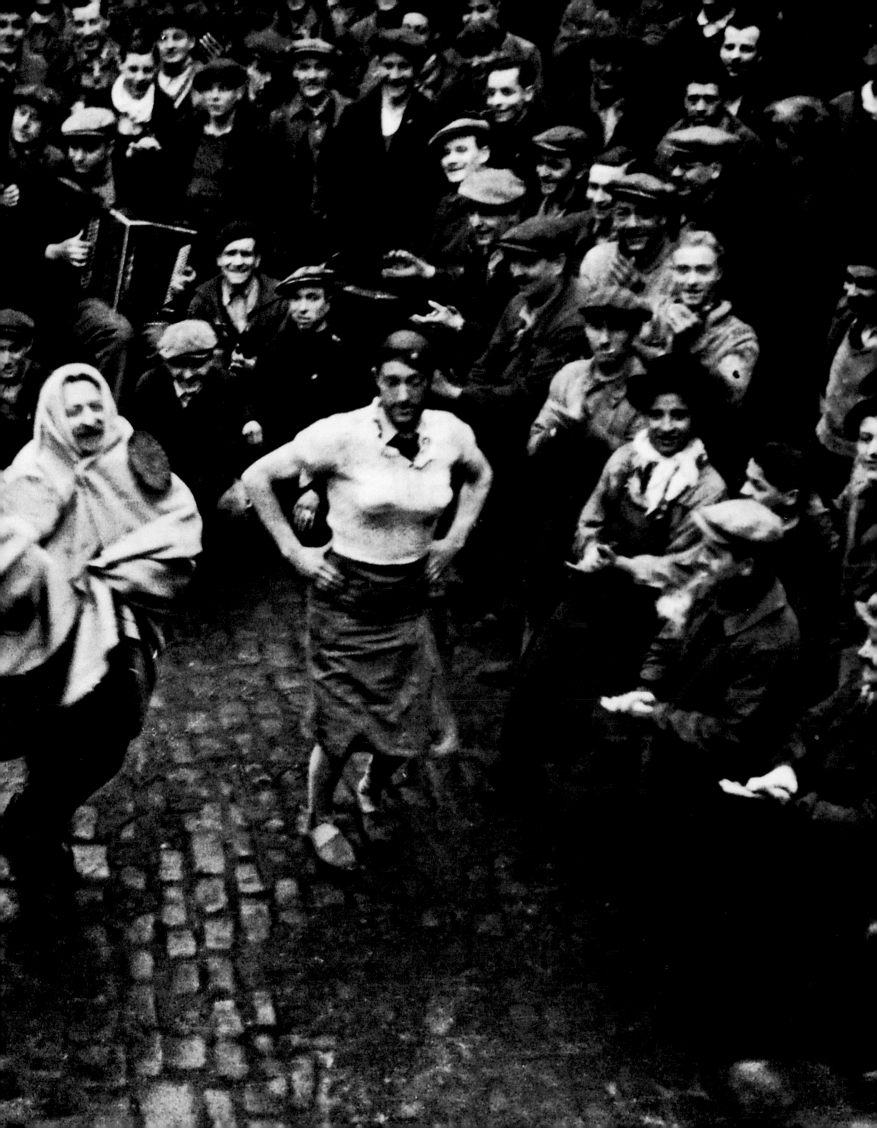

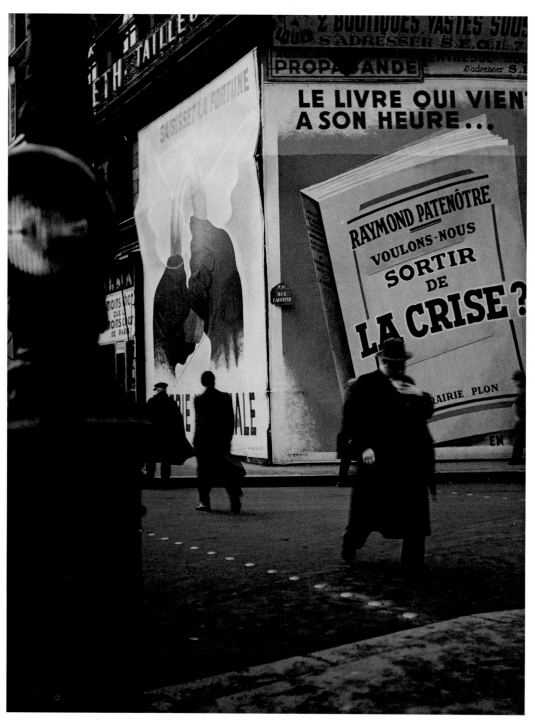

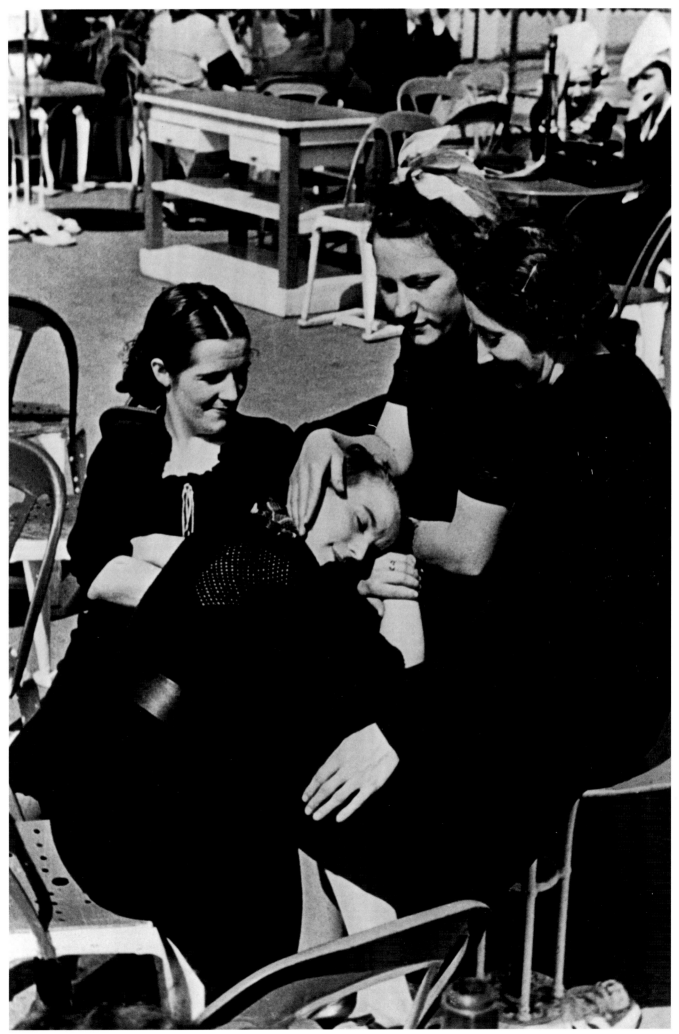

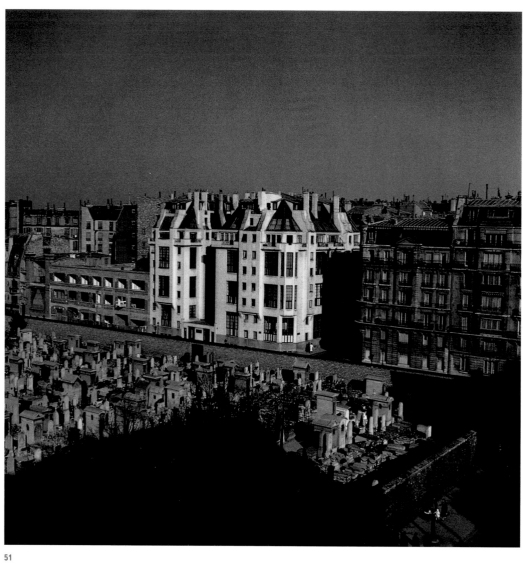

51

51 Willy Maywald
Montparnasse,
Paris XIV arrond., 1938

52 Maurice Zalewski
Paris during the Occupation
after the murder of Philippe
Henriot, 1944

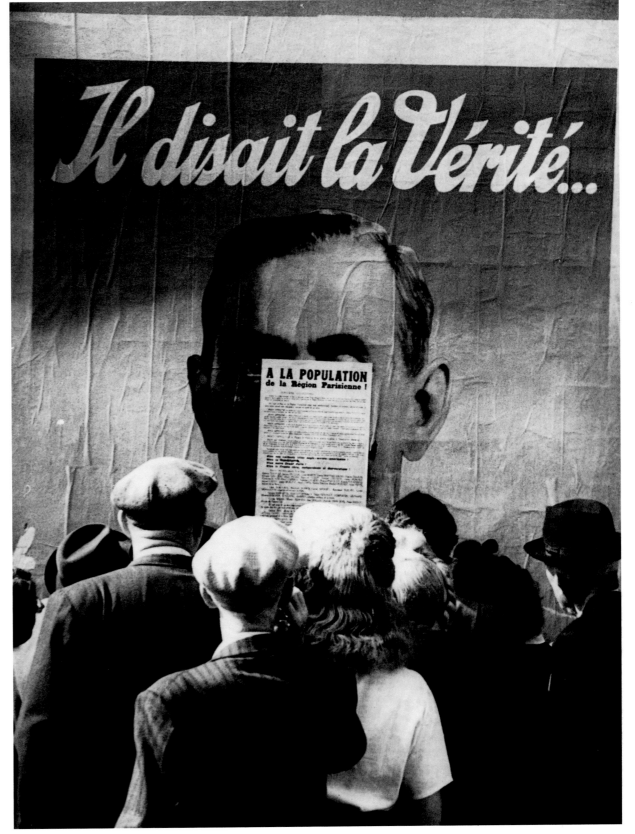

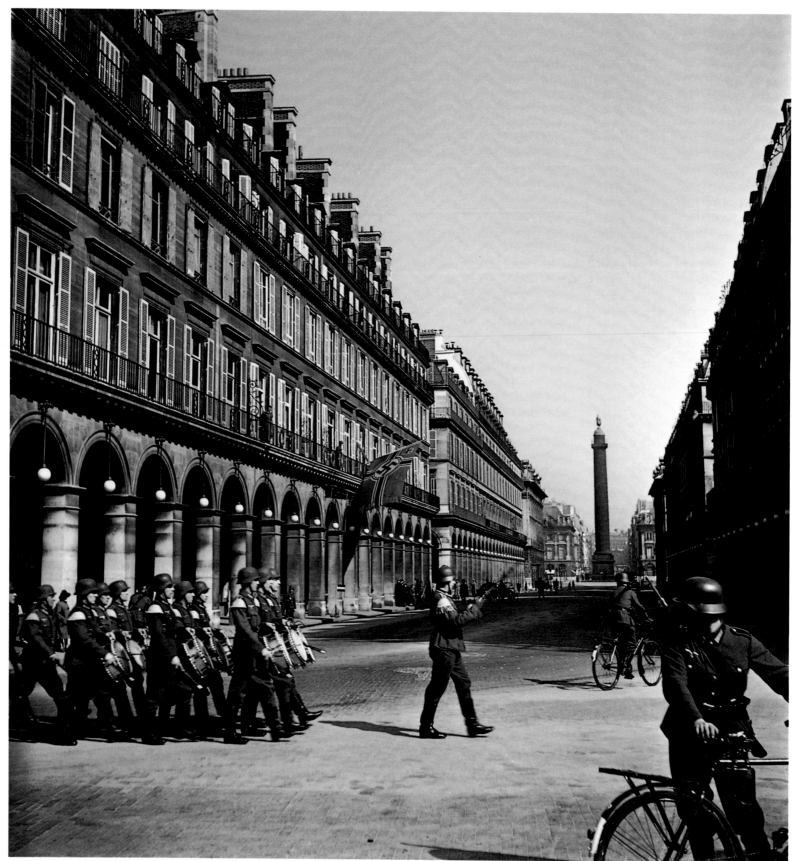

53

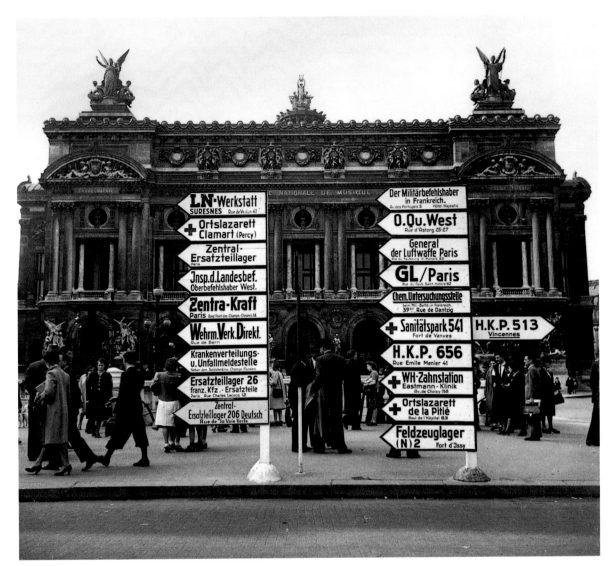

54

53 **Robert Doisneau**
Occupation,
Paris I arrond.,1943

54 **Roger Parry**
Occupation,
Paris II arrond., c. 1943

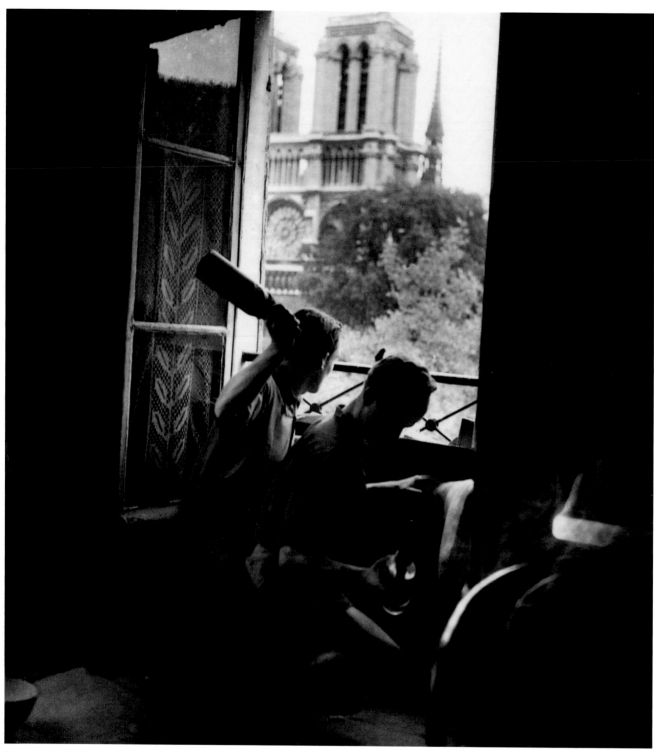

55

55 **Robert Doisneau**
Resistance fighters,
August 1944

56 **Robert Capa**
Place de l'Hôtel-de-Ville,
Paris IV arrond., 26 August 1944

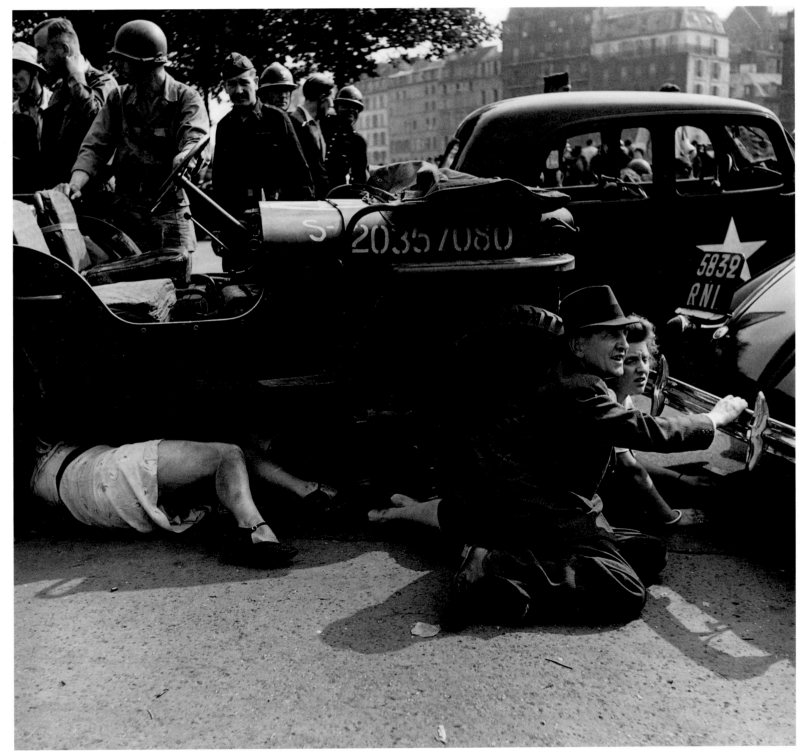

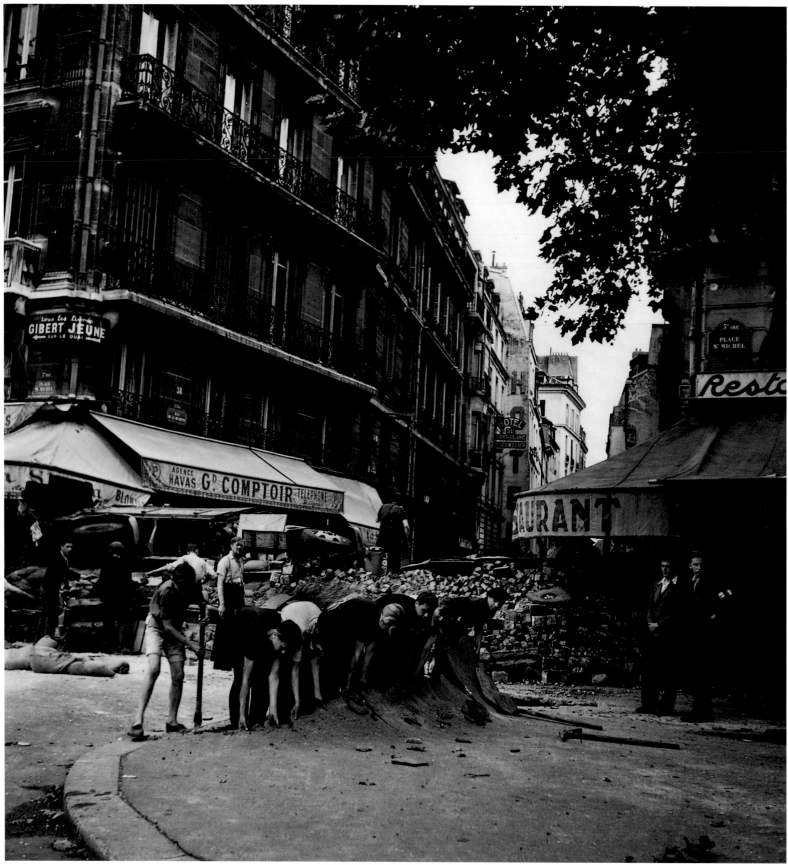

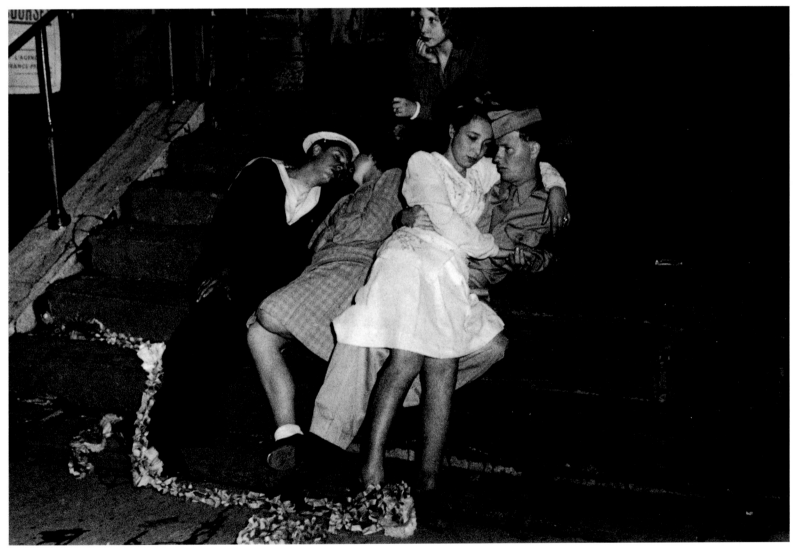

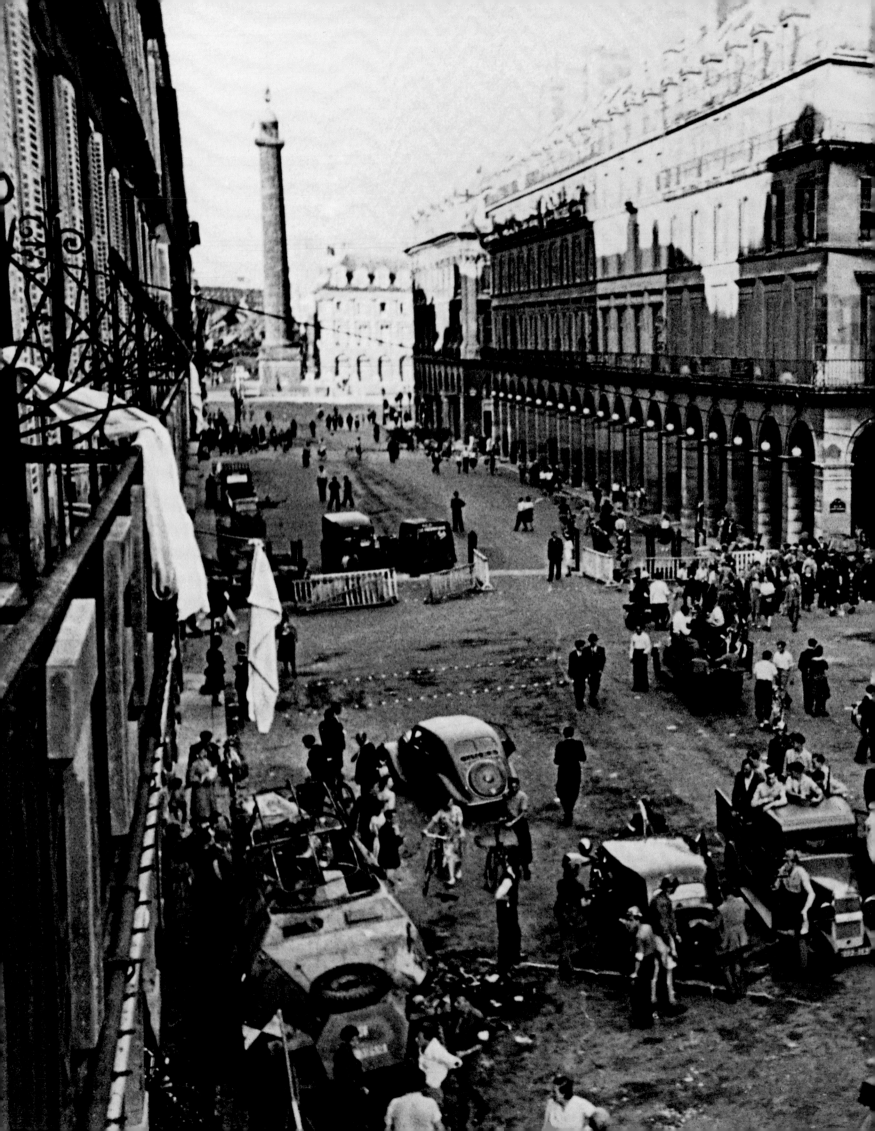

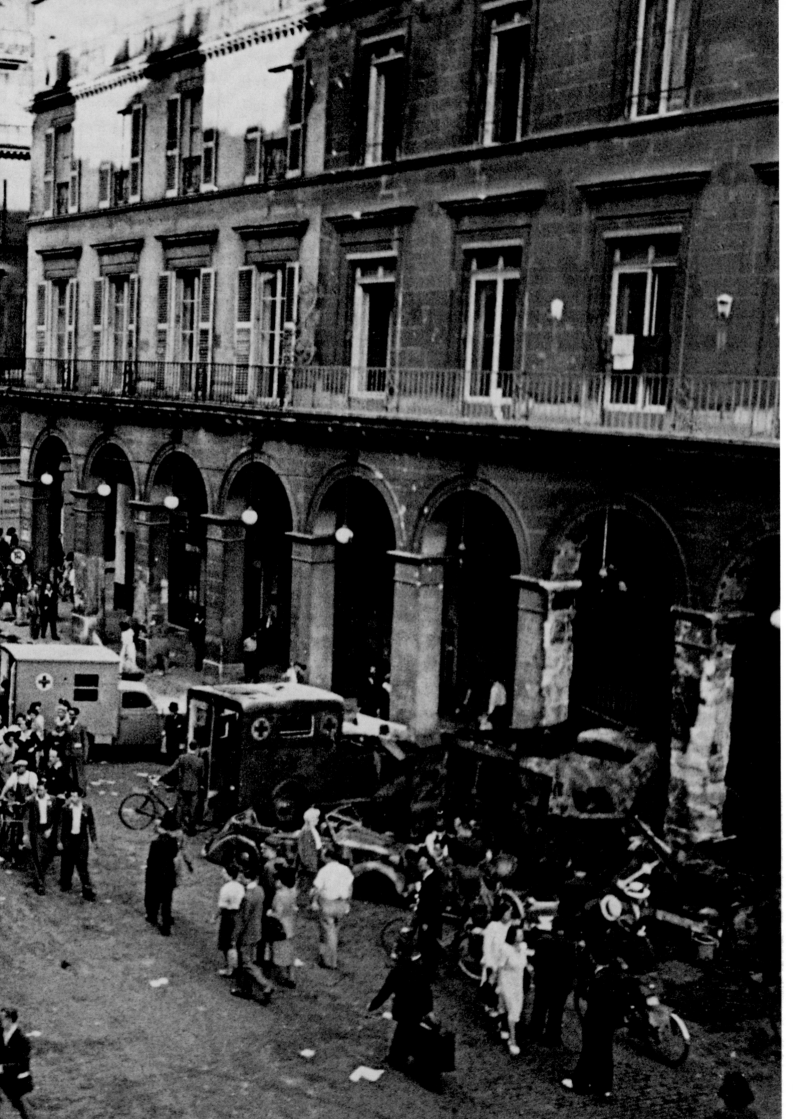

60 Robert Doisneau
Swimmers on the pont d'Iéna
during the Occupation,
Paris VII arrond., c. 1944

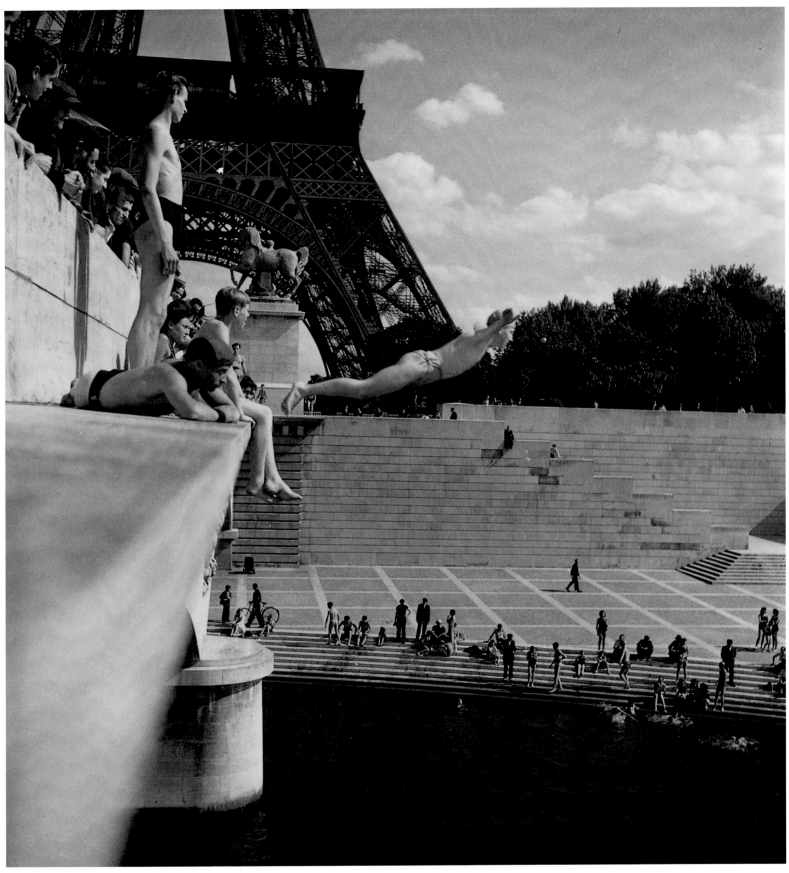

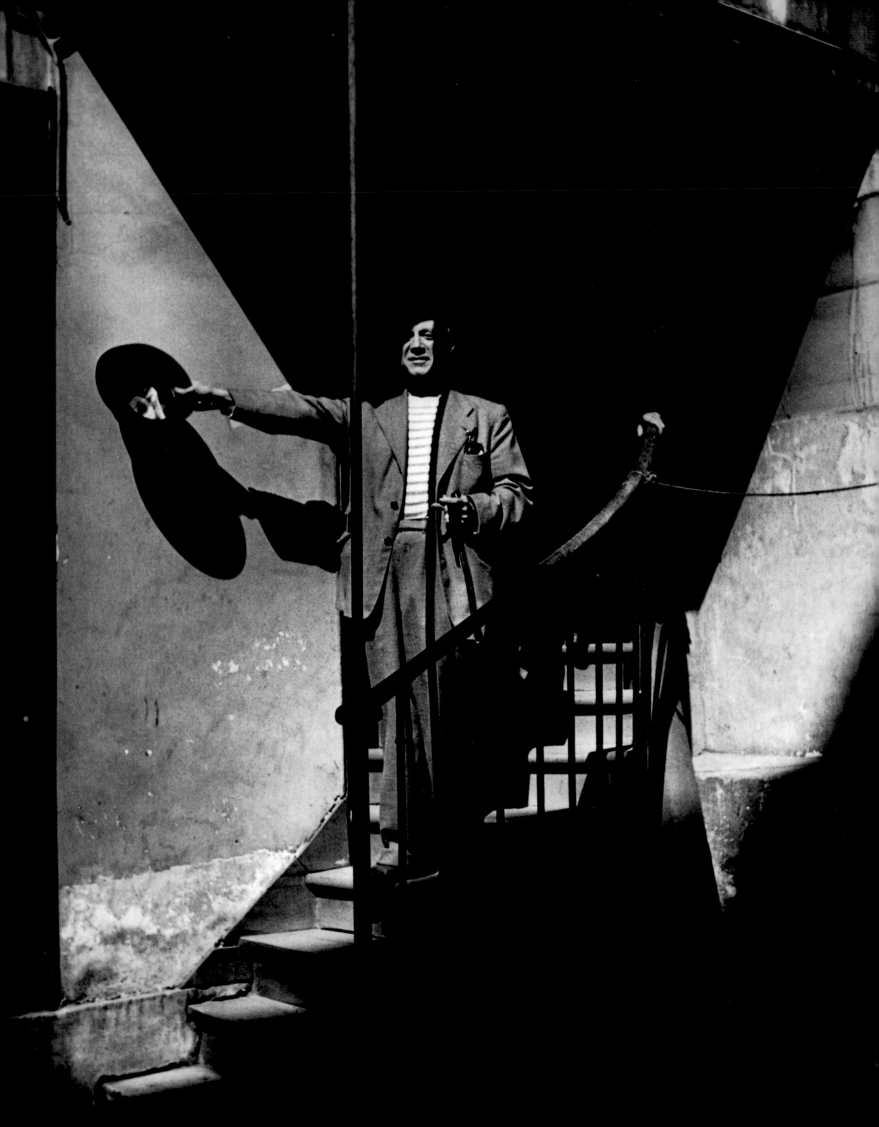

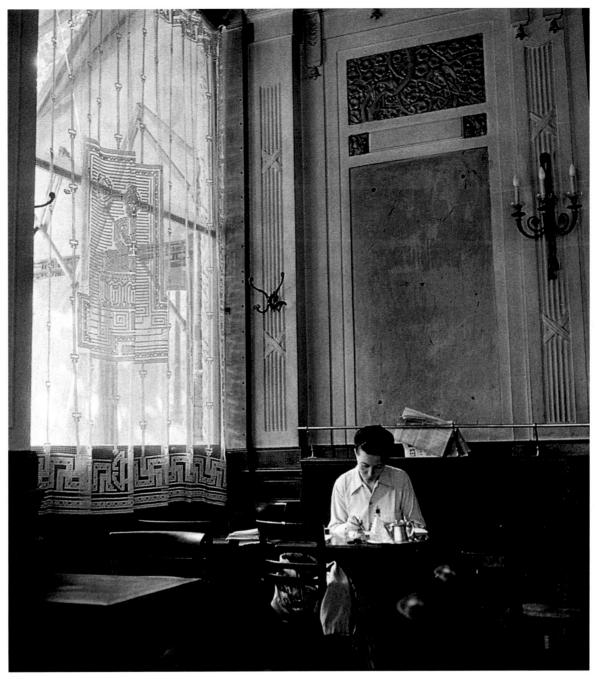

62

61 Robert Capa
Picasso in his studio on the
rue des Grands-Augustins a few
days after the liberation of Paris,
VI arrond., 2 September 1944

62 Robert Doisneau
Simone de Beauvoir at the Deux
Magots, Paris VI arrond., 1944

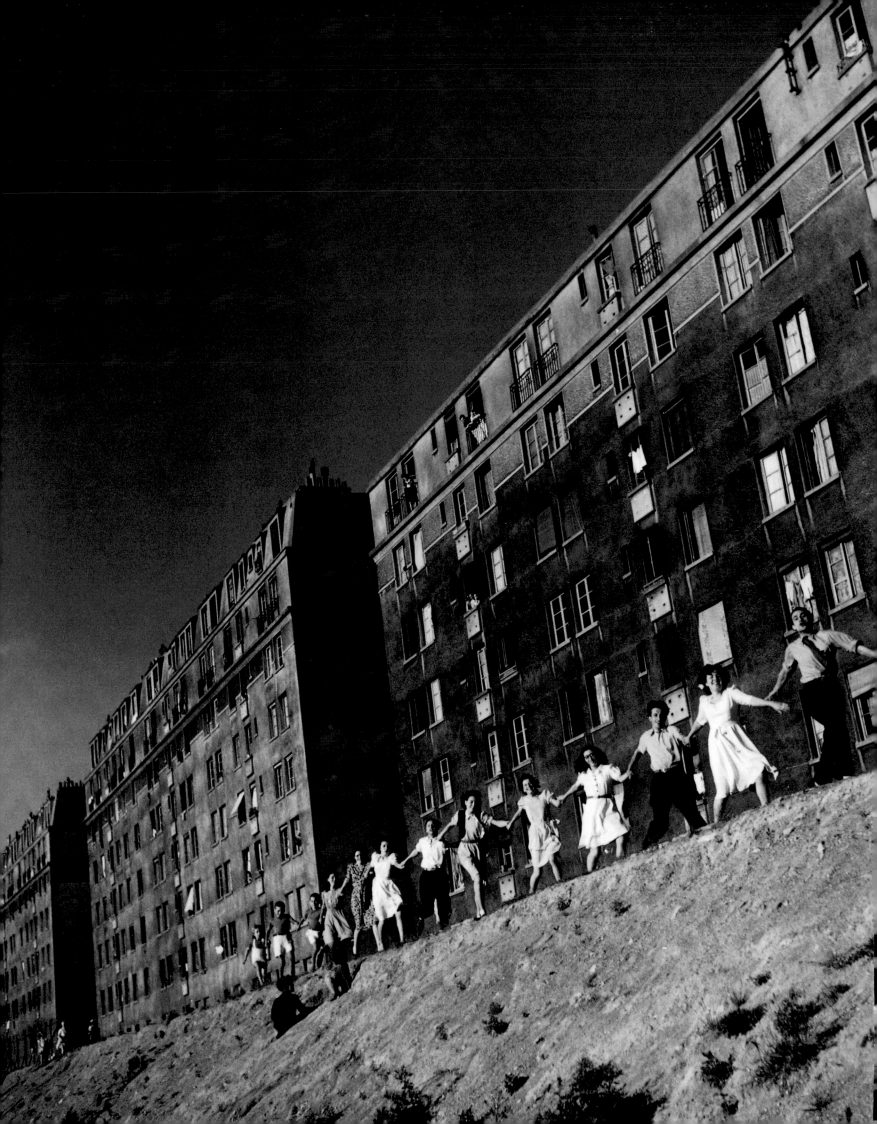

63 **Robert Doisneau**
Josette's twentieth birthday,
Gentilly, 1947

64 **Robert Doisneau**
Vitry-sur-Seine, 1945

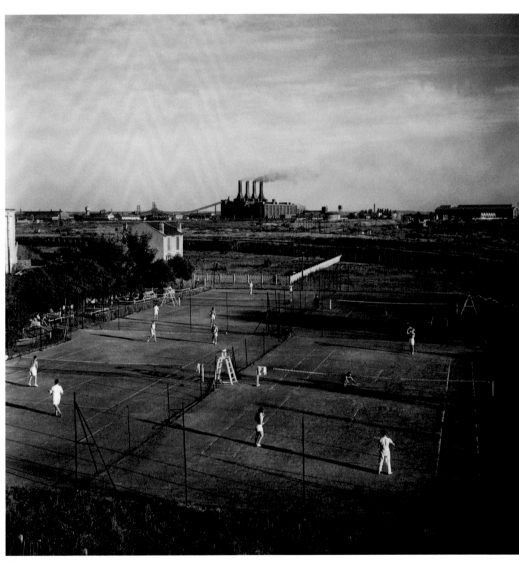

64

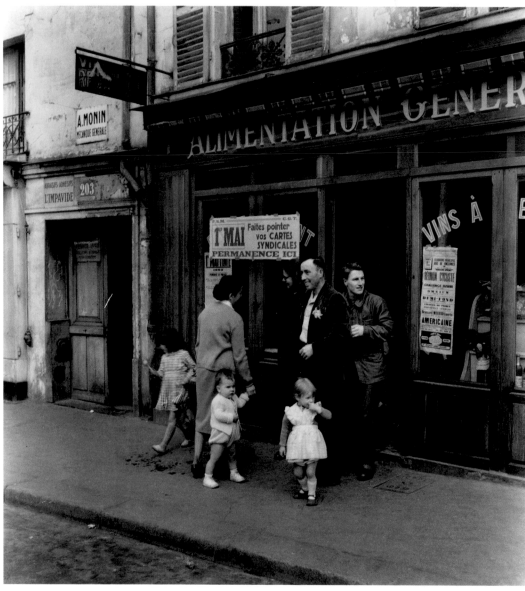

65

65 Willy Ronis
Rue de Belleville, Paris
XIX arrond., 1 May 1948

66 Willy Ronis
Street boys, Belleville district,
Paris, XX arrond., 1959

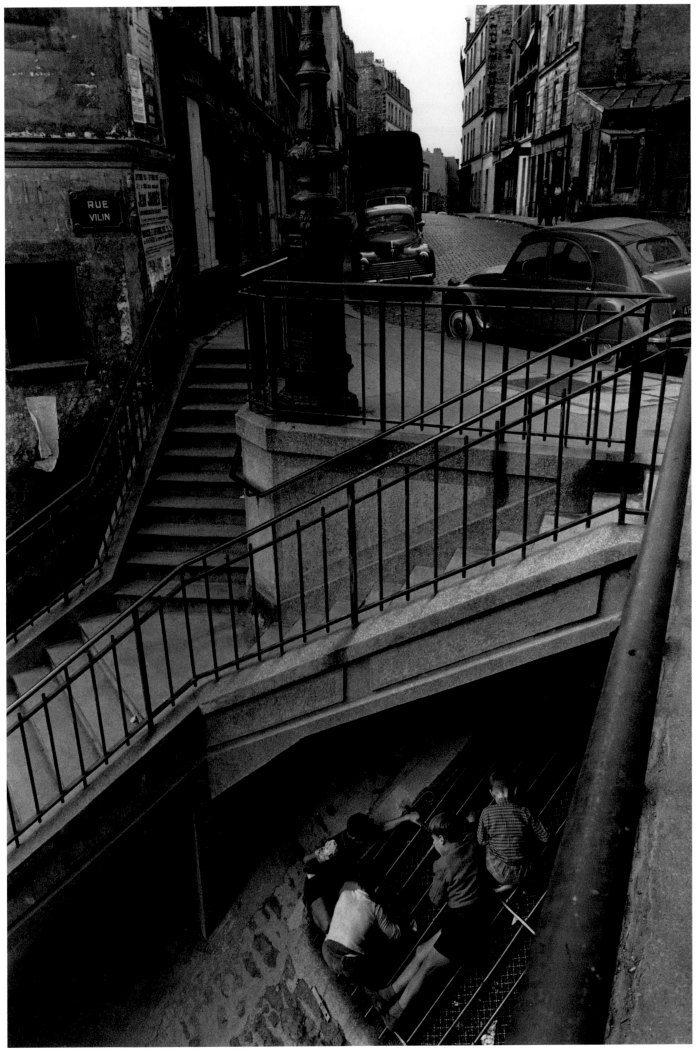

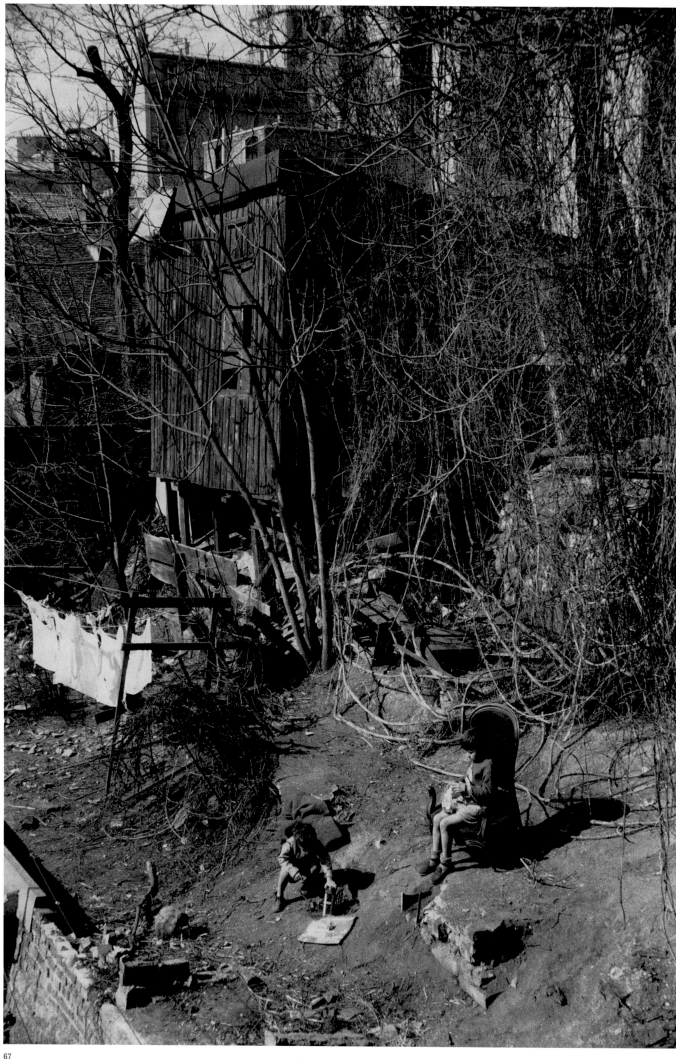

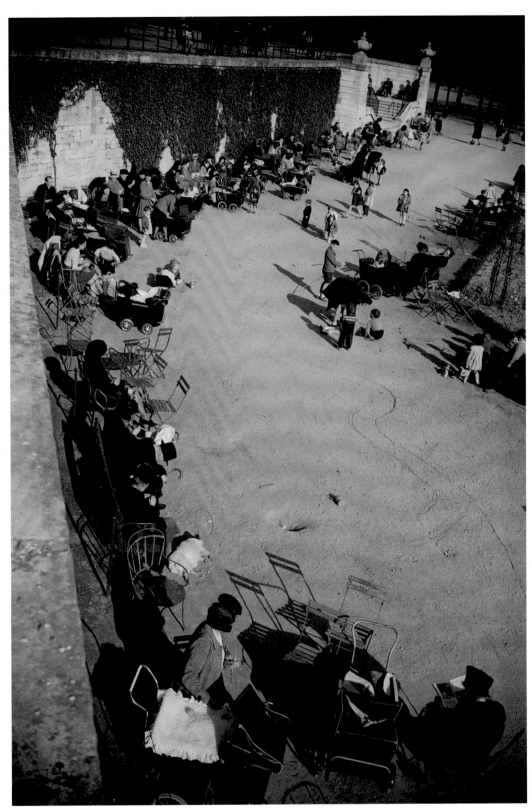

68

67 Henri Cartier-Bresson
Montmartre,
Paris XVIII arrond., 1958

68 Marcel Bovis
Jardin des Tuileries,
Paris I arrond., April 1947

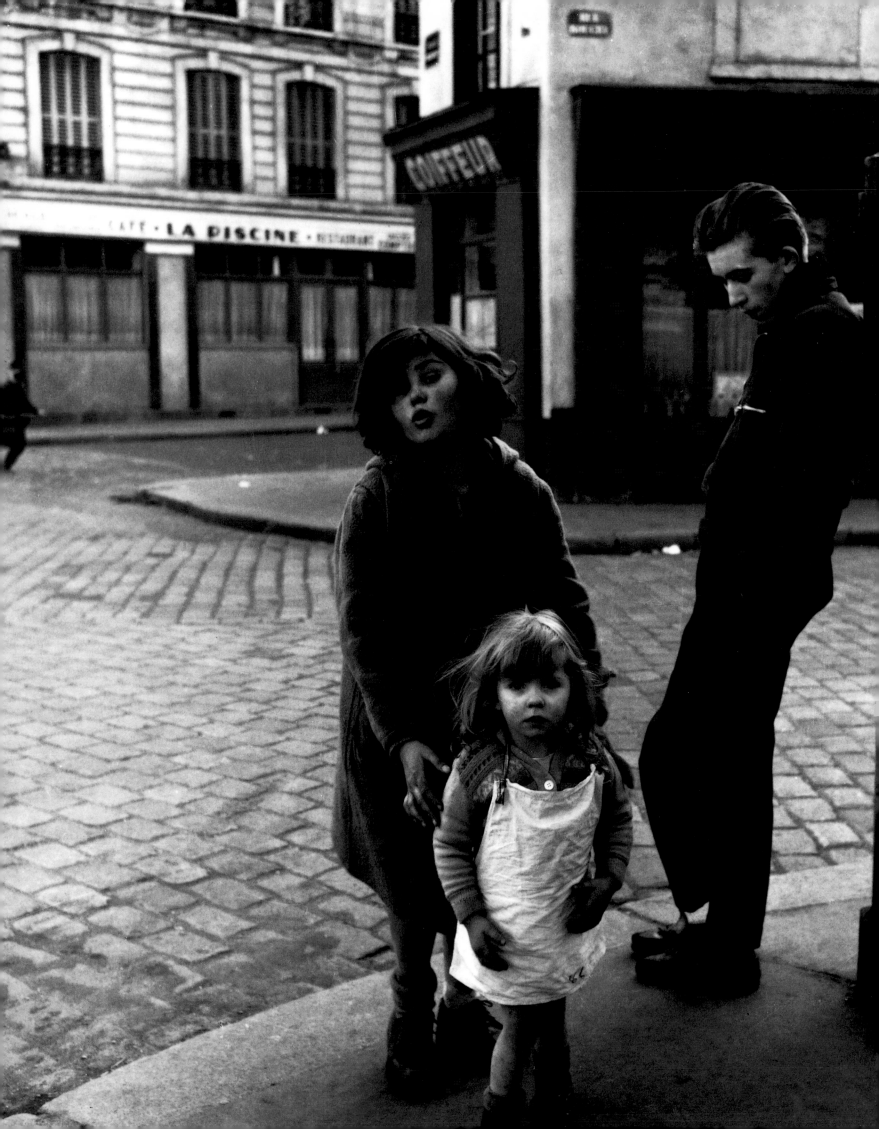

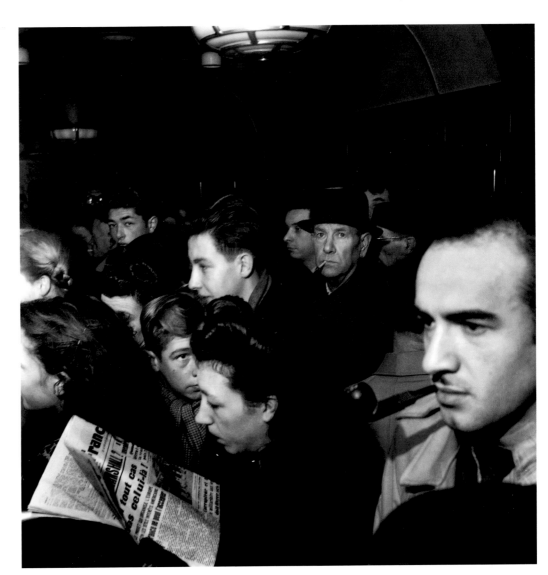

70

69 Robert Doisneau
Place Hébert, Paris
XVIII arrond., 1957

70 Robert Doisneau
Public transport,
Paris, 1946

71 Willy Ronis
Bar on the rue Montmartre,
Paris II arrond., 1955

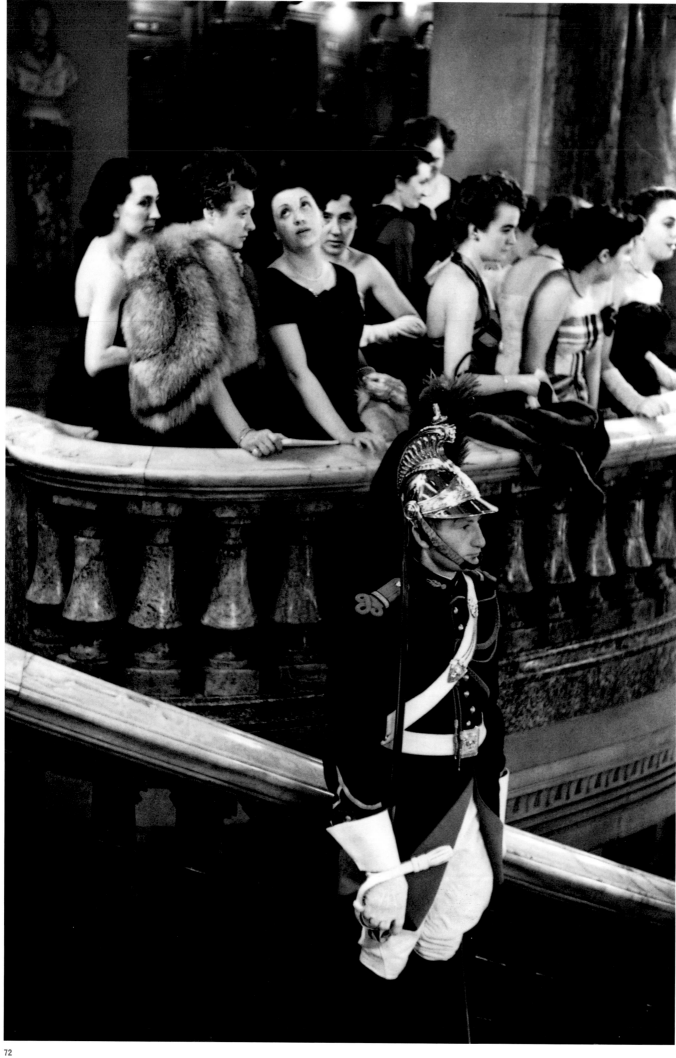

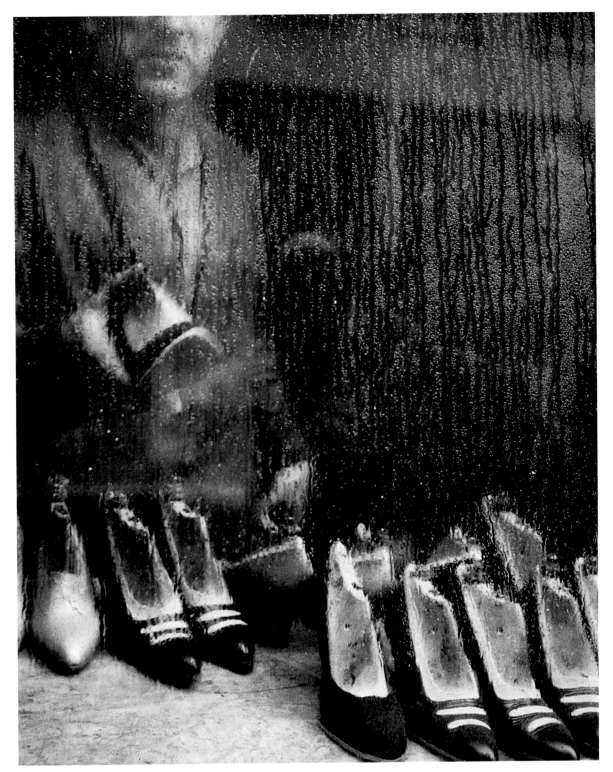

73

72 Henri Cartier-Bresson
The annual ball for the students
of the École Saint-Cyr Military
Academy, held in the Palais
Garnier Opera House,
Paris II arrond., 1952–53

73 Sabine Weiss
Shoes in a shop window,
Paris, 1955

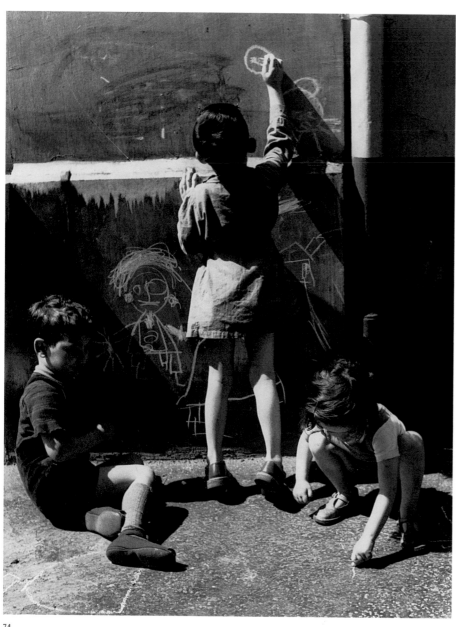

74

74 Denise Colomb
Children drawing in the street,
Paris, 1953

75 Robert Doisneau
Bistro Cloisonné, rue Lacépède,
Paris V arrond., 1950

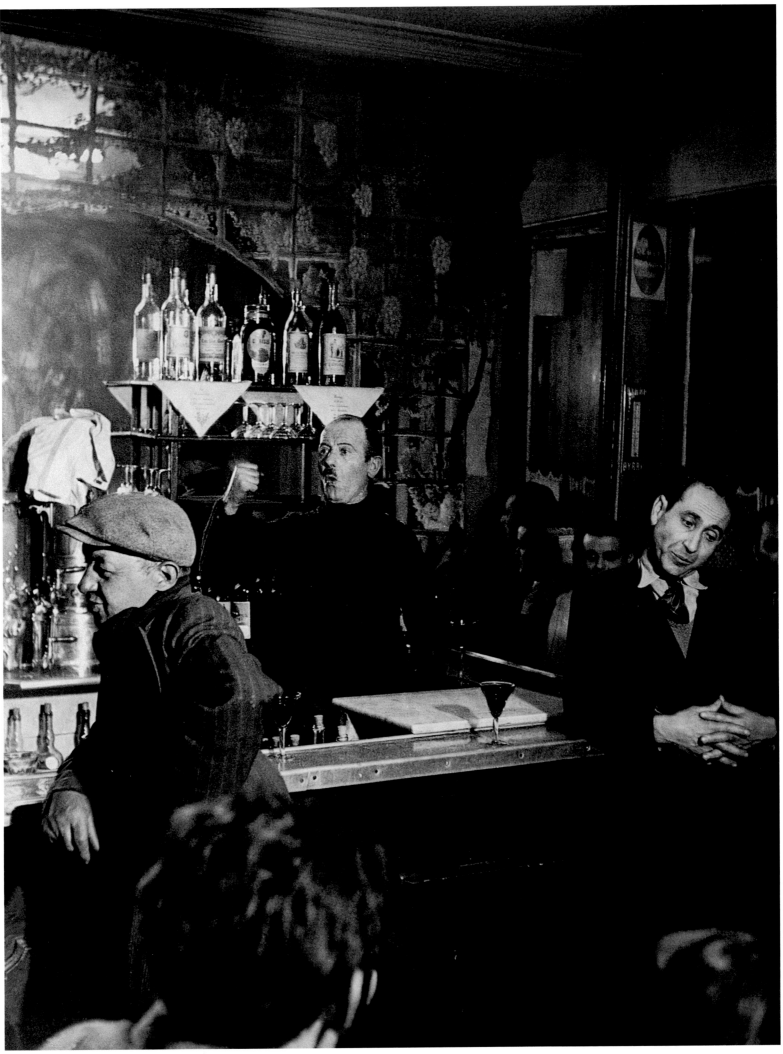

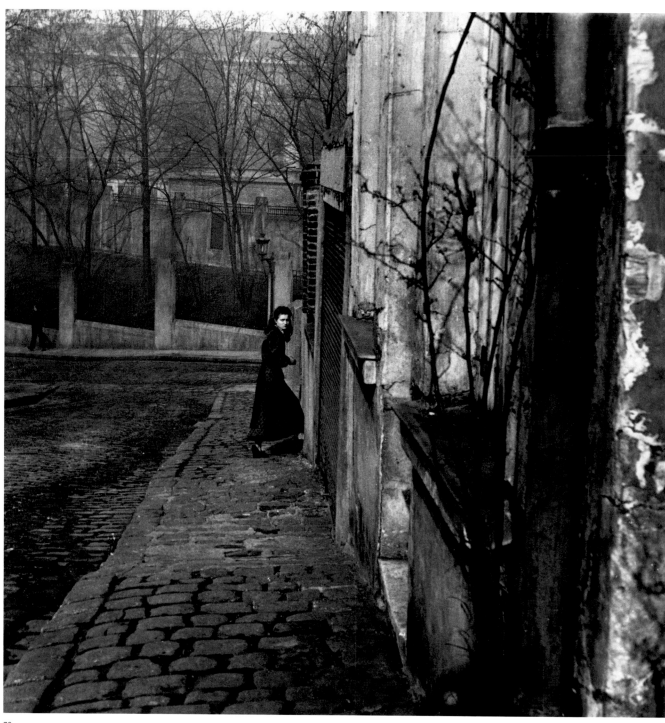

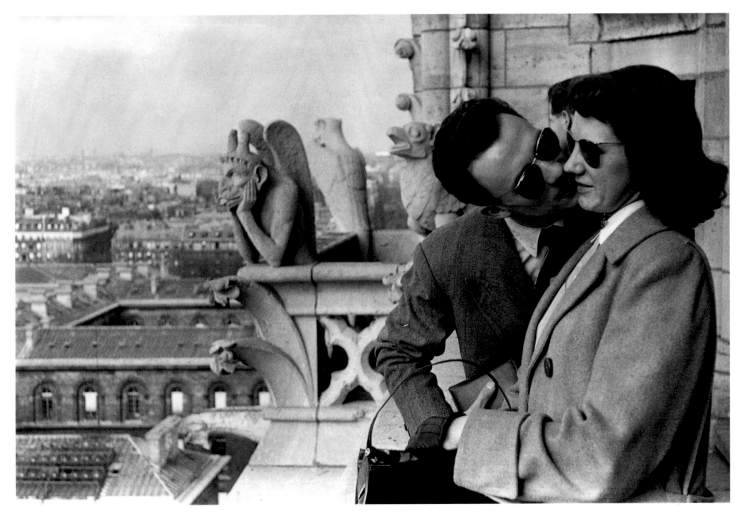

77

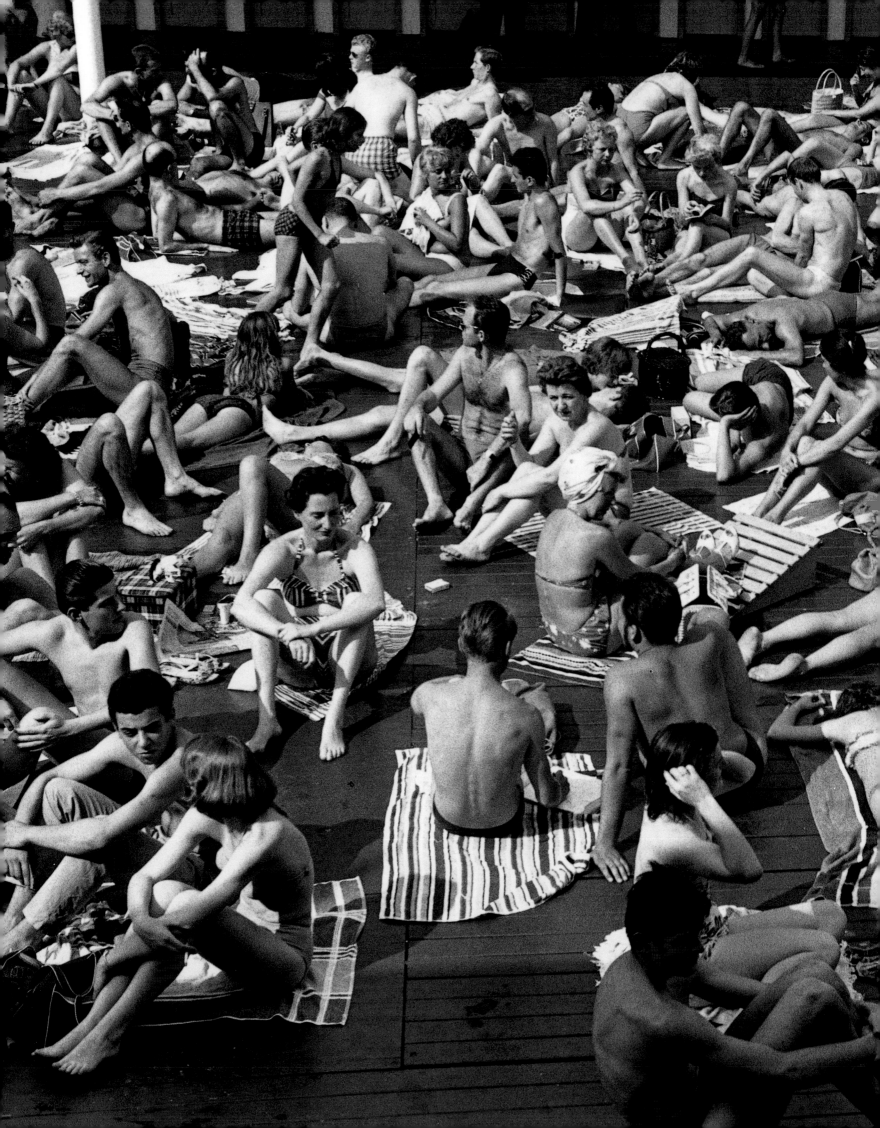

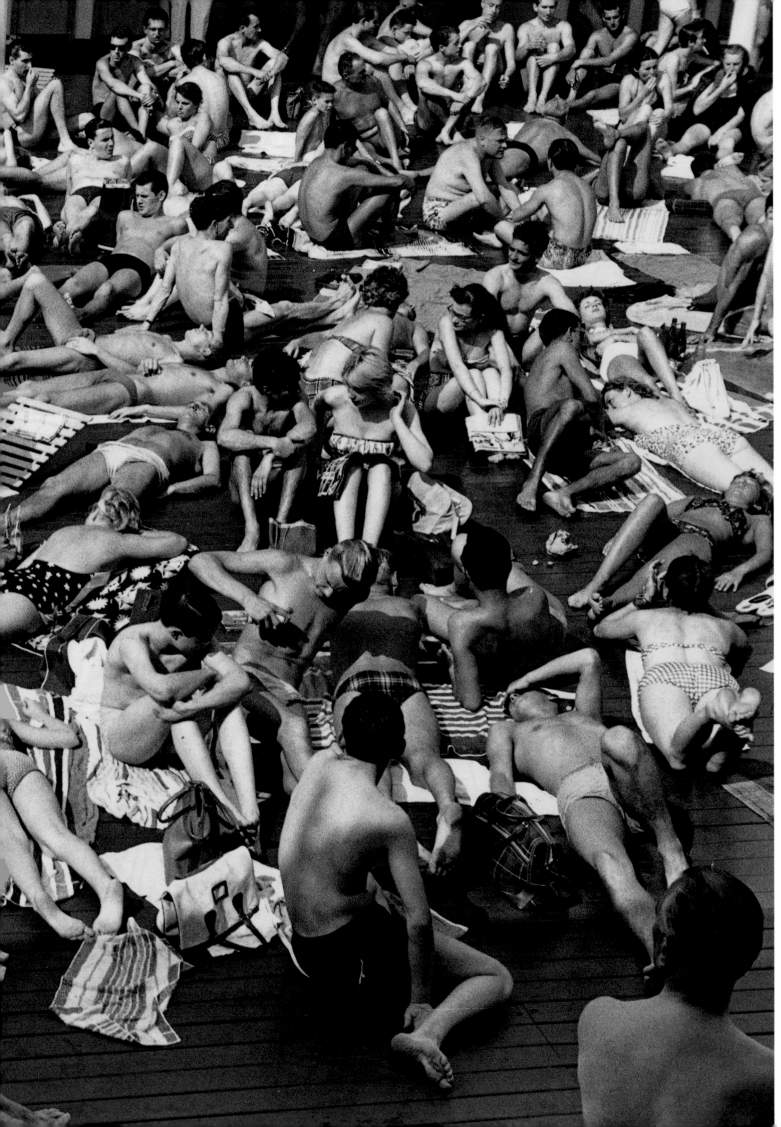

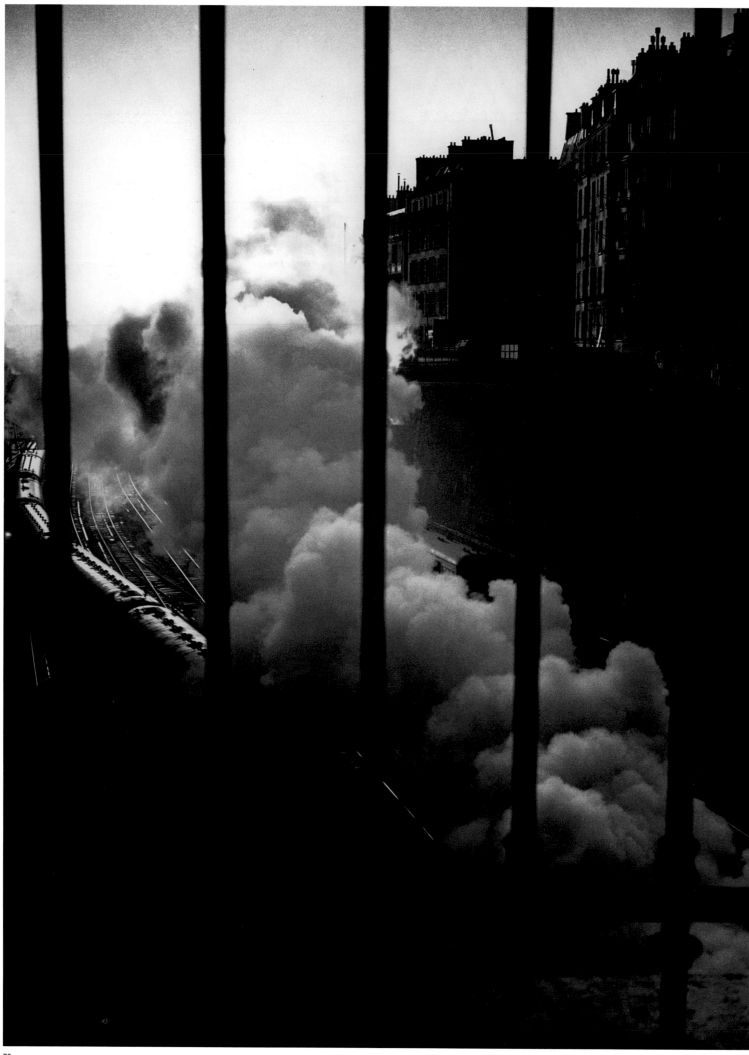

80

82

81 Robert Doisneau
Dog on pont des Arts,
Paris I arrond., 1953

82 Robert Doisneau
Jacques Prévert at the
Gueridon, Quai Saint-Bernard,
Paris V arrond., 1955

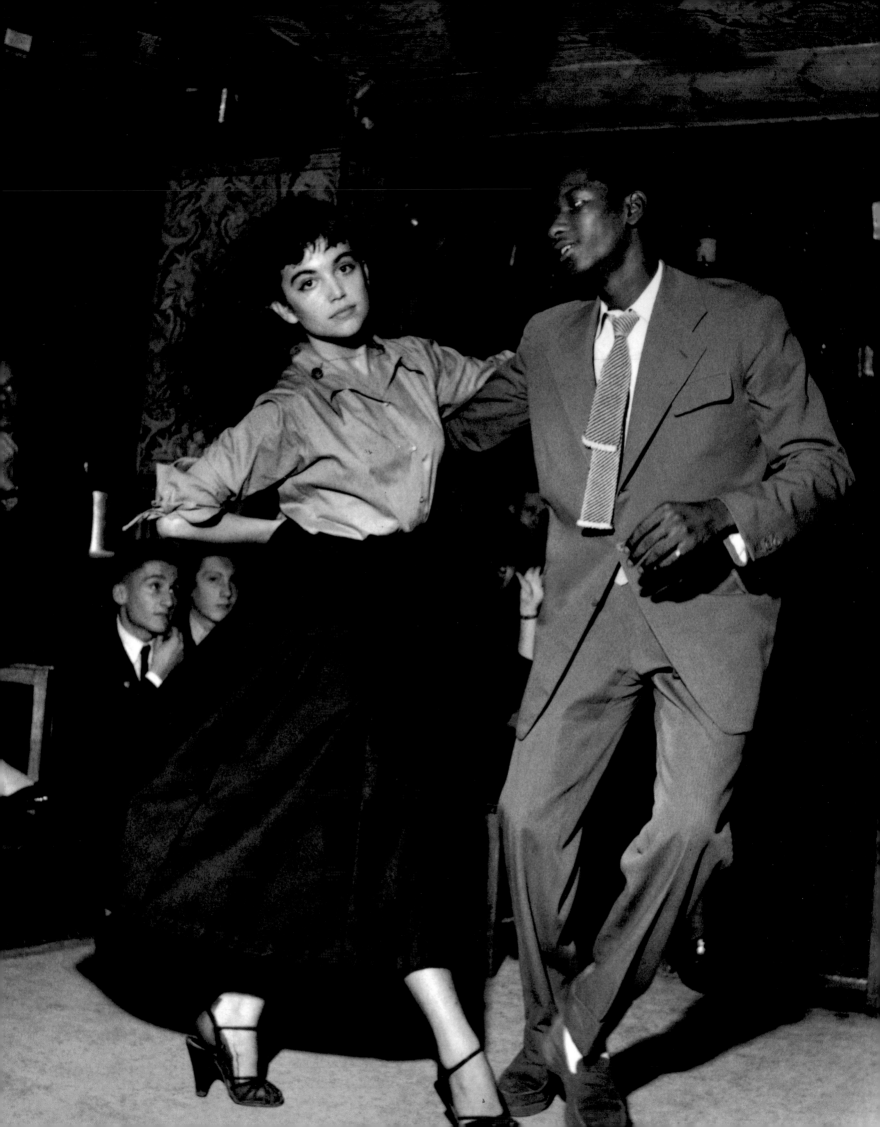

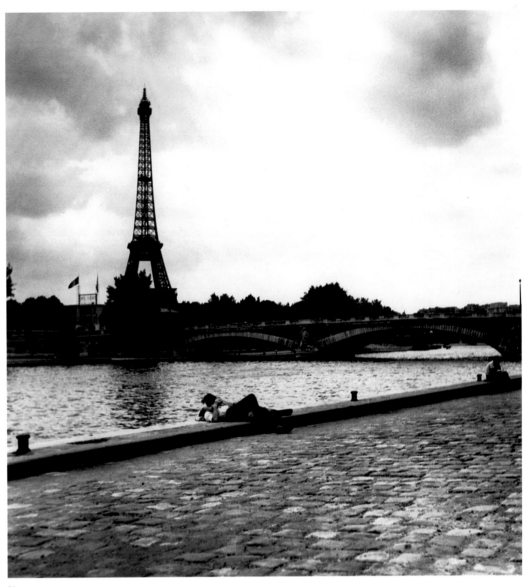

84

83 Robert Doisneau
Couple dancing 'bebop'
in a cellar nightclub,
Saint-Germain-des-Prés,
Paris VI arrond., 1951

84 Robert Capa
Paris I arrond., July 1952

85 Sabine Weiss
Printemps department store,
Paris, 1951

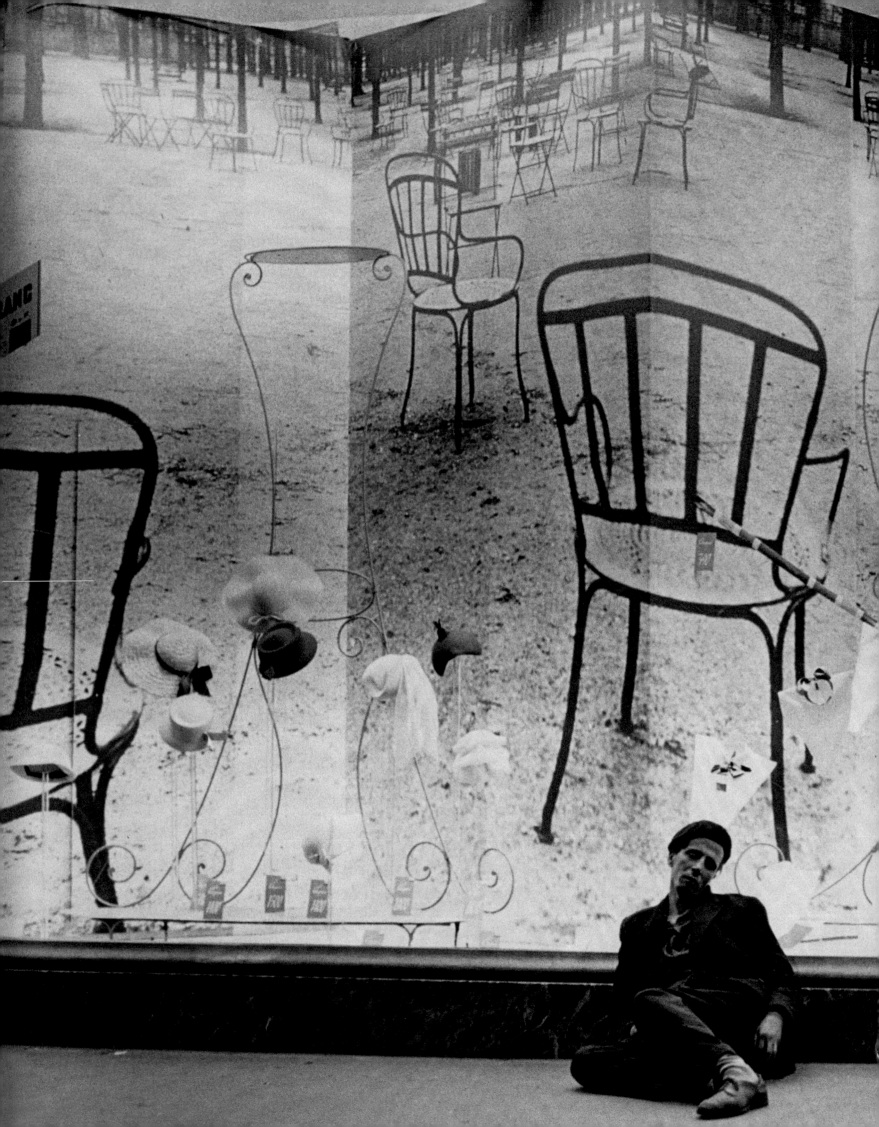

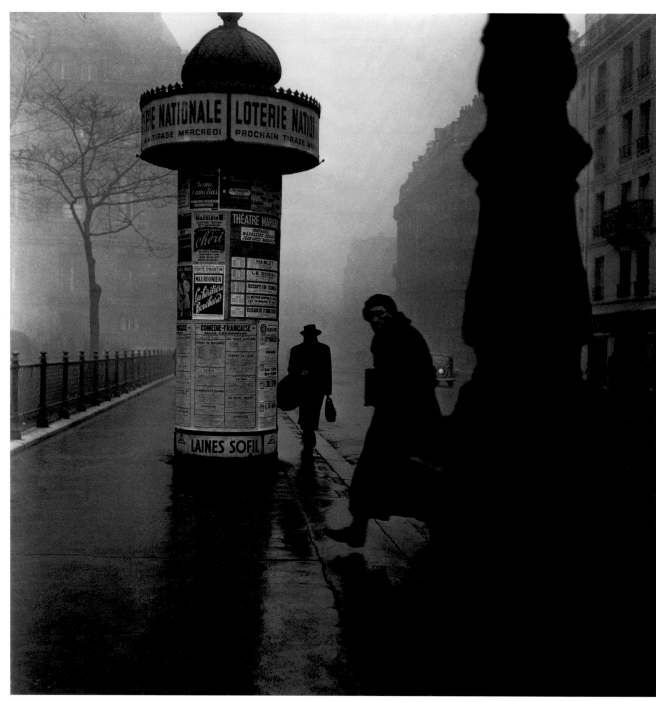

86 **Tore Johnson**
Rue des Écoles,
Paris V arrond., c. 1948–54

87 **Robert Frank**
Untitled, 1950

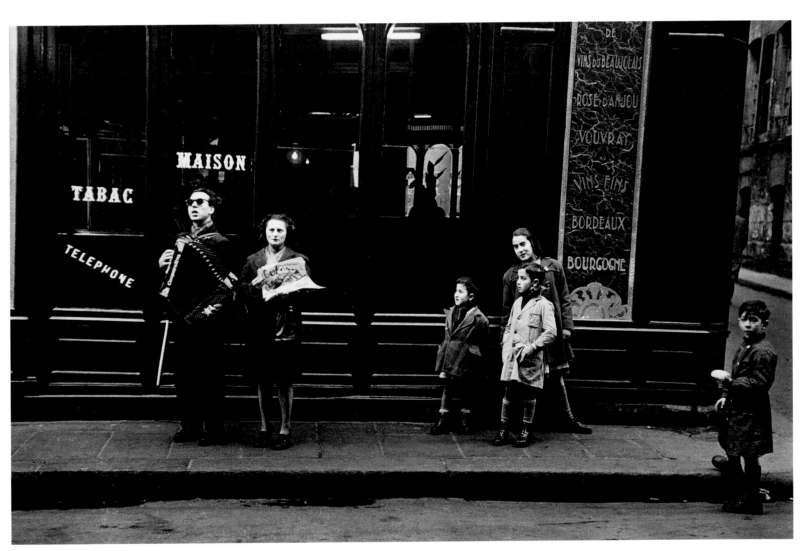

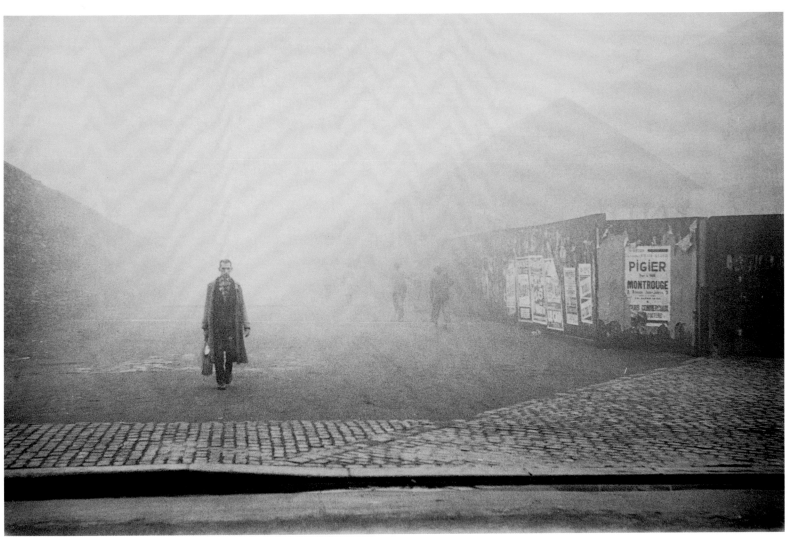

88

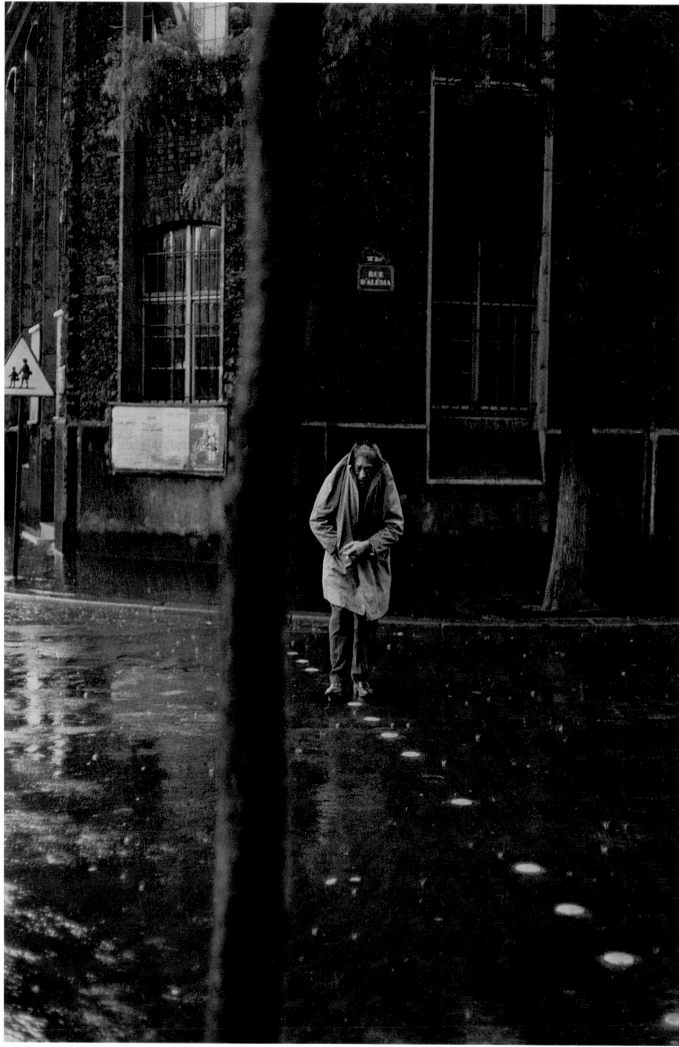

89 **Henri Cartier-Bresson**
Alberto Giacometti, rue d'Alésia,
Paris XIV arrond., 1961

90 **Sergio Larrain**
Paris VIII arrond., 1959

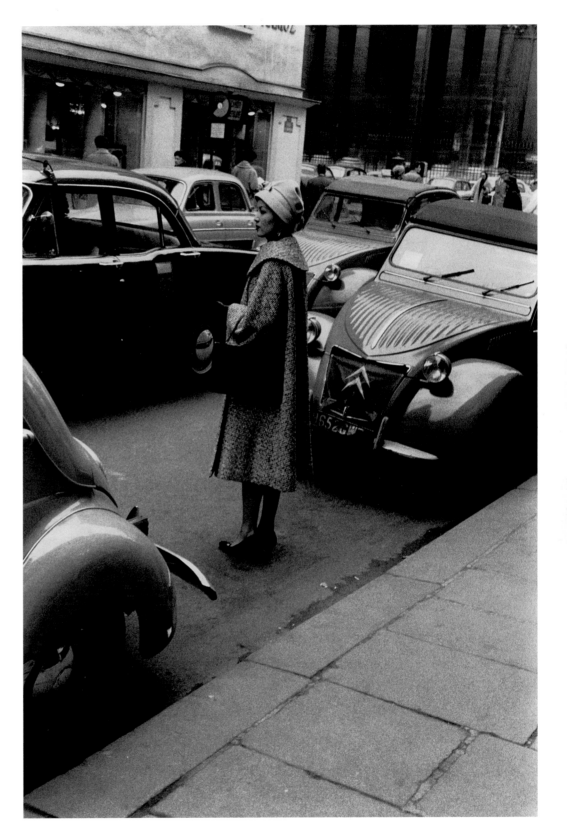

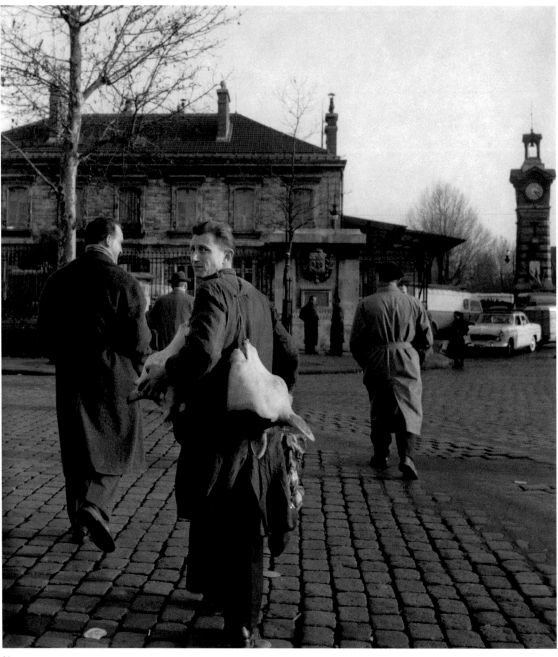

91

91 Janine Niepce
Slaughterhouses, La Villette,
Paris XIX arrond., 1956

92 Izis
Boulevard Saint-Michel,
Paris VI arrond., 1949

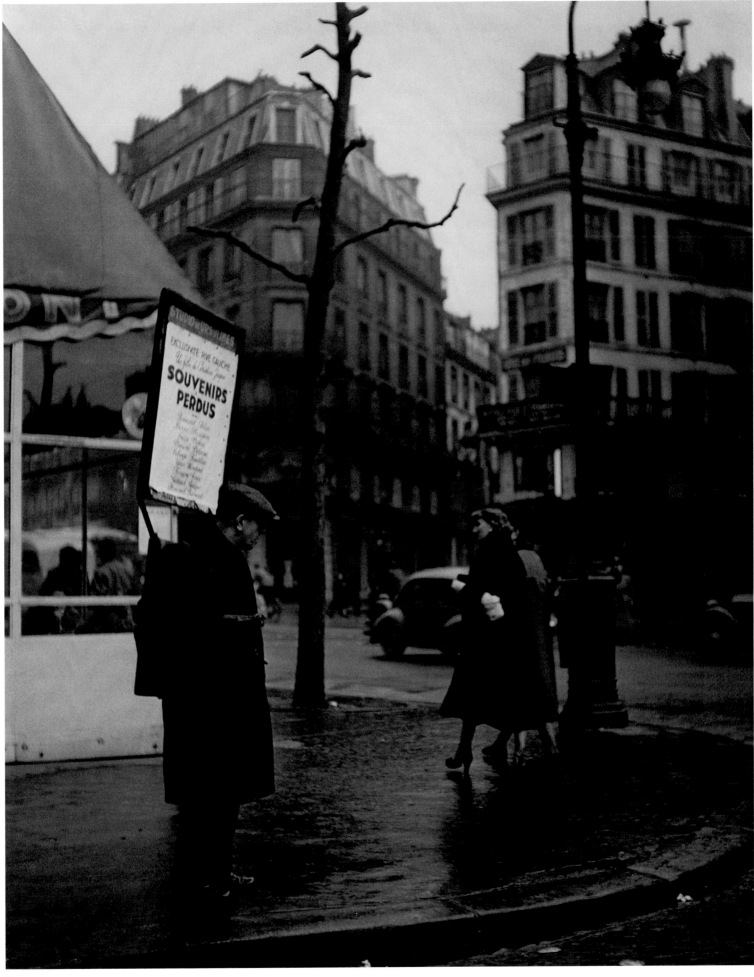

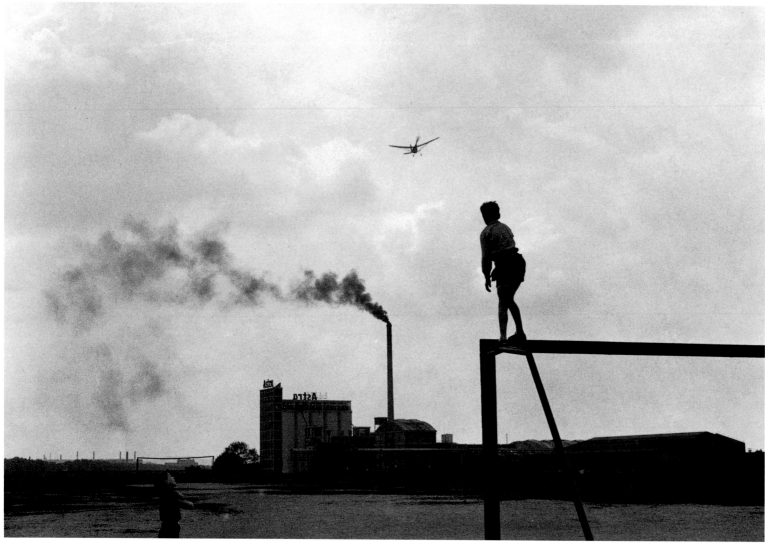

93

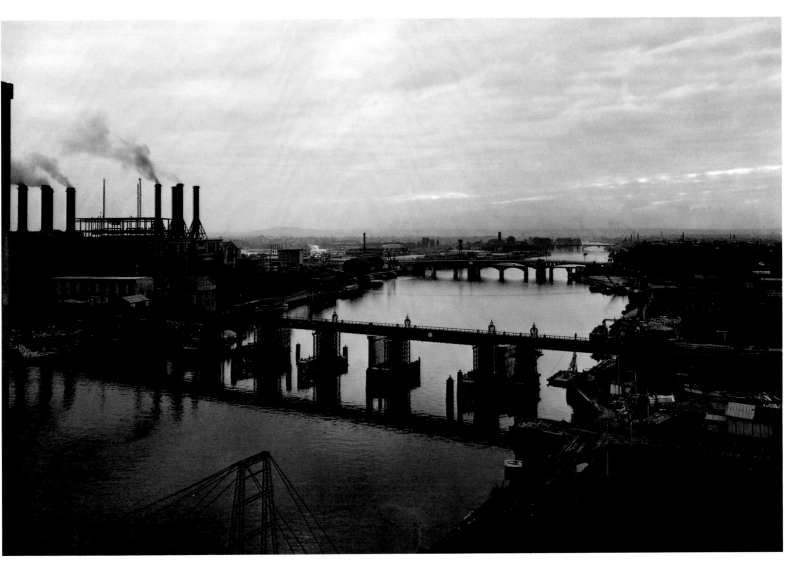

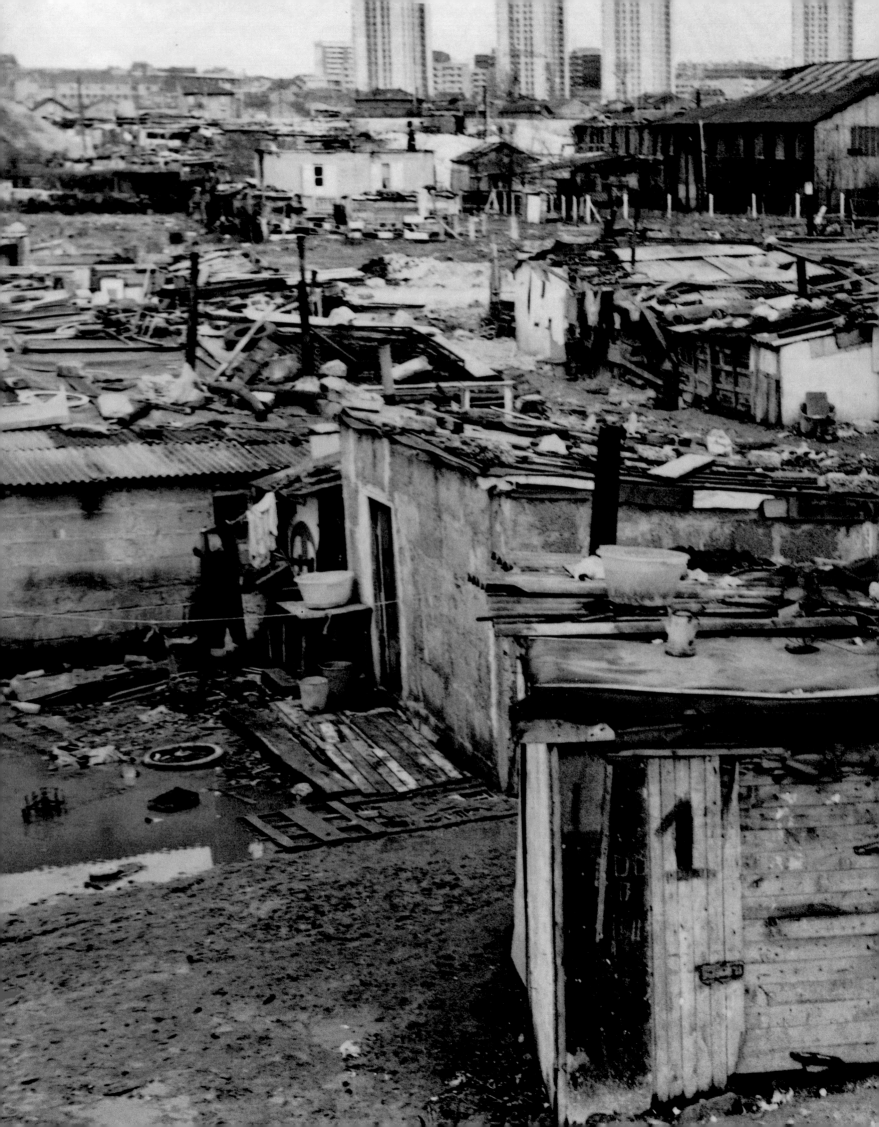

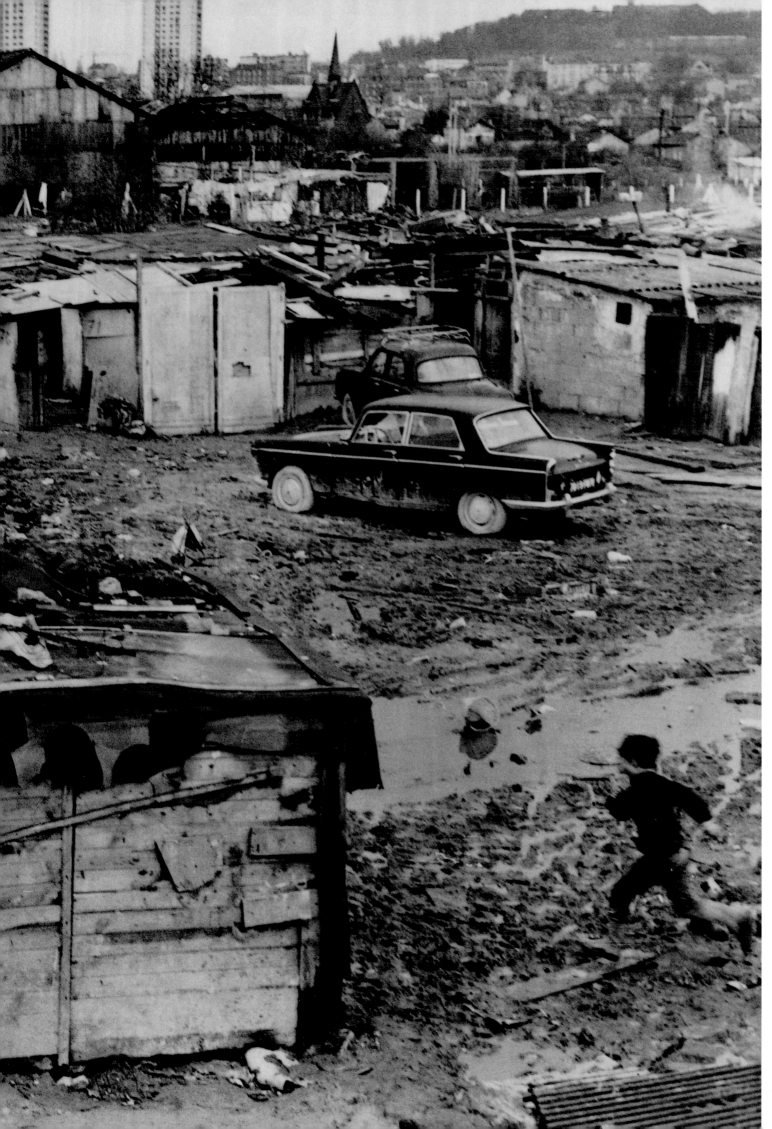

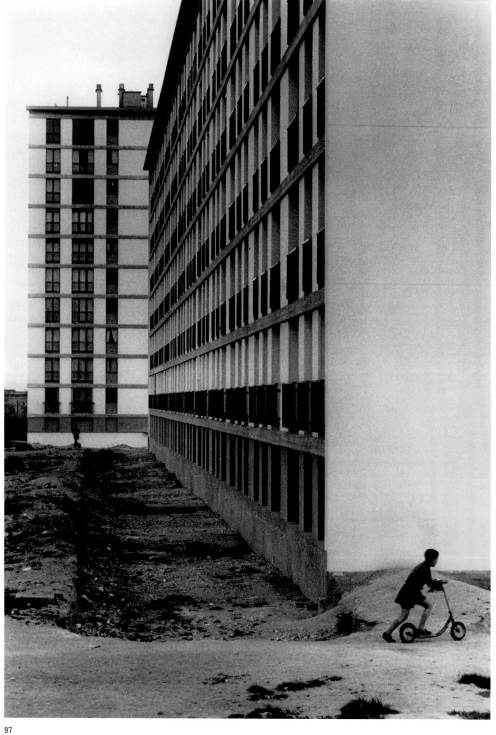

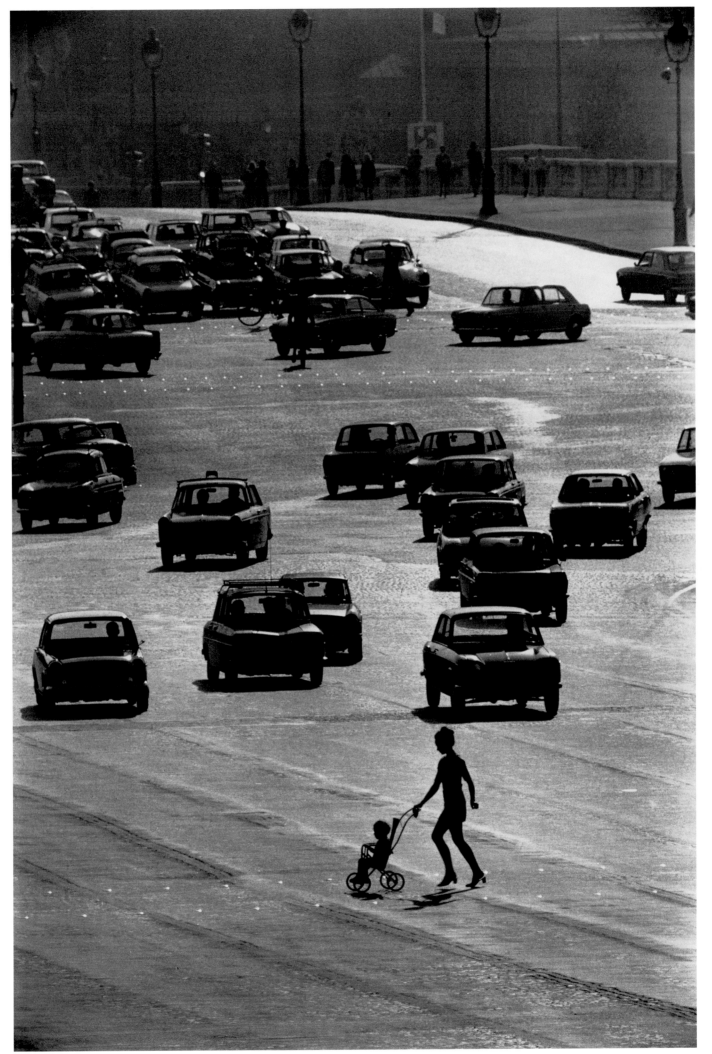

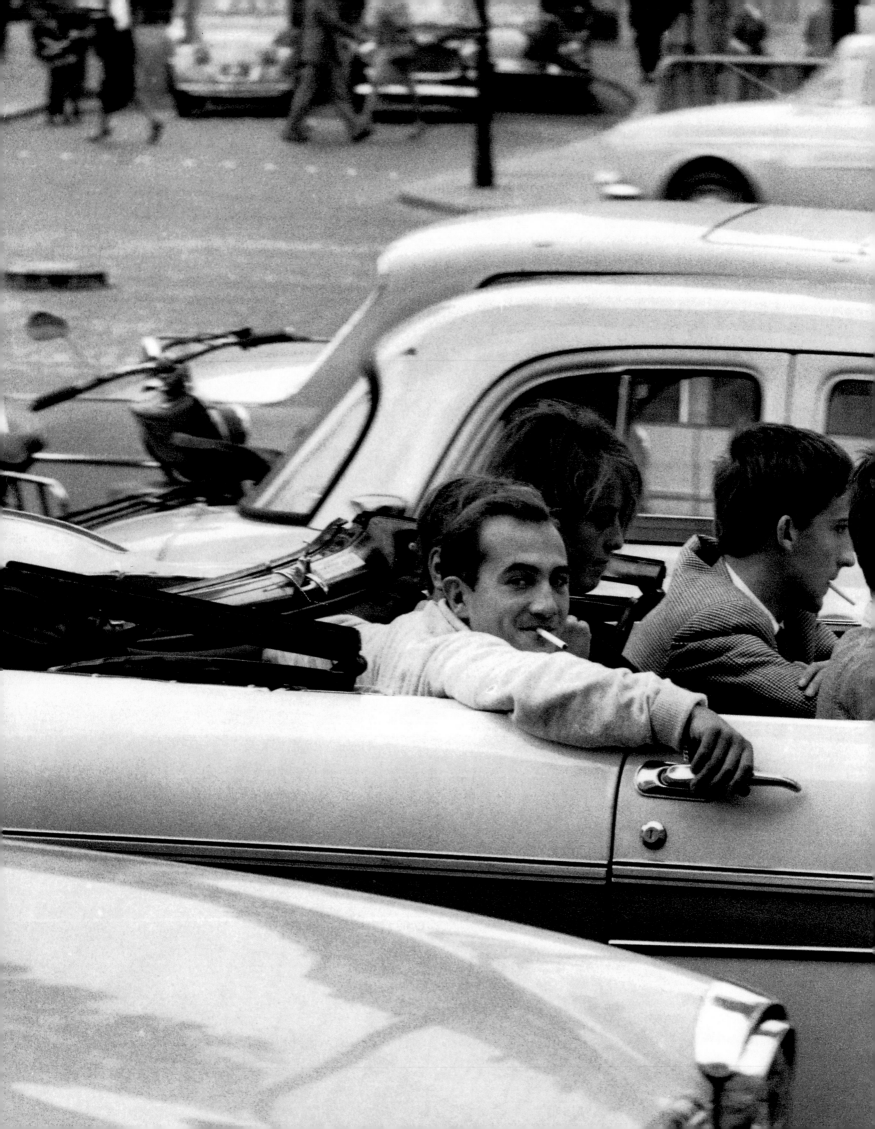

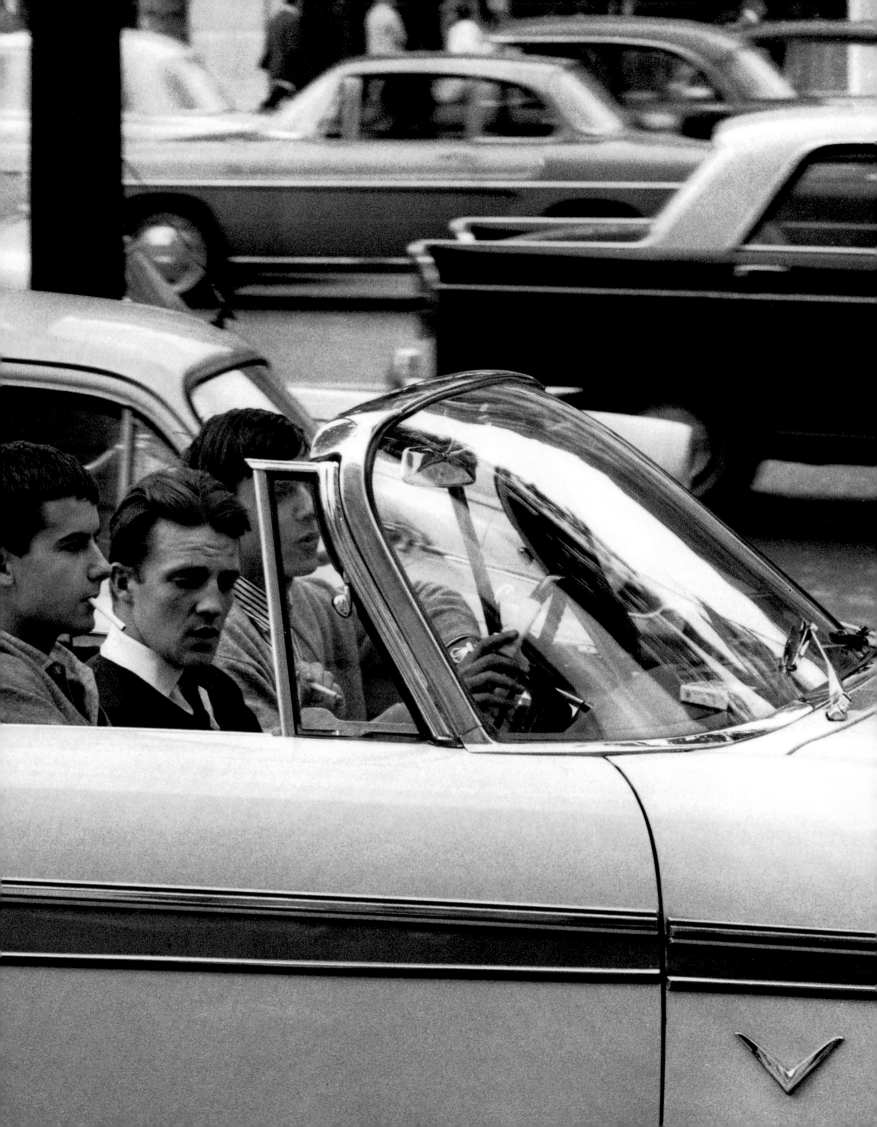

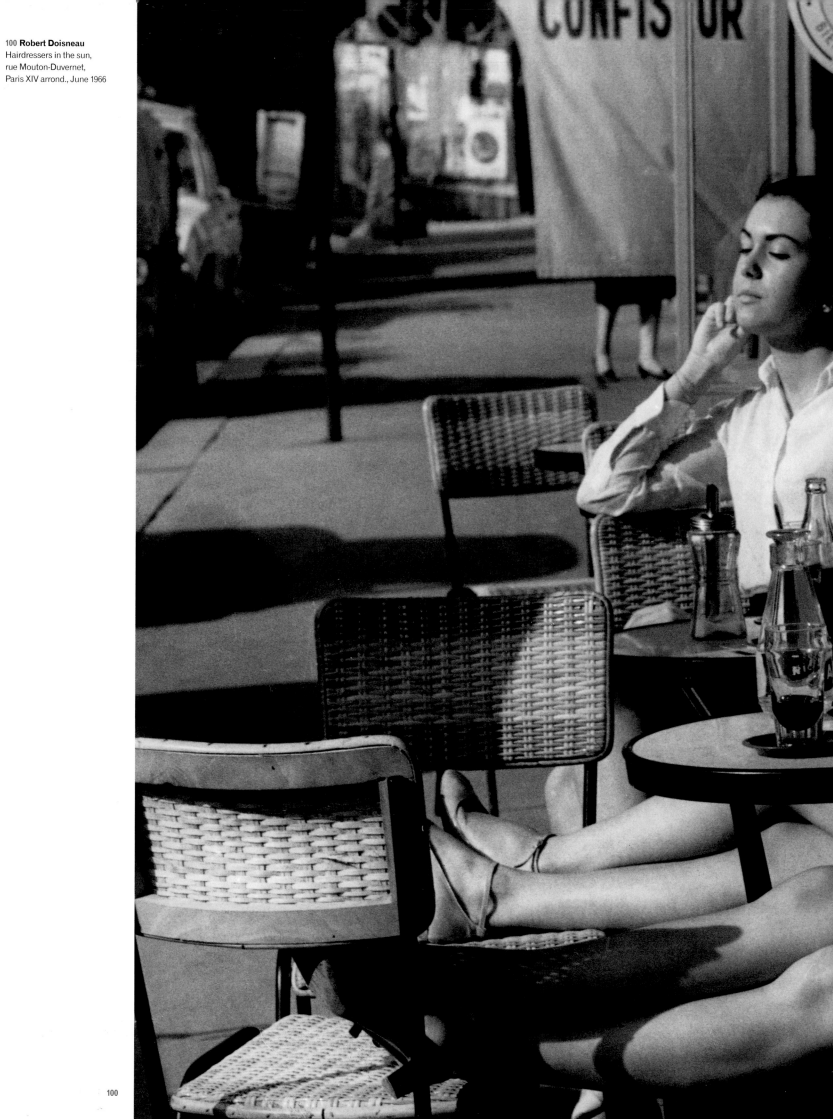

100 Robert Doisneau
Hairdressers in the sun,
rue Mouton-Duvernet,
Paris XIV arrond., June 1966

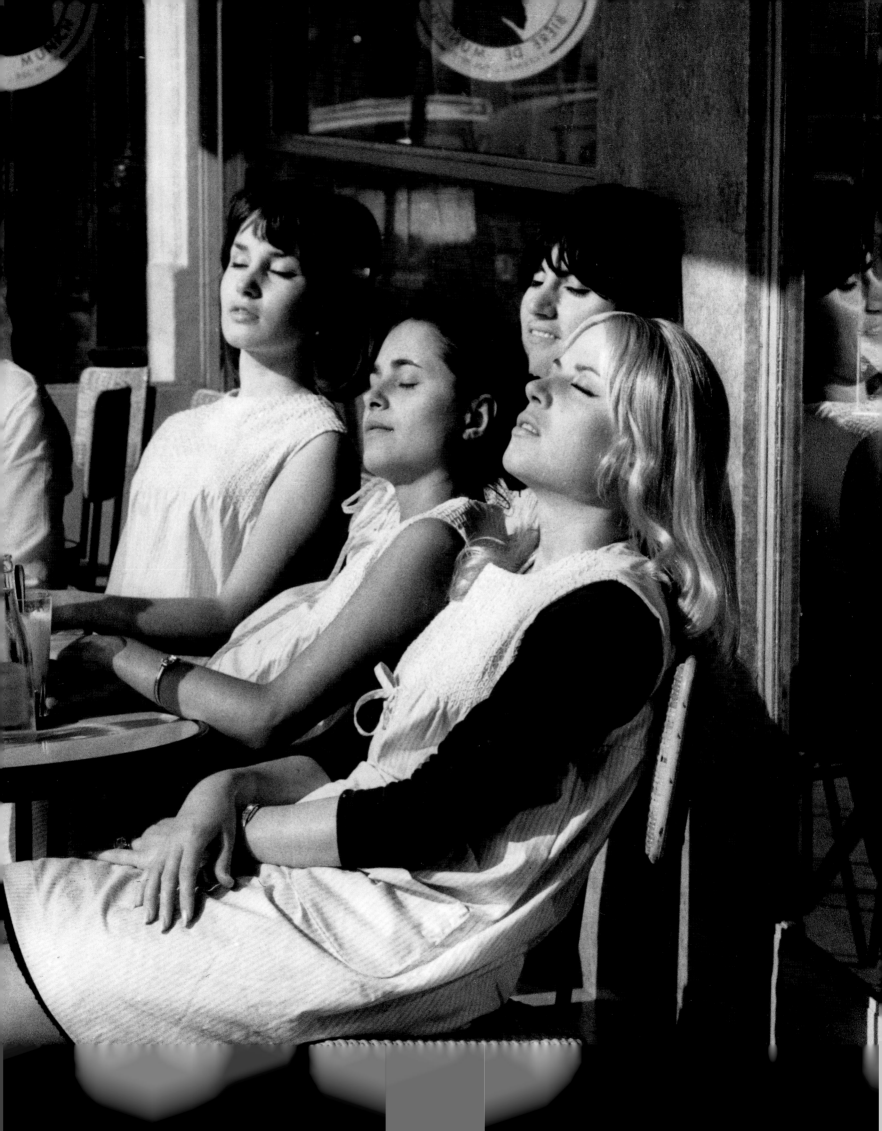

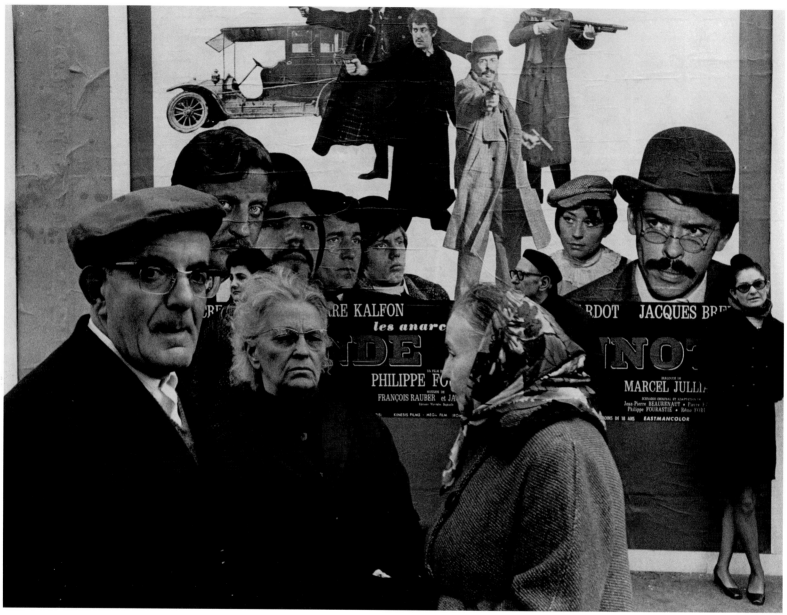

101

101 **William Klein**
'Bande à Bonnot', cours de
Vincennes, Paris XII arrond., 1968

102 **Henri Cartier-Bresson**
Bateau-mouche (cruise boat),
Paris, 1966

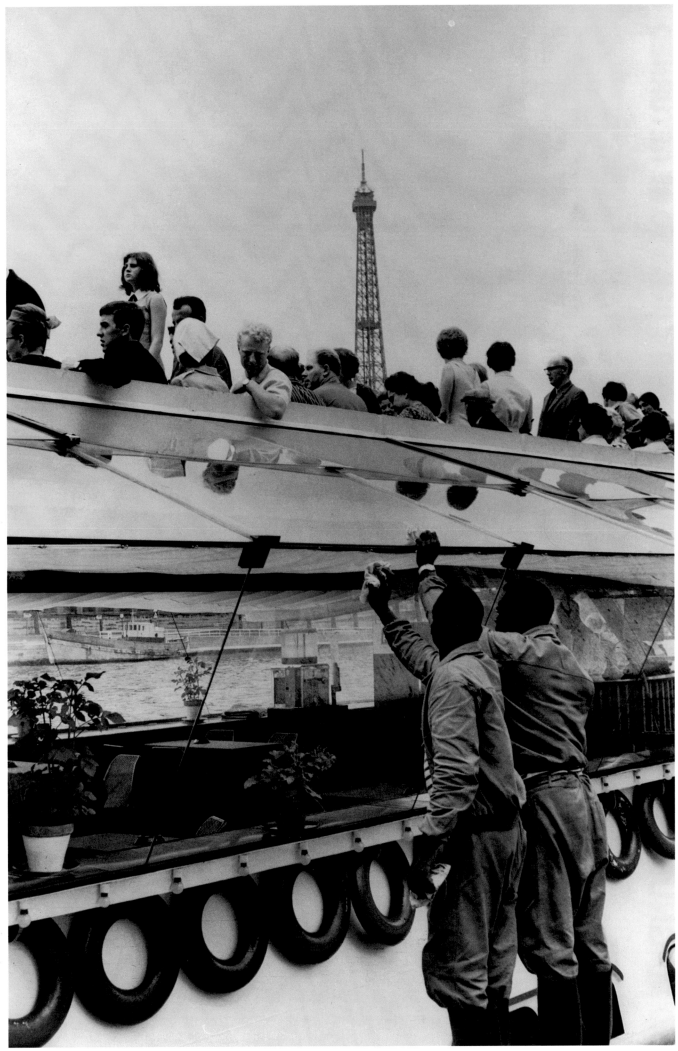

103 Paul Almasy
Café de Flore, Paris
VI arrond., 1966

104 Henri Cartier-Bresson
Fashion photographer,
Paris, 1965

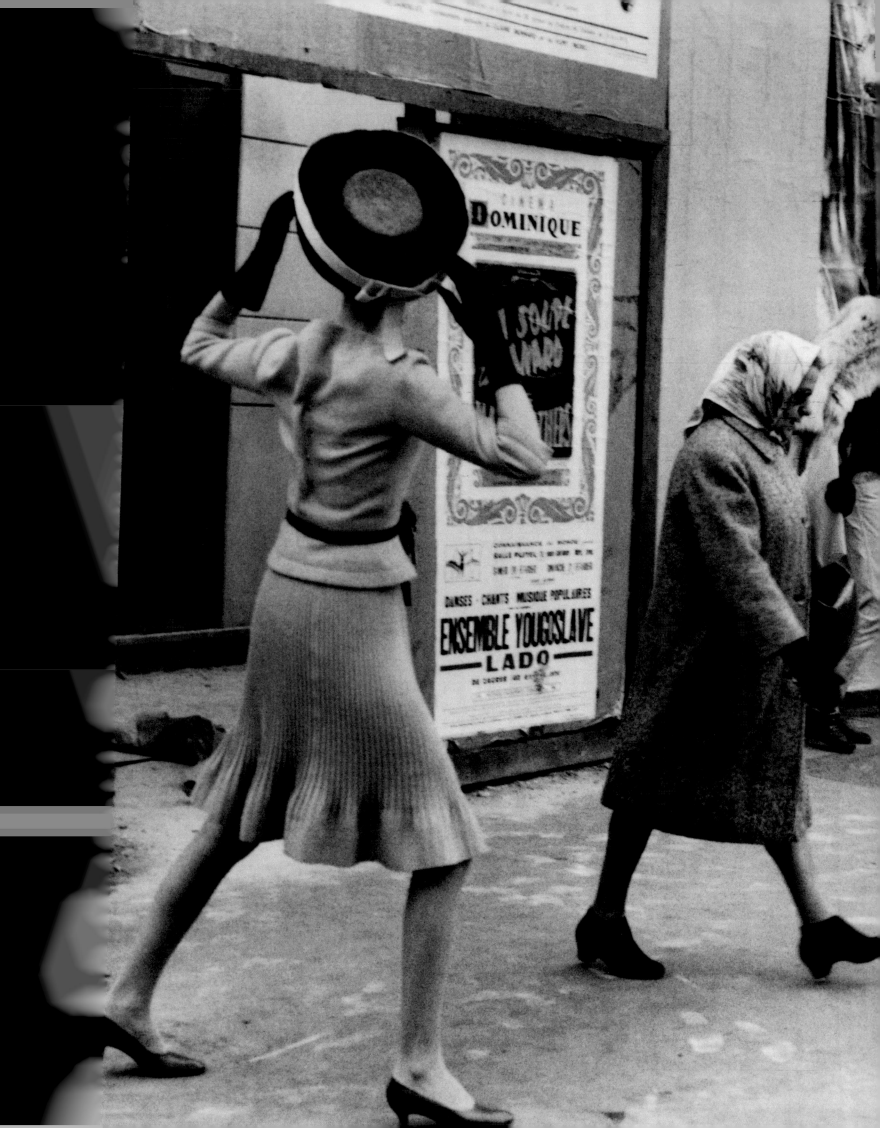

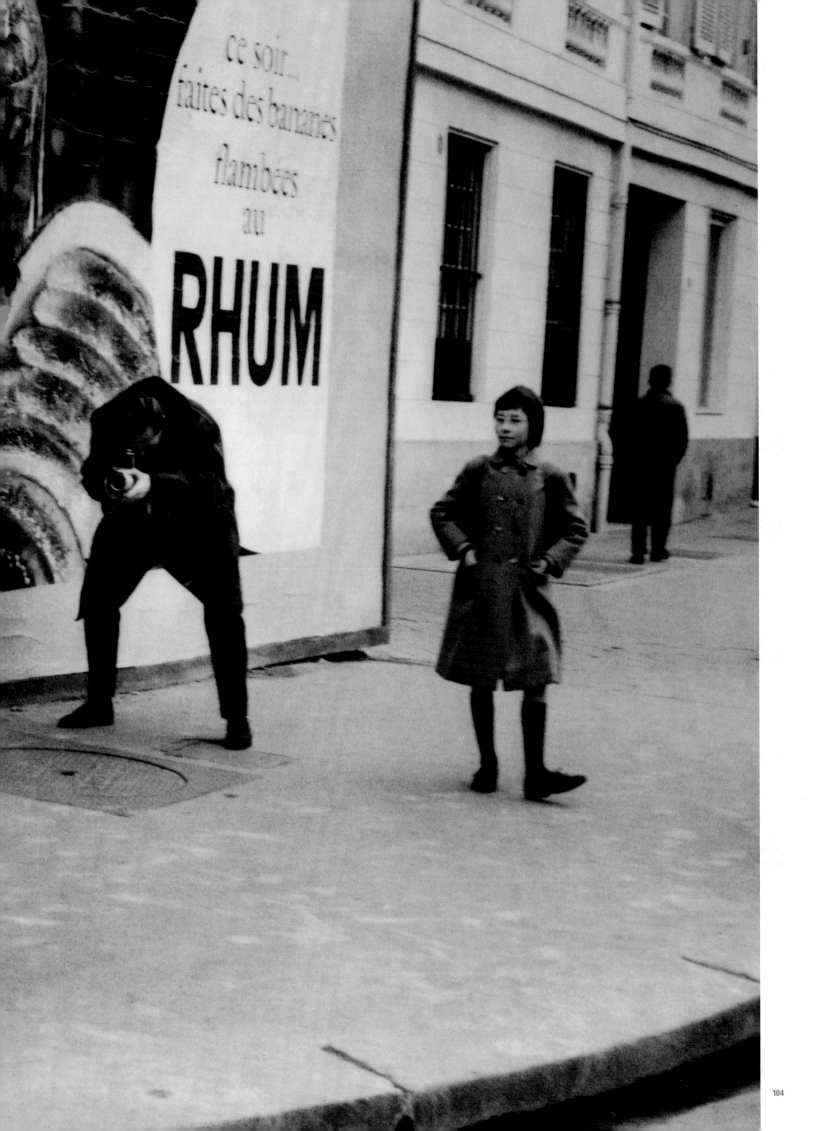

105 Henri Cartier-Bresson
Les Halles, Paris I arrond., 1969

106 Henri Cartier-Bresson
The day after the barricades,
Paris, May 1968

107 Gilles Caron
The Events of May 1968, Paris

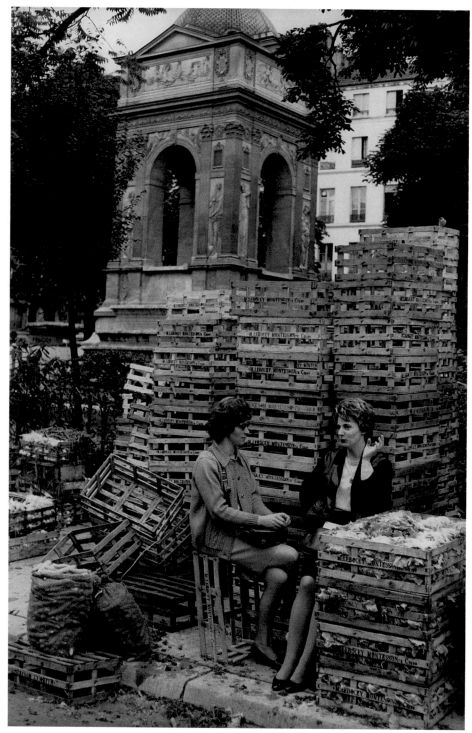

105

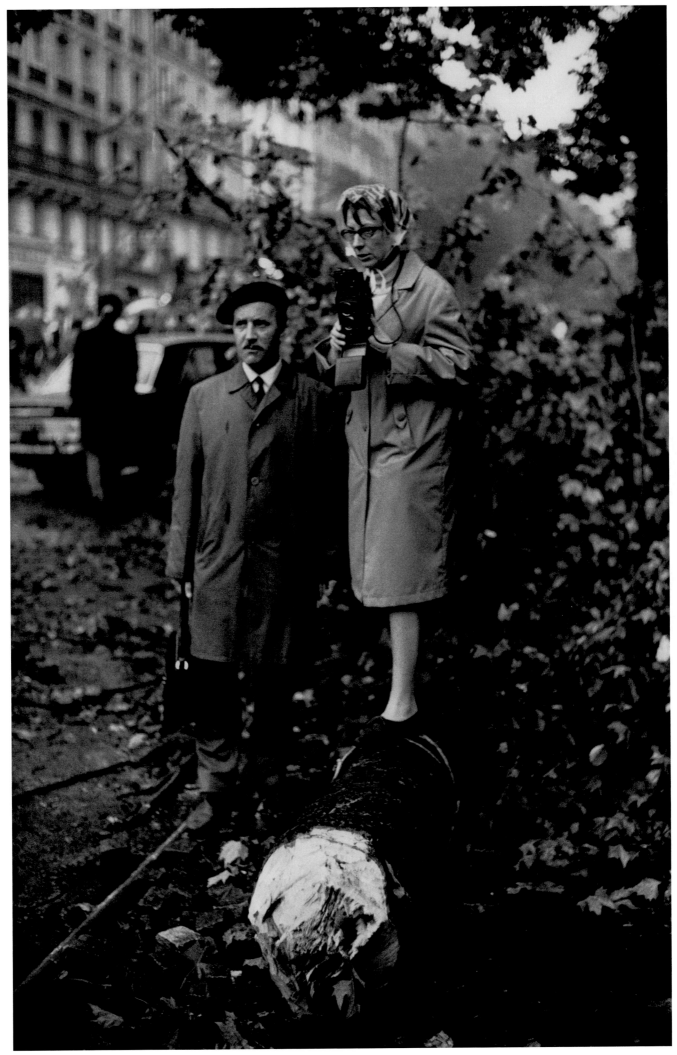

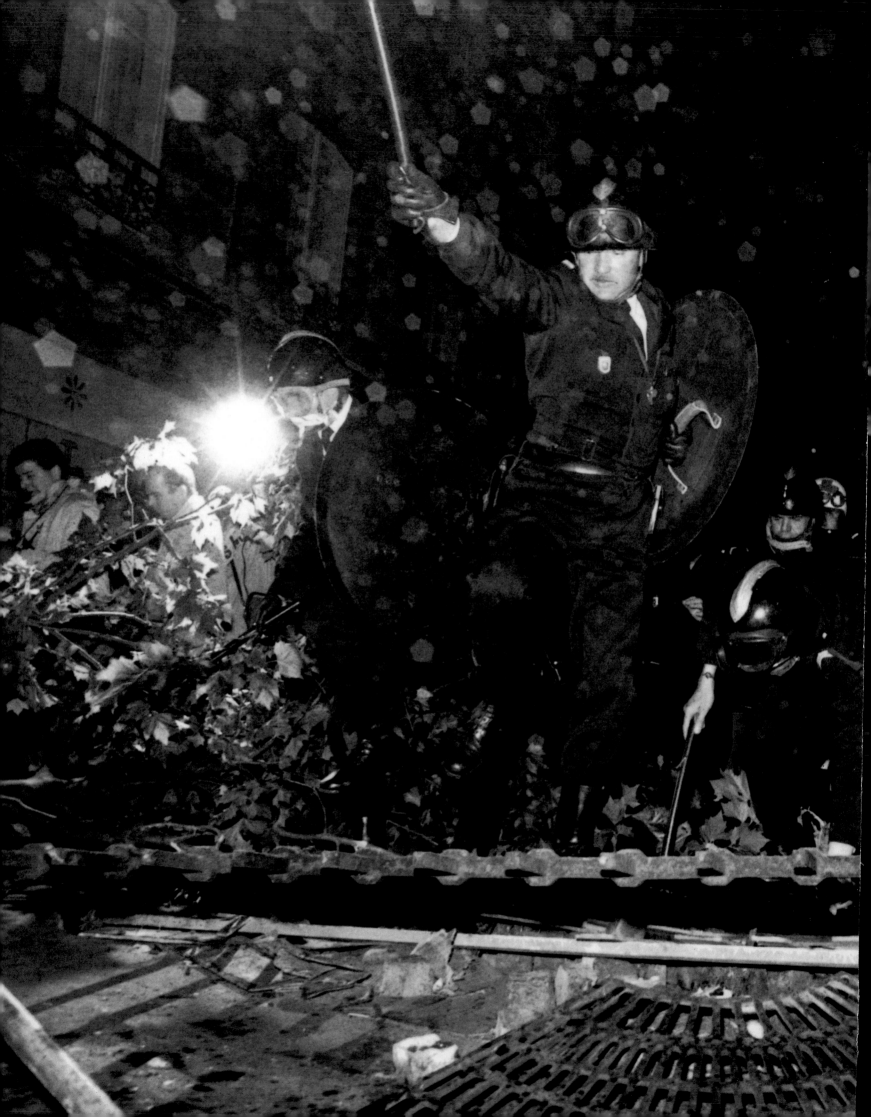

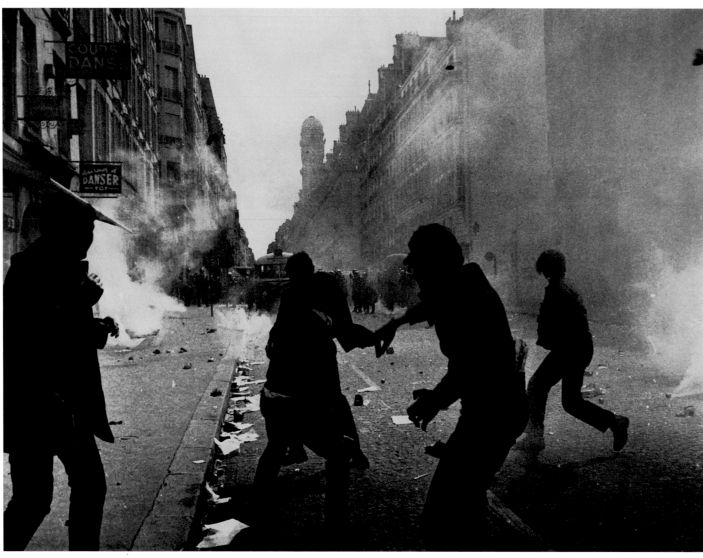

108

108 Photographer unknown
Students demonstrating
on the rue Saint-Jacques,
Paris V arrond.,7 May 1968

109 Giancarlo Botti
Demonstration of the CGT,
Paris, 1968

110 Gilles Caron
Rue Saint-Jacques,
Paris, V arrond., 10 June 1968

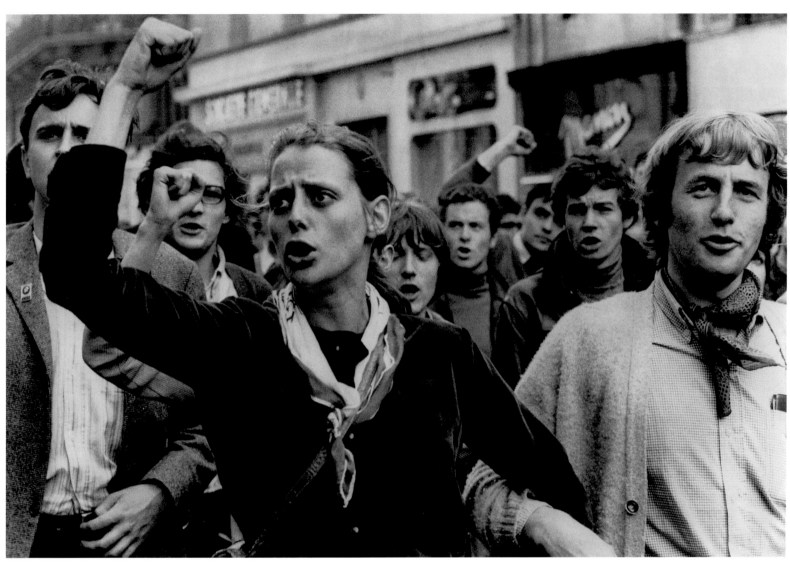

109

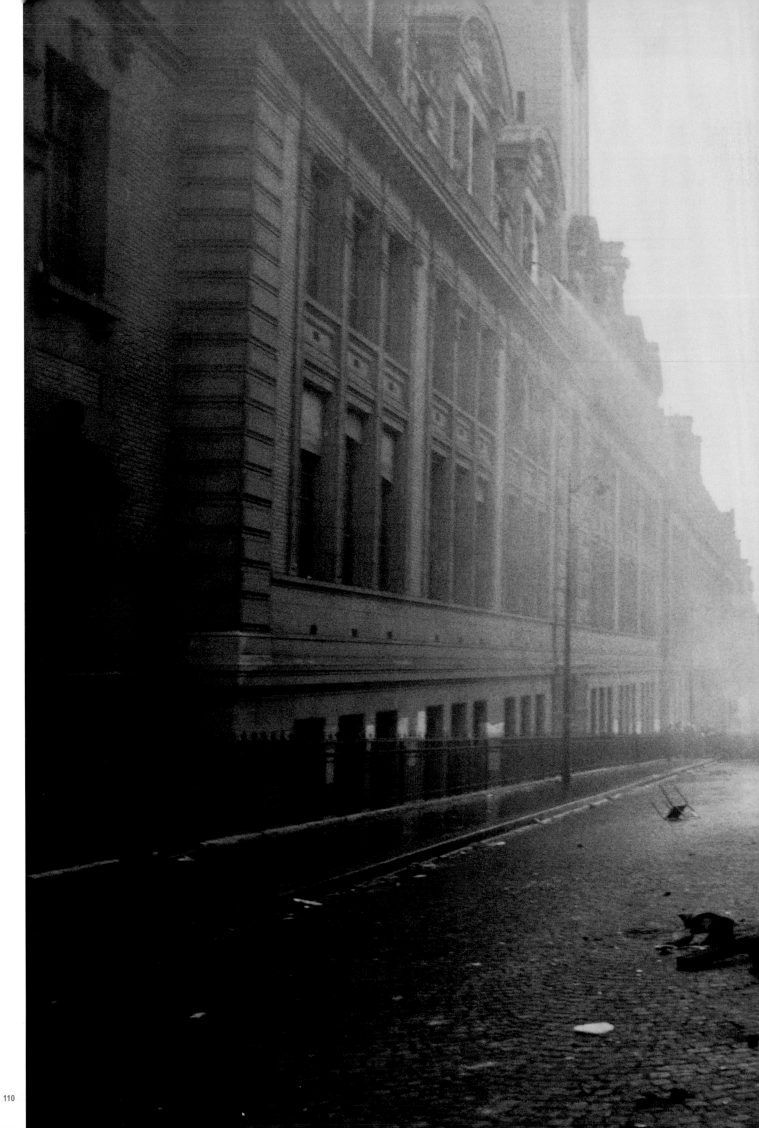

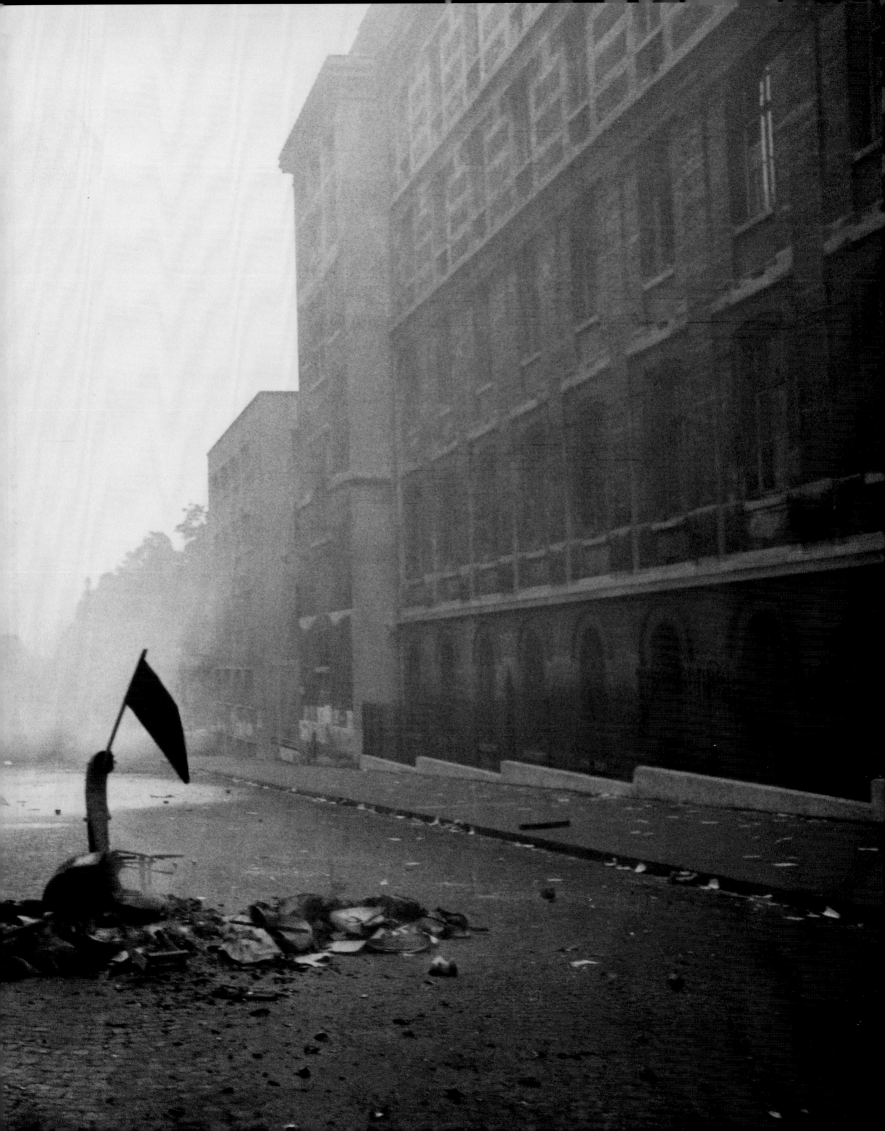

Bibliography

Where translations in English are available, these are listed.

L'Amour Fou: Photography and Surrealism, exh. cat., Hayward Gallery, Arts Council of Great Britain, London, 1986

André Kertész: Of Paris and New York, exh. cat., Art Institute of Chicago, 1985

Aragon, Louis, *Paris Peasant*, Simon Watson Taylor (trans.), London, 1981, first published Paris, 1926

Atget, Eugène, *Paris*, Nîmes, 1992

Baqué, Dominique, *Les documents de la modernité: Anthologie de textes sur la photographie de 1919 à 1939*, Paris, 1993

Barthes, Roland, 'Semiology and Urbanism', 1967, in *The Semiotic Challenge*, Richard Howard (trans.) , Berkeley, 1994

Benjamin, Walter, *The Arcades Project*, Howard Eiland and Kevin McLaughlin (trans.), Cambridge, Mass., 1999

Benjamin, Walter, 'Small History of Photography', in *Selected Writings, Volume 2, 1927–1934*, Michael W. Jennings, Howard Eiland and Gary Smith (eds.), Cambridge, Mass., 1999, first published in *Die literarische Welt*, (September–October 1931)

Bondi, Inge, *Chim: The Photographs of David Seymour*, London, 1996

Borhan, Pierre, *André Kertész: His Life and Work*, Boston, 1994

Bouqueret, Christian, *Des années folles aux années noires: La nouvelle photographie en France, 1920–1940*, Paris, 1997

Bovis, Marcel, *Lumières de Paris*, Lyon, 1996

Boyer, Christine M., *The City of Collective Memory: Its Historical Imagery and Architectural Expression*, Cambridge, Mass., 1996

Brassaï, *Paris by Night*, Gilbert Stuart (trans.), New York, 1987, first published Paris, 1933

Brassaï, *The Secret Paris of the 30s*, Richard Miller (trans.), London, 1976, first published Paris, 1976

Brassaï: the Eye of Paris, exh. cat., Museum of Fine Arts, Houston, 1999

Brassaï: No Ordinary Eyes, exh. cat., Hayward Gallery, London, 2001

Breton, André, *Nadja*, Richard Howard (trans.), New York, 1960, first published Paris, 1928

Cartier-Bresson, Henri, *D'une Chine à l'autre*, Paris, 1954

Cartier-Bresson, Henri, *The Decisive Moment*, New York, 1952

Chevalier, Louis, *The Assassination of Paris*, David P. Jordan (trans.), Chicago, 1994

Cohen, Margaret, *Profane Illumination: Walter Benjamin and the Paris of Surrealist Revolution*, Berkeley, 1993

Debord, Guy, *Society of the Spectacle*, New York ,1994, first published Paris, 1967

Deedes-Vincke, Patrick, *Paris: The City and its Photographs*, Boston, 1992

Doisneau, Robert, *La Banlieue de Paris*, Paris, 1949

Doisneau, Robert, *Instantanés de Paris*, Lausanne, 1955

Evenson, Norma, *Paris: A Century of Change, 1878–1978*, New Haven, 1979

Galassi, Peter, *Henri Cartier-Bresson: The Early Work*, exh. cat., Museum of Modern Art, New York, 1987

Green, Christopher, *Cubism and its Enemies: Modern Movements and Reaction in French Art, 1916–1928*, New Haven, 1987

Hamilton, Peter, *Robert Doisneau: A Photographer's Life*, New York, 1995

Hamilton, Peter, *Willy Ronis: Photographs 1926–1995*, exh. cat., Museum of Modern Art, Oxford, 1995

Izis, *Captive Dreams: Photographs 1944–1980*, London, 1993

Izis, *Paris des Rêves*, Lausanne, 1950

Kertész, André, *Paris vu par André Kertész*, Paris ,1934

Krull, Germaine, *Métal*, Paris, 1928

Krull, Germaine, *100 x Paris*, Berlin, 1929

Lefebvre, Henri , *Writings on Cities*, Eleonore Kofman and Elizabeth Lebas (eds. and trans.), Oxford, 1996

Lemagny, Jean-Claude, *Atget the Pioneer*, Munich, 2000

Luxembourg, Michel, *Paris, capitale de la photographie*, Paris, 1998

Mac Orlan, Pierre, *Atget, photographe de Paris*, Paris, 1930

Mac Orlan, Pierre, *Germaine Krull*, Paris, 1931

Maison Européene de la Photographie, *Mois de la photo à Paris: Catalogue générale*, Paris, 2000

Miller, Russell, *Magnum: Fifty Years at the Front Line of History*, London, 1997

Montier, Jean-Pierre, *Henri Cartier-Bresson*, London, 1996

Nesbit, Molly, *Atget's Seven Albums*, New Haven, 1992

Paris sous l'objectif, 1885–1994: Un siècle de photographies à travers de la ville de Paris, exh. cat., Association Paris Audovisuel/Maison Européene de la Photographie, Paris, 1998

'Photographie: Vision du monde', *Arts et Métiers Graphiques*, no.16 (15 March 1930)

Photography in the Modern Era: European Documents and Critical Writings, 1913–1940, Christopher Phillips (ed.), New York, 1989

Roegiers, Patrick, and Dominique Baque, *François Kollar*, Paris, 1989

Ronis, Willy, *Belleville-Ménilmontant*, Paris, 1954

Ronis, Willy, and Didier Daeninckx, *A nous la vie! 1936–1958*, Paris, 1996

Sichel, Kim, *Germaine Krull: Photographer of Modernity*, Cambridge, Mass., 1999

Szarkowsi, John, *Atget*, New York, 2000

Szarkowsi, John, and Maria Morris Hambourg, *The Work of Atget*, 4 vols., New York, 1981–85

Walker, Ian, *City Gorged with Dreams: Surrealism and Documentary Photography in Inter-war Paris*, Manchester, 2002

Warehime, Marja, *Brassaï: Images of Culture and the Surrealist Observer*, Baton Rouge, 1996

Whelan, Richard, *Robert Capa: A Biography*, London, 1985

Photographic Credits

Paul Almasy Plate 103 © AKG London/Paul Almasy

Eugène Atget Plate 5 © Bibliothèque historique de la ville de Paris/negative: Alison Harris; Plate 9 © Photothèque des musées de la ville de Paris/negative: Habouzit; Plate 10 Photographic Archives © Centre des monuments nationaux, Paris; Plate 13 © Photo RMN-Gérard Blot; Plate 16 © Photothèque des musées de la ville de Paris/negative: Ladet

Jacques-André Boiffard Plate 31 Collection Christian Bouqueret, Paris © A.R.D.P. Paris

Giancarlo Botti Plate 109 Photo: Giancarlo Botti © Camera Press/London

Édouard Boubat Plate 78 © Édouard Boubat

Marcel Bovis Plates 40, 68 © Ministère de la Culture, France

Brassaï Plates 1, 25, 33, 34, 35, 36, 37, 39 Courtesy Edwynn Houk Gallery, New York © Gilberte Brassaï

Henri Cartier-Bresson Frontispiece, Figs. 7, 9, Plates 28, 59, 67, 72, 77, 80, 89, 95, 96, 102, 104, 105, 106 © Henri Cartier-Bresson/Magnum Photos

René Burri Plate 99 © René Burri/Magnum Photos

Robert Capa Plates 47, 50, 56, 61, 84 © Robert Capa/Magnum Photos

Gilles Caron Plates 107, 110 © Gilles Caron/Contact Press Images/Colorific!

Jean-Philippe Charbonnier Plate 58 © J. P. Charbonnier/Agence TOP, Paris

Alvin Langdon Coburn Plate 11 © Courtesy George Eastman House, New York

Denise Colomb Plate 74 © Ministère de la Culture, France

Leon Robert Demachy Plate 4 © Collection of the Société Française de Photographie

Robert Doisneau Plates 53, 55, 57, 60, 62, 63, 64, 69, 70, 75, 81, 82, 83, 94, 98, 100 © Robert Doisneau/Rapho/Network

Robert Frank Plates 87, 88 © Robert Frank, courtesy Pace/MacGill Gallery, New York

Gisèle Freund Fig. 1, Plate 26 © Gisèle Freund/Agence Nina Beskow, Paris

Izis Plates 79, 92 © Photo Izis

Tore Johnson Plate 86 © Tore Johnson/Tiofoto, Stockholm

André Kertész Plates 18, 19, 22, 27, 32, 42, 43, 46 © Ministère de la Culture, France

Anneliese Kretschmer Plate 41 Collection Christian Bouqueret, Paris © Famille Kretschmer

William Klein Plate 101 © William Klein

François Kollar Fig. 2 © Ministère de la Culture, France, Plates 30, 38, 44 Collection Christian Bouqueret, Paris © A.R.D.P. Paris

Germaine Krull Plates 20, 21 Collection Christian Bouqueret, Paris © A.R.D.P. Paris

Sergio Larrain Plate 90 © Sergio Larrain/Magnum Photos

Jacques-Henri Lartigue Plates 8, 12, 14, 15 © Ministère de la Culture, France/A.A.J.H.L.

Éli Lotar Plate 24 © Jacques Faujour/CNAC/MNAM-Dist.RMN

Man Ray Plate 23 © Man Ray Trust/ADAGP, Paris and DACS, London 2002

Charles Marville Fig. 3 © Bibliothèque historique de la ville de Paris

Willy Maywald Plate 51 © Association Willy Maywald/ADAGP, Paris and DACS, London 2002

László Moholy-Nagy Fig. 5 © DACS 2002

Jean Moral Plate 49 Collection Christian Bouqueret, Paris © A.R.D.P. Paris

Janine Niepce Plate 91 © Janine Niepce/Rapho/Network

Roger Parry Plate 54 © Ministère de la Culture, France

Aurélio da Paz dos Reis Plates 2, 3 © Centro Português de Fotografia/Ministério da cultura

Willy Ronis Fig. 6, Plates 65, 66, 71, 76, 93, 97 © Willy Ronis/Rapho/Network

Seeberger Brothers Fig. 4, Plate 6 Photographic Archives © Centre des monuments nationaux, Paris

David Seymour (Chim) Plates 45, 48 © David Seymour (Chim)/Magnum Photos

Lucien Solignac Plate 17 © Photothèque des musées de la ville de Paris/ negative: Briant

Alfred Stieglitz Plate 7 © Photo RMN-Reversement Orsay

André Steiner Plate 29 Collection Christian Bouqueret, Paris © A.R.D.P. Paris

Roger Touchard Fig. 8 © Roger Touchard/Bibliothèque historique de la ville de Paris

Sabine Weiss Plates 73, 85 © Archives Sabine Weiss/Rapho/Network

Maurice Zalewski Plate 52 © M. Zalewski/Rapho/Network

Photographer unknown Plate 108 © Hulton Getty/AFP

Royal Academy Publications
David Breuer
Fiona McHardy
Peter Hinton
Peter Sawbridge
Nick Tite

Design: Esterson Lackersteen
Copy-editor: Philippa Baker
Picture research: Julia Harris-Voss with Alison Harris
Colour origination: DawkinsColour

Printed in Italy by EBS, Verona

British Library Cataloguing-in-Publication Data
A catalogue record for this book is available from the
British Library

ISBN 1-903973-02-3

Distributed outside the United States and Canada by
Thames & Hudson Ltd., London

ISBN 0-8109-6640-9

Distributed in the United States and Canada by
Harry N. Abrams, Inc., New York